D0754639

Beautiful
ALBERTA

Mike Grandmaison

FIREFLY BOOKS

A FIREFLY BOOK

Publisher Cataloging-in-Publication Data (U.S.)
Grandmaison, Mike, 1954-
 Beautiful Alberta / Mike Grandmaison.
[144] pages : color photographs ; cm.
Summary: "A photographic portrait of Canada's most prosperous
province, containing 125 exquisite photographs of Alberta's distinct
and varied topographies: prairies, badlands, forests and mountains.
Alberta's urban regions are no less impressive with images of Calgary,
Edmonton and Fort McMurray and towns of Banff, Jasper, Canmore
and Drumheller" – Provided by publisher.
ISBN-13: 978-1-77085-578-6
1. Alberta – Pictorial works. I. Title.
917.123 dc23 FC3662.G736 2015

Library and Archives Canada Cataloguing in Publication
Grandmaison, Mike, 1954-, photographer
 Beautiful Alberta / photographer, Mike Grandmaison.
ISBN 978-1-77085-578-6 (bound)
 1. Alberta--Pictorial works. I. Title.
FC3662.G73 2015 971.23 C2015-903109-5

Published in the United States by
Firefly Books (U.S.) Inc.
P.O. Box 1338, Ellicott Station
Buffalo, New York 14205

Published in Canada by
Firefly Books Ltd.
50 Staples Avenue, Unit 1
Richmond Hill, Ontario L4B 0A7

Printed in China

*The publisher gratefully acknowledges the financial support for our
publishing program by the Government of Canada through the Canada
Book Fund as administered by the Department of Canadian Heritage.*

PHOTO CREDITS
All photography is by Mike Grandmaison except for the
following:
pp. 3: LuciaP/Shutterstock
pp. 18-19: John E. Marriott
pp. 37, 87, 98-99: Anita Erdmann
pp. 92-93: eXpose/Shutterstock
pp. 102-103 113, 116, 117: Jeff Whyte/Shutterstock
pp. 106-107: Gail Foster
pp. 110-111: 2009fotofriends/Shutterstock
pp. 112: Jason Kasumovic/Shutterstock

Opposite: Wild rose

Contents

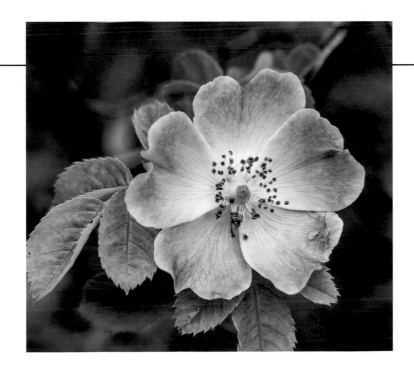

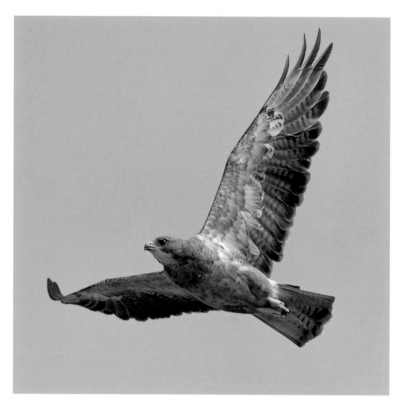

Swainson's hawk, Taber

Introduction

Alberta is a province of superlatives. From majestic mountains to the big skies of the vast, open prairies, to the eerie landscape where dinosaurs once roamed to its plentiful wildlife, Alberta figures prominently in Canada's vast landscapes. Moraine Lake, surrounded by Valley of the Ten Peaks in the magnificent Canadian Rockies, was featured on the back of the old Canadian twenty dollar bill. Songs like "Four Strong Winds" by Alberta's own Ian and Sylvia Tyson, as well as Gordon Lightfoot's "Alberta Bound" and Stompin Tom Connors' "Alberta Rose" praise the beauty and longing for life in Canada's most westerly of the three prairie provinces. Alberta's striking beauty is preserved in more than 500 parks and protected areas including five national parks: Banff, Jasper, Waterton Lakes, Elk Island and Wood Buffalo; and five of Canada's 17 UNESCO World Heritage Sites: Head-Smashed-In Buffalo Jump, Wood Buffalo National Park, Dinosaur Provincial Park, Canadian Rocky Mountain Parks and Waterton–Glacier International Peace Park. Alberta has always been a favorite destination.

Northern Alberta was originally part of the North-Western Territory until 1870 when the newly formed Canadian Government purchased Rupert's Land. In 1882, both the North-Western Territory and Rupert's Land then became Canada's North-West Territories. Finally, in 1905, the District of Alberta was enlarged and assumed provincial status as it entered Confederation along with the province of Saskatchewan. With an area of 661,848 km2, Alberta is a sizeable province bordered to the west by British Columbia, to the east by Saskatchewan, to the north by the Northwest Territories and to the south by the state of Montana in the United States. Its highest point is Mount Columbia in the Rocky Mountains along the southwest border at 3,747 meters at the summit, while its lowest point is on the Slave River in Wood Buffalo National Park at 152 meters.

Alberta is Canada's fourth most populated province, with an estimated 4,145,992 people living in Alberta, behind Ontario, Quebec and British Columbia respectively. The capital city Edmonton, located approximately in the geographic center of the province, is the most

northerly major Canadian city. Together with Alberta's biggest city, Calgary, these two cities make up about half of the province's population. This Calgary–Edmonton Corridor is the most urbanized region in the province as well as one of the densest in all of Canada. While Edmonton is the gateway and hub for resource development in northern Canada, Calgary acts as the financial center for western Canada because of its role in the development of oil and gas exploration in the region.

Alberta has one of the country's strongest economies. It is Canada's largest producer of conventional crude oil, synthetic crude, natural gas and gas products. It is also the world's largest exporter of natural gas as well as the world's fourth largest producer. Agriculture, while historically important, remains a sustainable industry in Alberta with cereal crops of wheat and canola and a strong world market in the cattle industry. With its more than three million head of cattle, Alberta produces more than half of all Canadian beef. The forest sector continues to produce large quantities of lumber, plywood and oriented strand board (OSB), while several plants in northern Alberta supply North America and the Pacific Rim nations with bleached wood pulp and newsprint. Tourism has played an important role in drawing visitors worldwide to its many natural attractions, including the majestic Canadian Rocky Mountains and the peculiar badlands in the Red River Valley, as well as the urban attractions of the Calgary Stampede and Edmonton's K-Days and the Ukrainian Cultural Heritage Village.

I lived in Edmonton and surroundings for nearly seven years starting in the late 1970s. I have since traveled back to Alberta more than a dozen times to visit family and friends, to vacation and to work. I have explored much of the province's landscape from east to west and north to south. I have driven its roads, canoed and boated its waterways, hiked and cross-country skied many of its trails and I have seen much of it from the air too! I have been fortunate to get to know Alberta as few people have.

Alberta offers a diversity of habitats. We find six natural regions within its borders: the Rocky Mountains, the foothills, the boreal forest, the Canadian Shield, the Parkland and the grasslands.

The Rocky Mountains are a national treasure and represent about 7.4 percent of Alberta's total area. They are one of Canada's most popular destinations, second only to Ontario's Niagara Falls. From Alberta's southern border with Montana, they form the western boundary with British Columbia as far north as Grande Cache, at which point the Rockies veer westward into neighbouring British Columbia. The region is famous for its national parks such as Banff (Canada's first national park), Jasper and Waterton Lakes (the world's first international park). But it also includes many other parks and preserves of equal beauty in Kananaskis

Country and the Wilmore Wilderness. One of the country's most scenic drives is the Icefields Parkway running north south through Jasper and Banff national parks. Maligne Lake and its famous Spirit Island is the largest lake in these breathtaking Canadian Rockies at 22 kilometers long. Peyto Lake, Bow Lake, Moraine Lake and Lake Louise are immensely popular as much for their deep rich blue color from the suspended glacial calcium particles otherwise known as glacial flour as for their picturesque and awe-inspiring settings. Vermilion Lakes, along with Pyramid Lake, Patricia Lake and Herbert Lake offer wonderful photographic opportunities. Deep canyons like Maligne Canyon, Mistaya Canyon and Johnston Canyon offer vantage points where the erosional power of torrential flows from rivers during the last ice age carved through the mountains can be witnessed. There are also many lesser well-known locations which are just as stunning for different reasons, like Horseshoe Lake, Cameron Lake, Spillway Lake and the Kootenay Plains Ecological Reserve to name a few.

What defines this region are the mountains, the high foothills, the deep glacial valleys, the bare rock, the glaciers and the snowfields. Summers tend to be cool and short while winters are typically long, cold and snowy. At lower elevations, coniferous forests of lodgepole pine dominate with grasslands and mixed-wood forests in the valley bottoms and warmer slopes. Higher in the subalpine zone stands of Engelmann spruce and subalpine fir are the norm and, approaching the alpine zone, stunted trees form the tree line. Higher still is the alpine zone where alpine meadows of colorful wildflowers and bare rock finally give way to exposed slopes of bare rock, glaciers and ice fields. The longest river in the province, the Athabasca River, begins at the Columbia Icefields and flows 1,538 kilometers to Lake Athabasca in the north but first spills over at the famous Athabasca Falls in Jasper National Park. Wildlife is abundant in the mountains and foothills. Many species such as the grizzly bear, the Bighorn sheep, mountain goat, pika, hoary marmot and Clark's Nutcracker are typically found in the mountains along with elk, mule deer, moose, coyote, wolf, cougar and the Columbian ground squirrel, to name a few.

Surprisingly, the forests, not the prairies, account for a large portion of Alberta's surface area. The Boreal Forest Natural is the largest forest in Alberta and it alone covers 48 percent of the province. It manifests itself as a nearly continuous belt of coniferous trees of black and white spruce, balsam fir and jack pine broken by wetlands, rivers and lakes. The mighty Athabasca, Smoky, Peace and Hay rivers run through the boreal forest. The Aspen Parkland, which covers about 12 percent of the province, is a transitional forest between the prairie and boreal forest and is comprised of poplars and spruce interspersed with prairie grasslands. An excellent example of this is Elk Island National Park, which also protects herds of plains and wood bison. The plains bison used to roam the Canadian Prairies in the millions before they were hunted nearly to extinction. The Aspen Parkland is one of Alberta's richest agricultural regions, but much of the original aspen parkland survives only as small

fragments (less than 5 percent) because of the expansion of farming. Four significantly different habitats are commonly found in the aspen parklands: the fescue prairie, the woodlands, the ravines and the wetlands and lakes. About 1.5 percent of the province is covered by the Canadian Shield, 2 billion-year old rock formations in the northeastern part of the province that was carved by the glaciers. Typical wildlife that live in the forests include black bear, wolf, moose, deer, elk, beaver and lynx, as well as the endangered Whooping Crane and the threatened boreal Woodland caribou. Forestry, mining and oil-and-gas industries are important industries in the forest region.

The grasslands region, which represents about 14 percent of Alberta, is found in southern Alberta. While the landscape is mostly flat, small hills, valleys, coulees, sand hills and badlands make the prairie landscape even more complex. The grasslands region is subtler, with a restrained color palette. This is the hottest region in the province with warm, dry summers that are often windy. Winters tend to be cold but without much snow.

In the early 1900s, the region was mostly covered with a natural prairie of grasses and forbs, like the wild rose, Alberta's provincial flower. But today most of the region has been transformed into cropland with wheat and canola as two of the more important crops. Irrigation is practiced in some parts of the province. Farmers and ranchers raise cattle, horses, sheep and other animals. Because the region also has oil and gas, oil pump jacks commonly dot the landscape. Wildlife consisting of ground squirrels (golfers), deer, pronghorn, coyotes, hares, foxes and a variety of hawks, owls and songbirds are common in this region.

Many of Alberta's cities are built along the major waterways that cut though the prairie like the North Saskatchewan River (Edmonton), the South Saskatchewan River (Medicine Hat), the Bow River (Calgary), the Oldman River (Lethbridge), the Red Deer River (Red Deer) and the Athabasca River (Fort McMurray). Lamont County, east of Edmonton, is known as the Church Capital of Canada with 47 churches — many of which are of Ukrainian heritage — more than anywhere else in North America.

A few prairie locations deserve special mention. Head-Smashed-In Buffalo Jump Provincial Park, also a UNESCO World Heritage Site, protects a site where hunters once drove plains bison over cliffs some 5,700 years ago and where remaining piles of bones at the base can measure up to 10 meters deep. Cypress Hills Provincial Park is the highest point in central Canada at almost 1,500 meters in elevation. This plateau was never glaciated and plants and animals found here are not found in the surrounding area. A lesser well-known but very interesting prairie site is Red Rock Coulee Natural Preserve where roundish sandstone concretions measuring up to 2 meters in height are scattered along a coulee like marbles.

Interspersed through the grasslands region, the badlands feature a desert-like habitat that is the warmest and driest of all habitats found in Alberta. Carved by glaciers and eroded by wind and water, this eerie landscape made up principally of clay is the world's richest fossil bed of late Cretaceous dinosaurs. Three locations are of particular interest. Dinosaur Provincial Park is a UNESCO World Heritage Site where dinosaurs roamed 75 million years ago and where hoodoos — sandstone pillars — are a prominent feature. Further down the Red Deer River, the badlands in East Coulee near Drumheller house the world-class Royal Tyrrell Museum. In southern Alberta near the Montana border and along the Milk River, Writing-on-Stone Provincial Park features more badlands as well as the greatest concentration of aboriginal rock paintings and carvings on the North American Great Plains. The park also encompasses the largest area of protected prairie in the Alberta park system where mule deer, jackrabbits, short-horned lizards, scorpions and rattlesnakes coexist with cactus, tumbleweed and sagebrush, as well as cottonwood and willow trees along the rivers.

"Wild rose country" is a place I lived, worked and played. It's also a place I always look forward to returning to. I hope that the following selection of photographs inspire you to visit Alberta and appreciate all it has to offer.

Mike Grandmaison
www.grandmaison.mb.ca

Following page, left: Castle Mountain, Banff National Park

Following page, right: Waterfowl Lake, Mount Chephren and the Icefields Parkway, Banff National Park

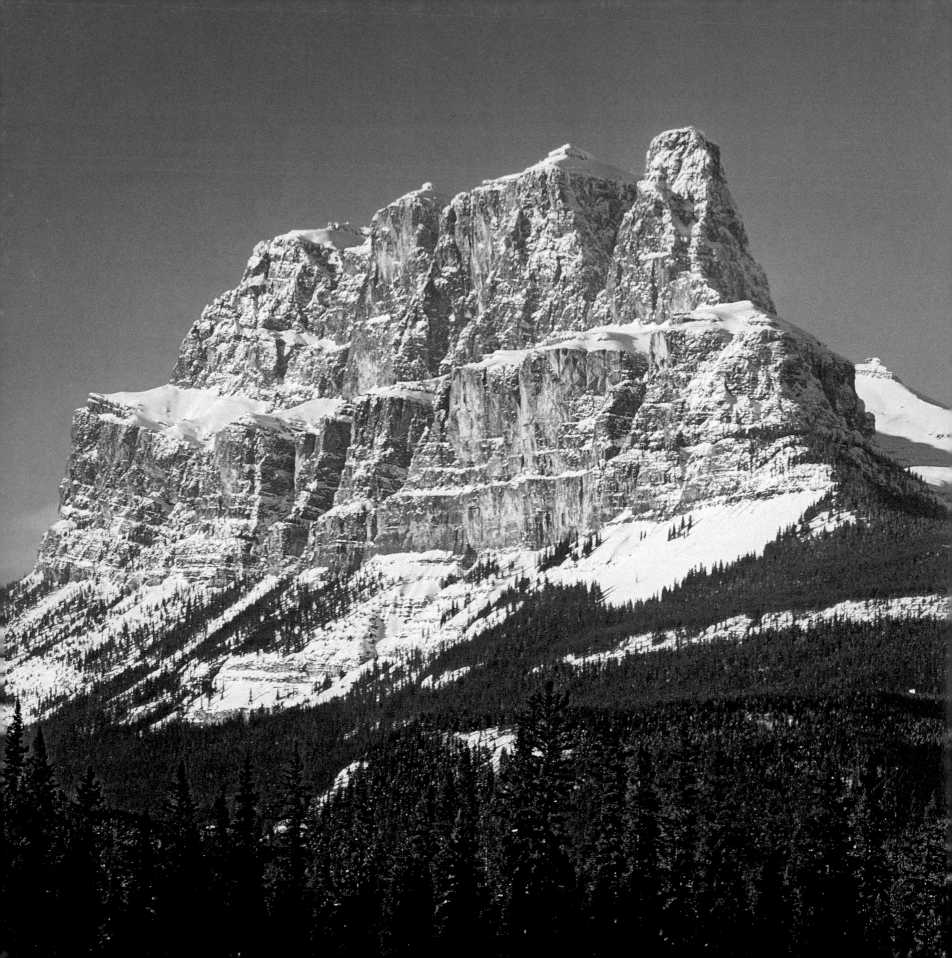

Mountains

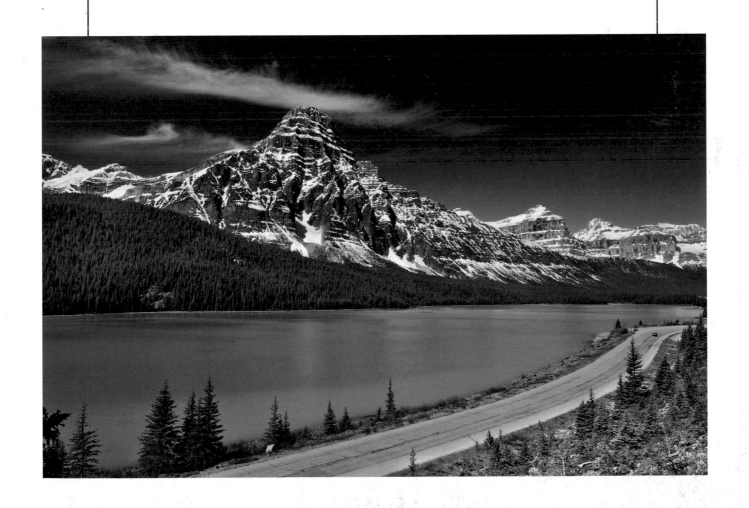

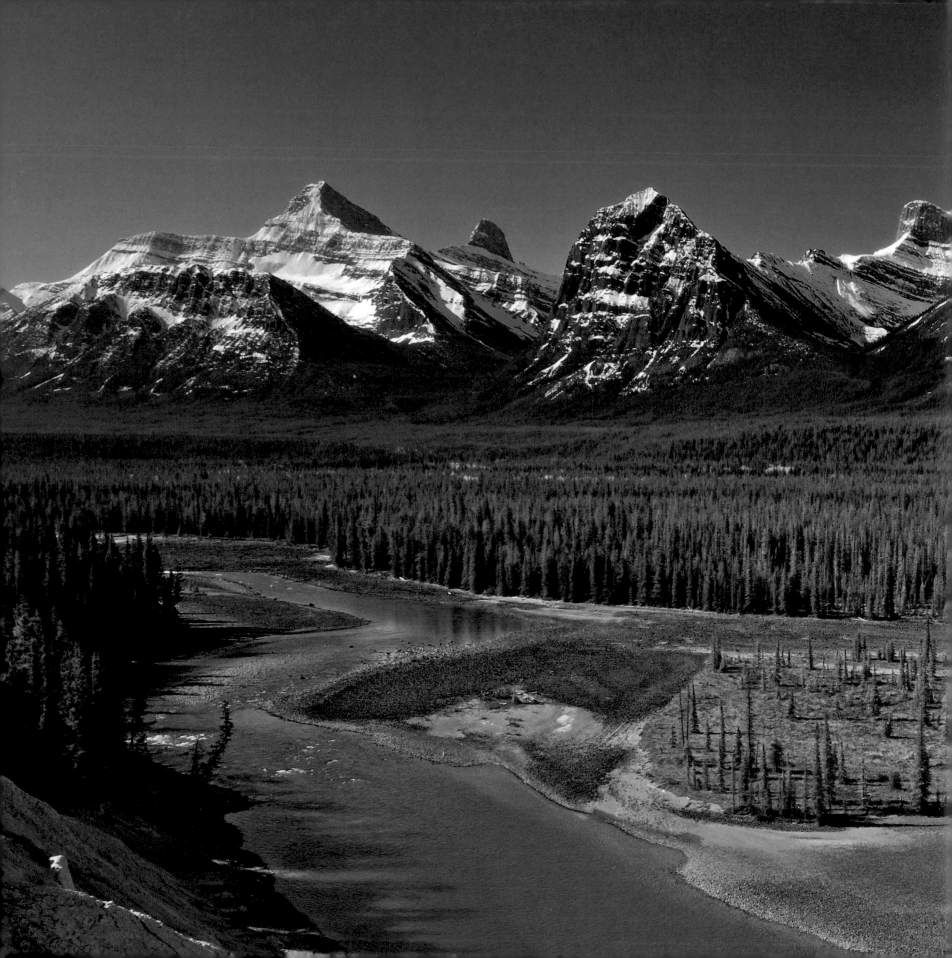

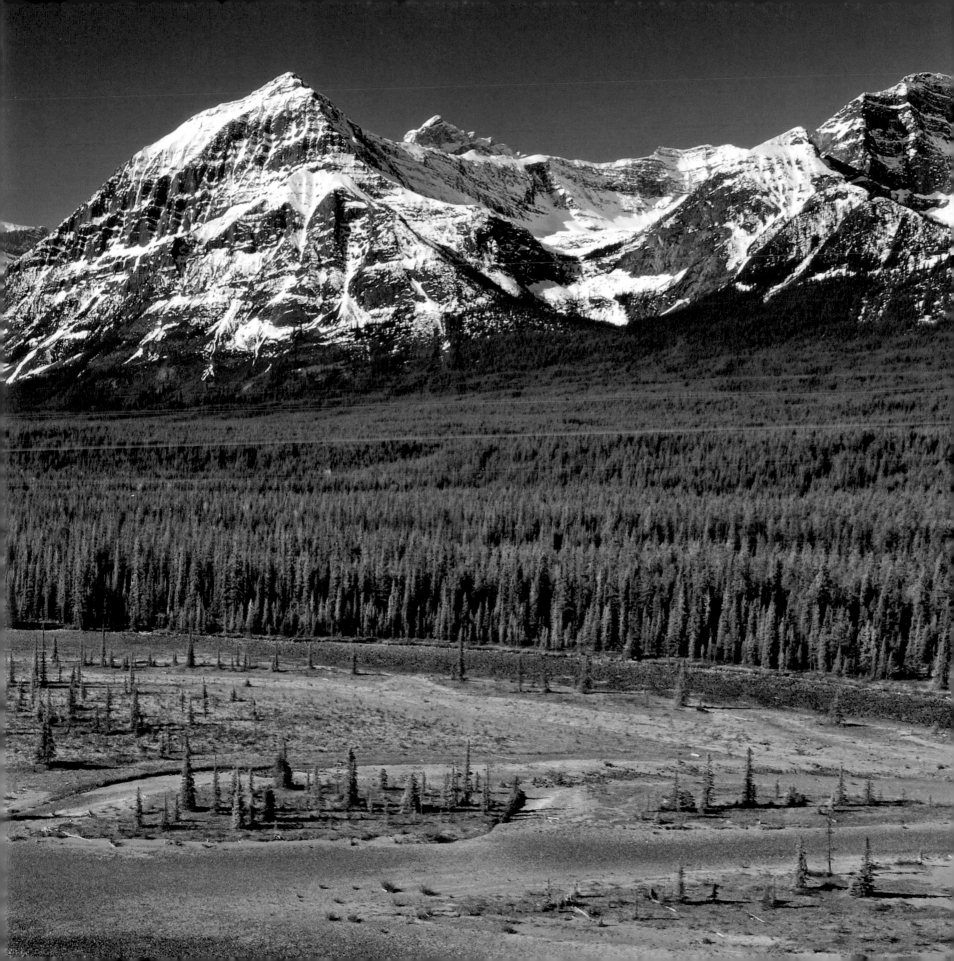

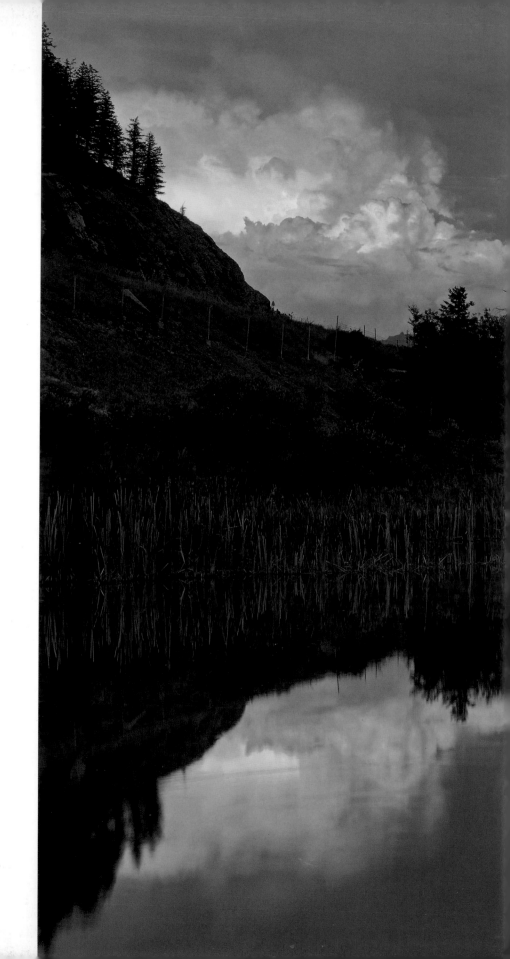

Previous spread:
Athabasca River and the Canadian Rocky Mountains,
Jasper National Park

Opposite: Vermilion Lakes and storm, Banff National Park

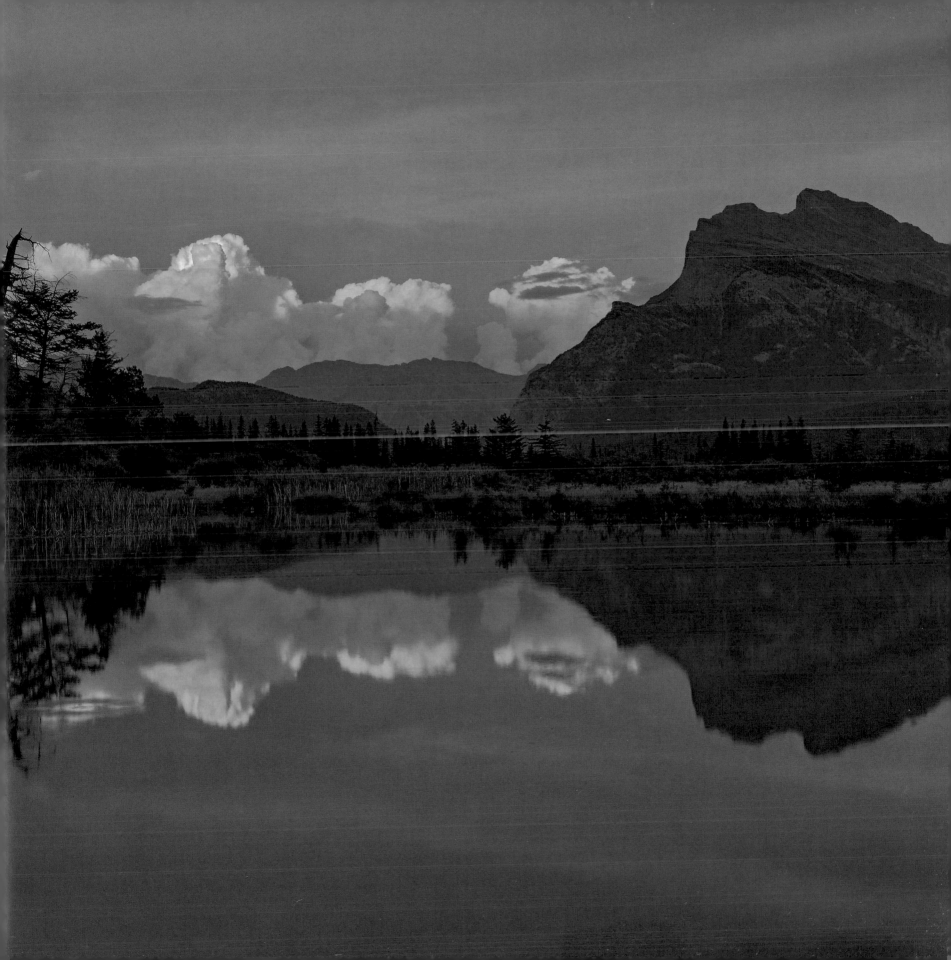

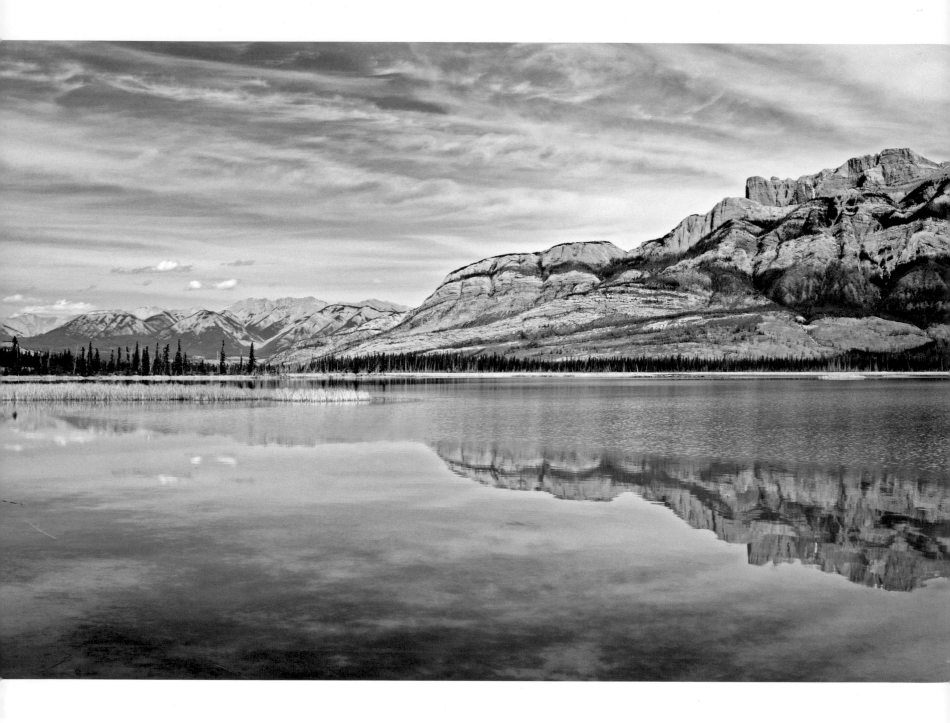

Above: Reflection on Talbot Lake, Jasper National Park

Opposite: Sunwapta Falls, Jasper National Park

Following spread: Northern lights over Lake Minnewanka, Banff National Park

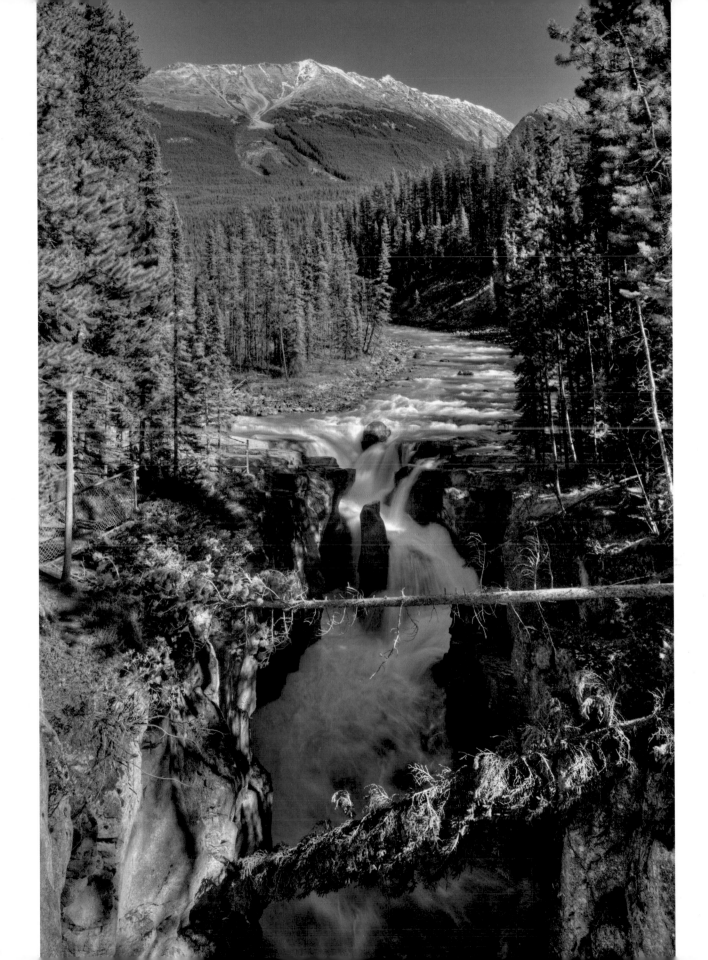

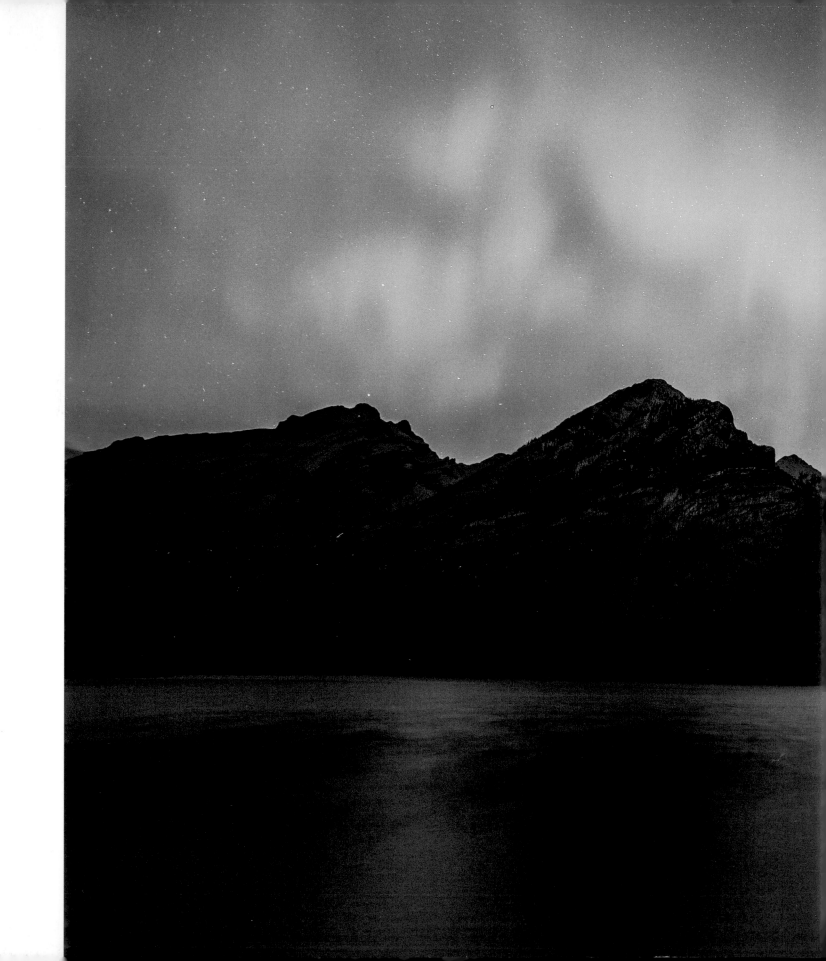

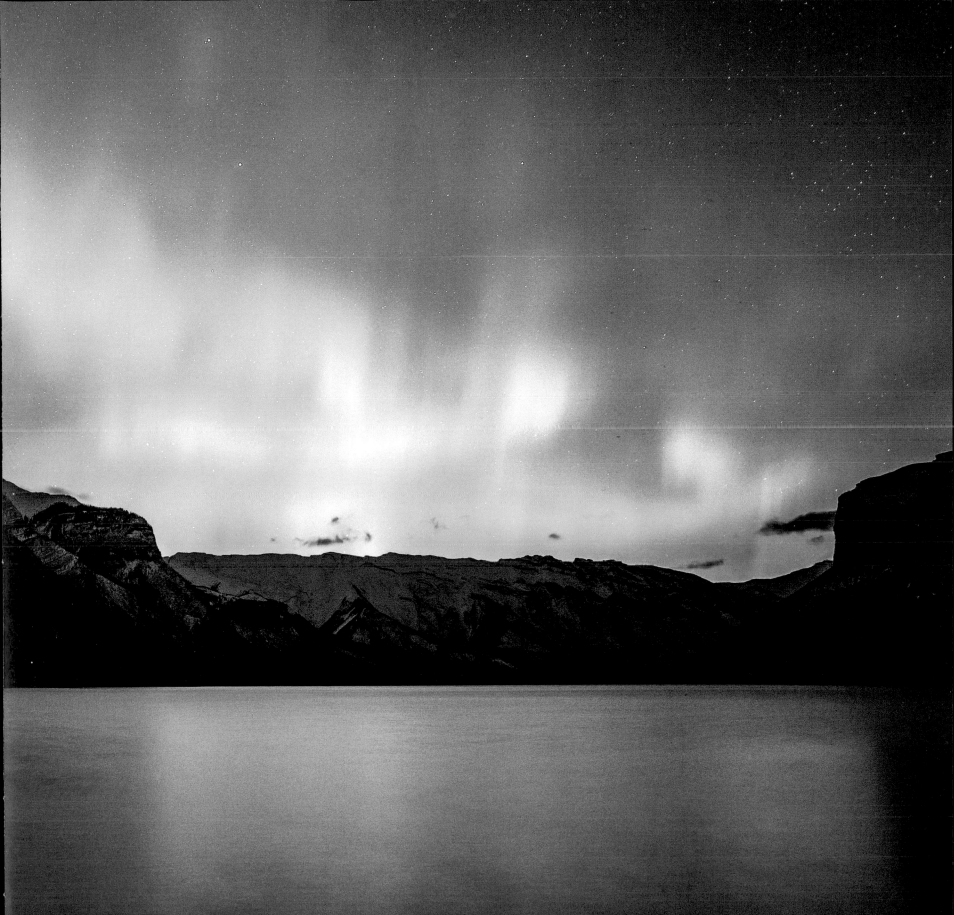

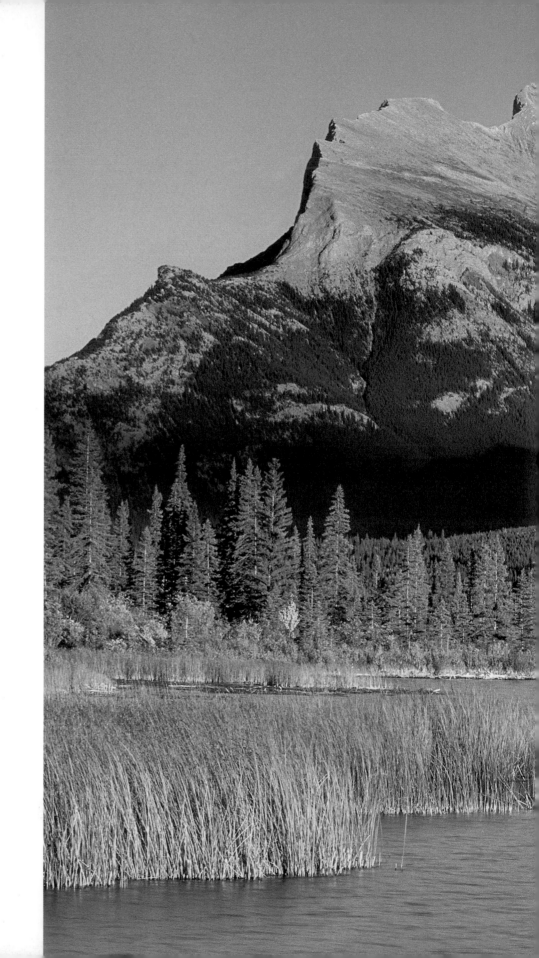

Mt. Rundle and Vermilion Lakes in autumn,
Banff National Park

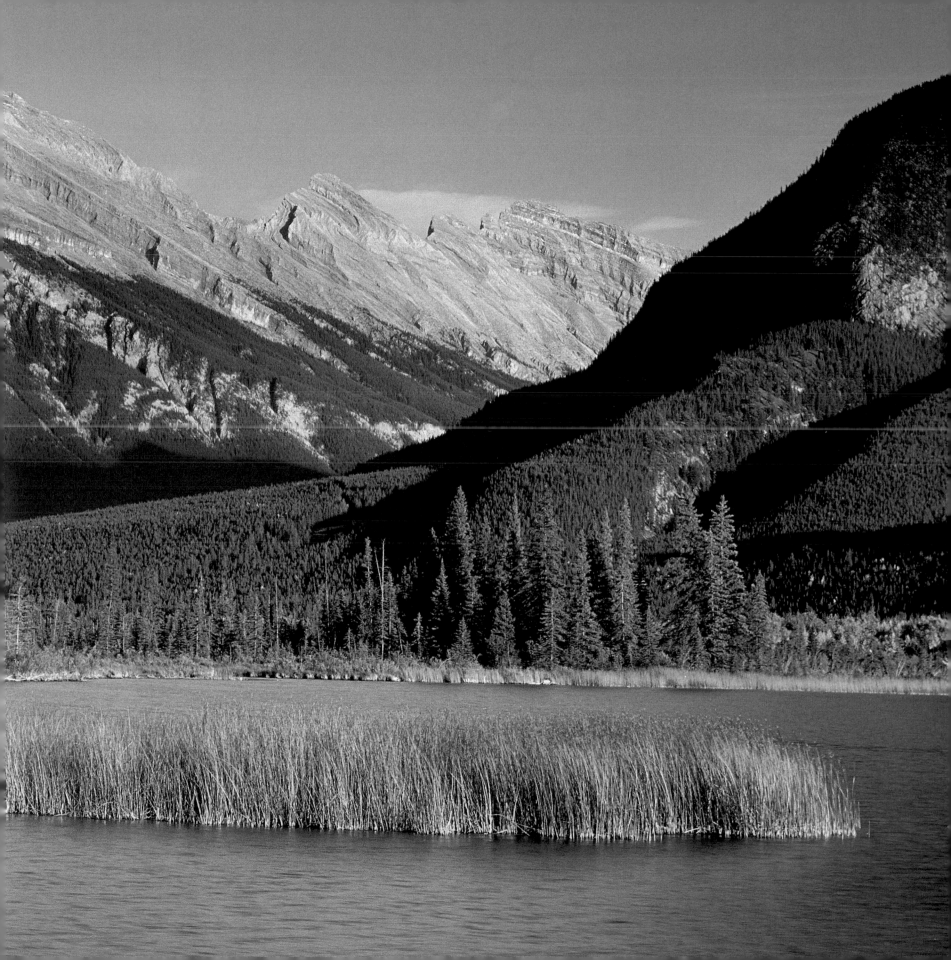

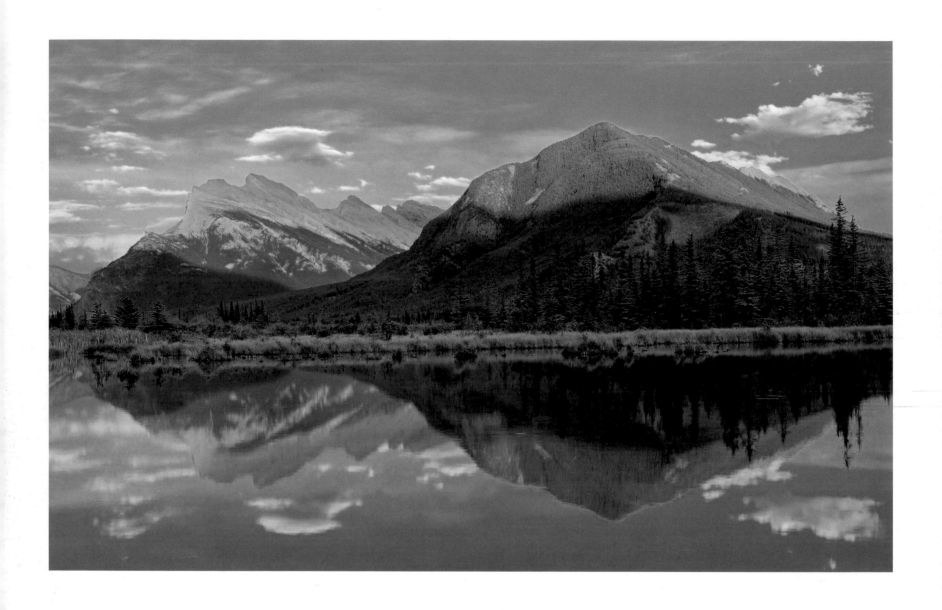

Above: Mount Rundle (left) and Sulphur Mountain (right) reflected in Vermilion Lakes at sunset, Banff National Park

Opposite: Fireweed and Bow Lake with Crowfoot Mountain, Banff National Park

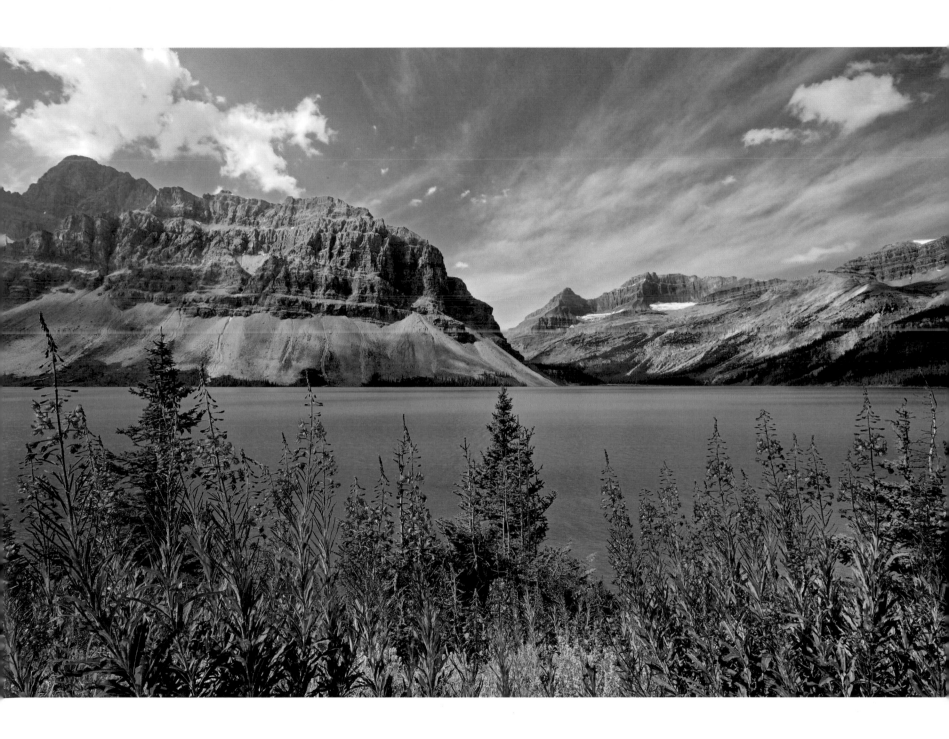

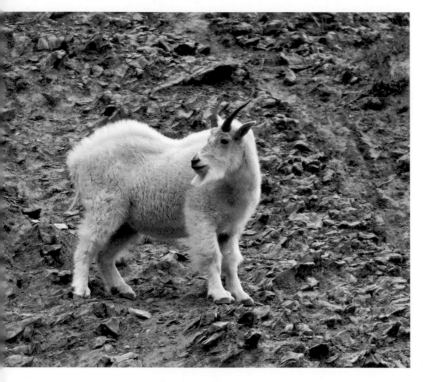

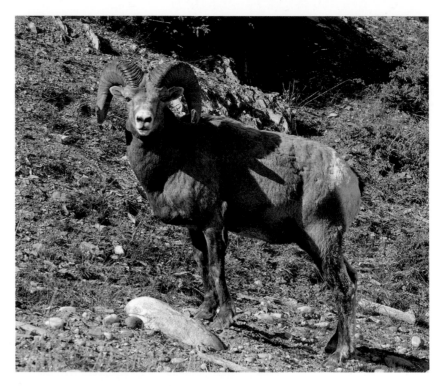

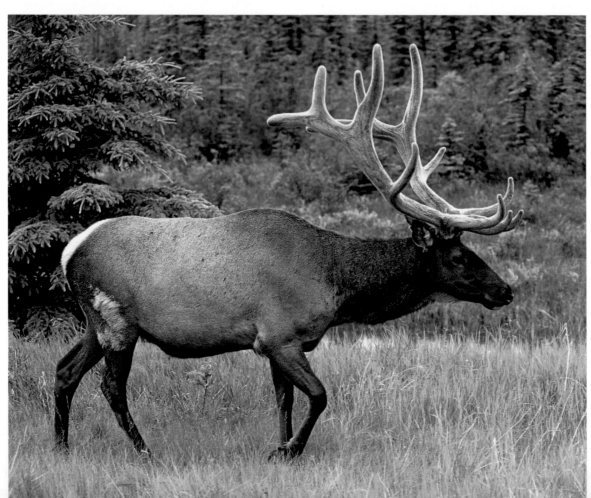

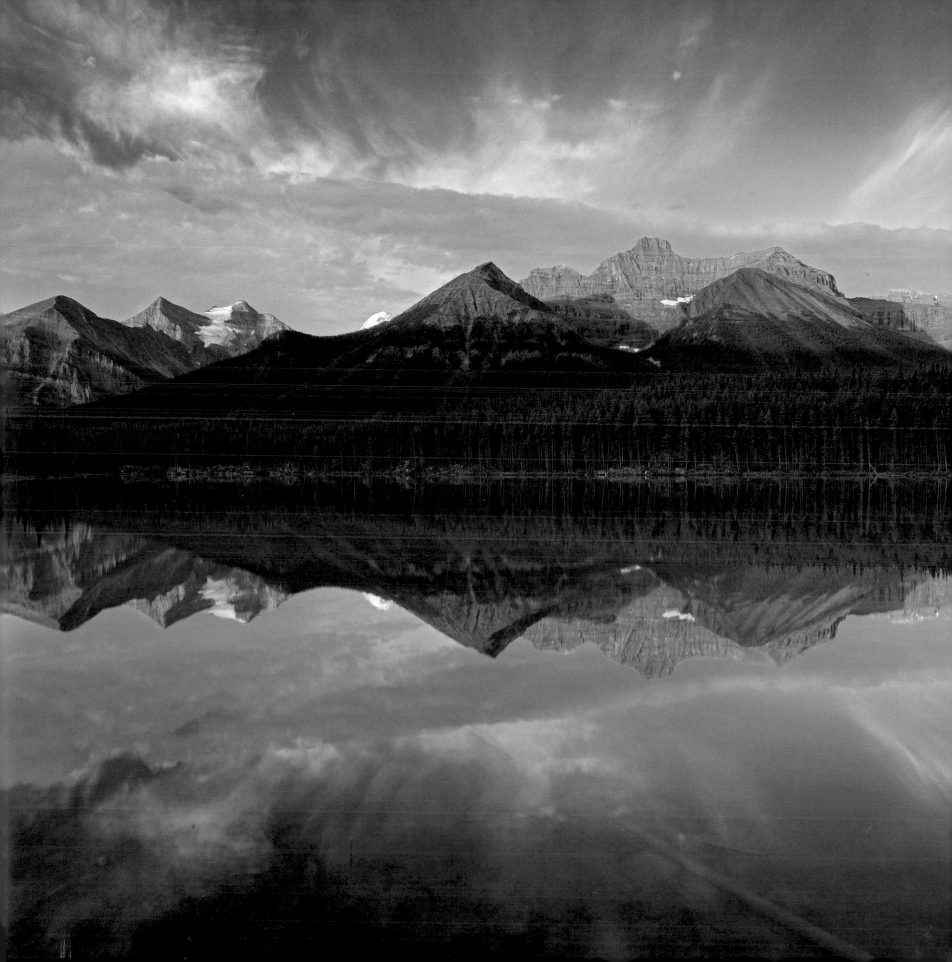

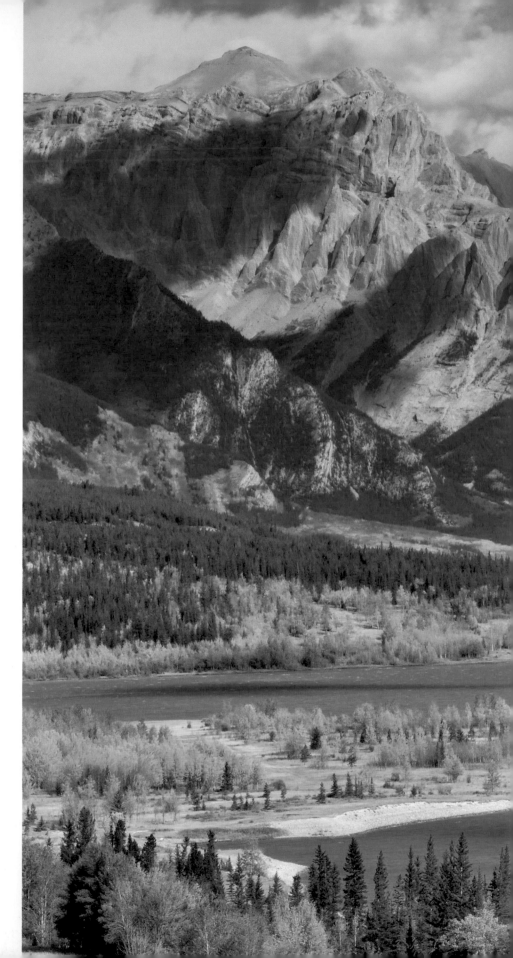

Previous spread left, top left:
Mountain goat, Jasper National Park
The Mountain goat, also called the Rocky Mountain goat, is actually a member of the antelope, gazelle and cattle family. Mountain goats are large-hoofed mammals found only in North America.

Previous spread left, top right:
Bighorn sheep, Jasper National Park
The Bighorn sheep belongs to the same family as the true goats, sheep and muskox family. It is one of three species of wild sheep found in North America, along with Dall sheep and Stone sheep. Like the Mountain goat, the Bighorn sheep is a very agile rock climber.

Previous spread, left bottom:
American elk, Jasper National Park
The American elk is also known as a wapiti. In North America it is one of the largest member of the deer family, second only in size to the moose.

Previous spread, right: Herbert Lake and the peaks surrounding Lake Louise, Banff National Park

Opposite: Abraham Lake in autumn, Kootenay Plains

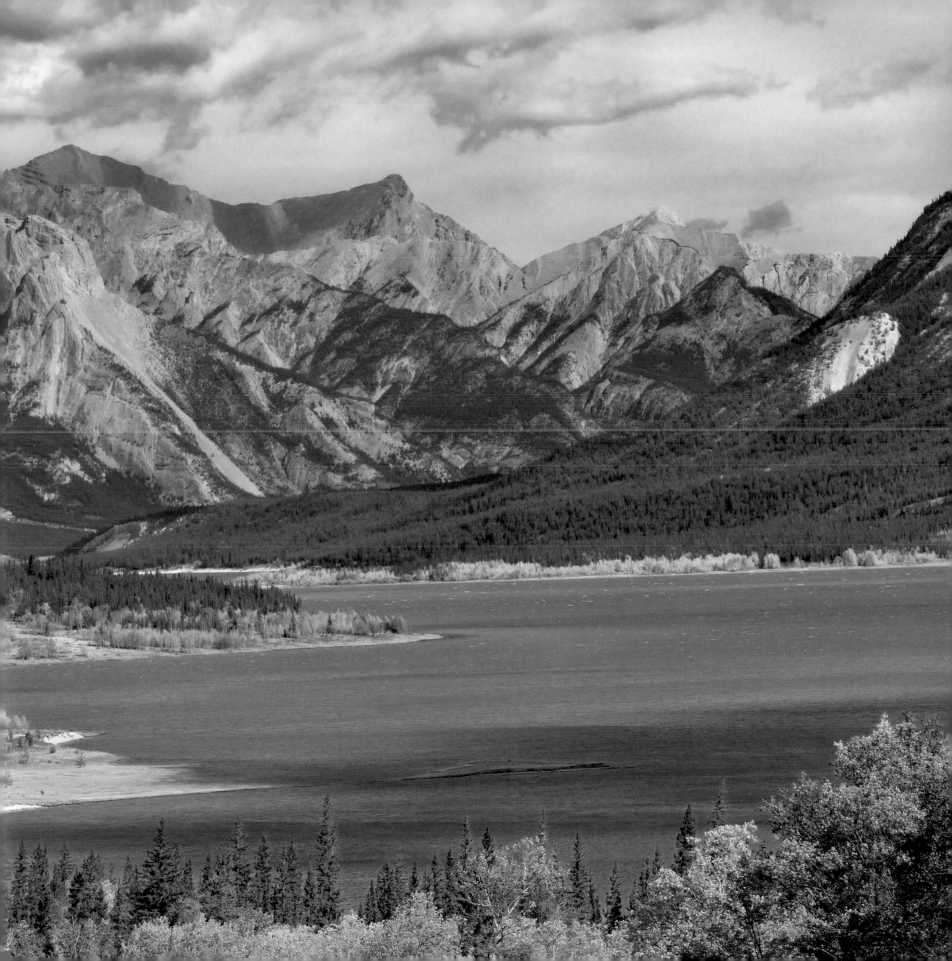

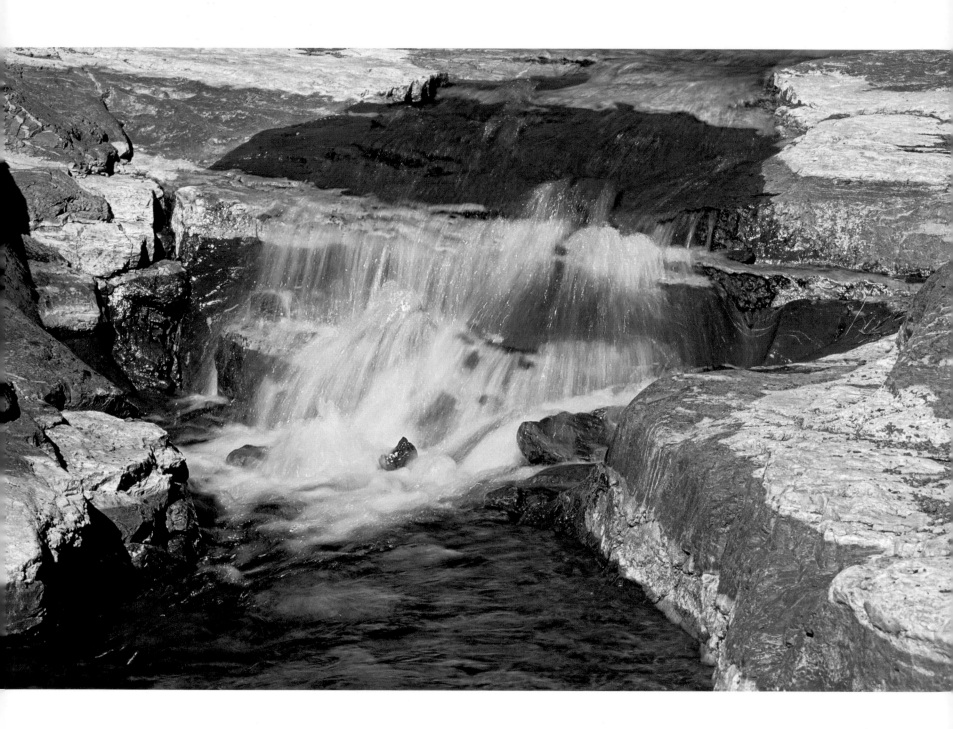

Above: Argillite rock in Red Rock Canyon, Waterton Lakes National Park

Opposite: Clouds reflected in Patricia Lake at dawn, Jasper National Park

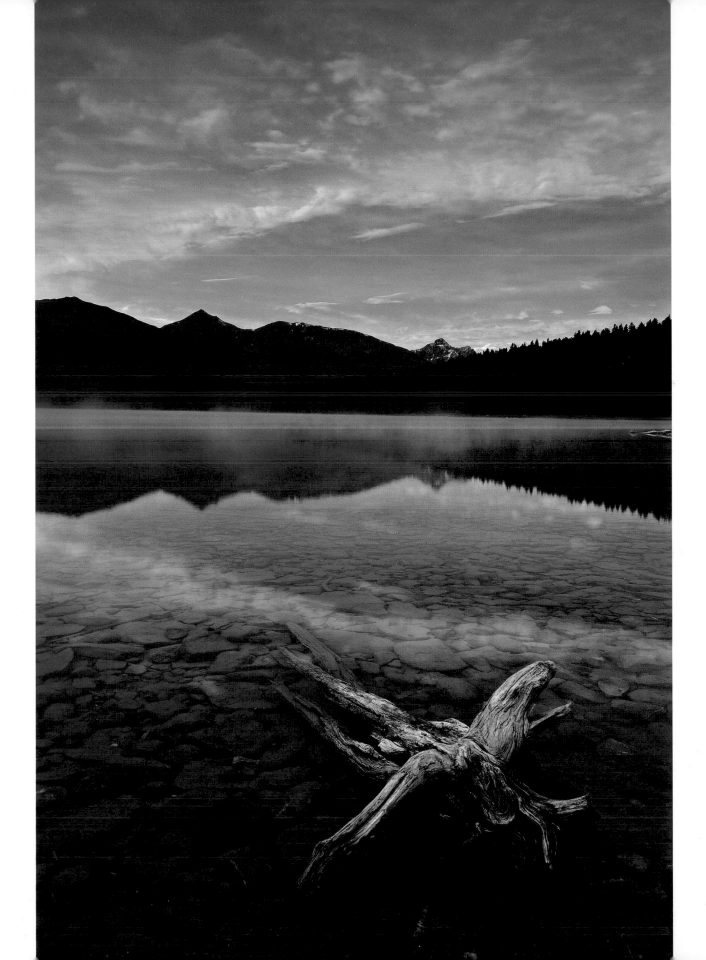

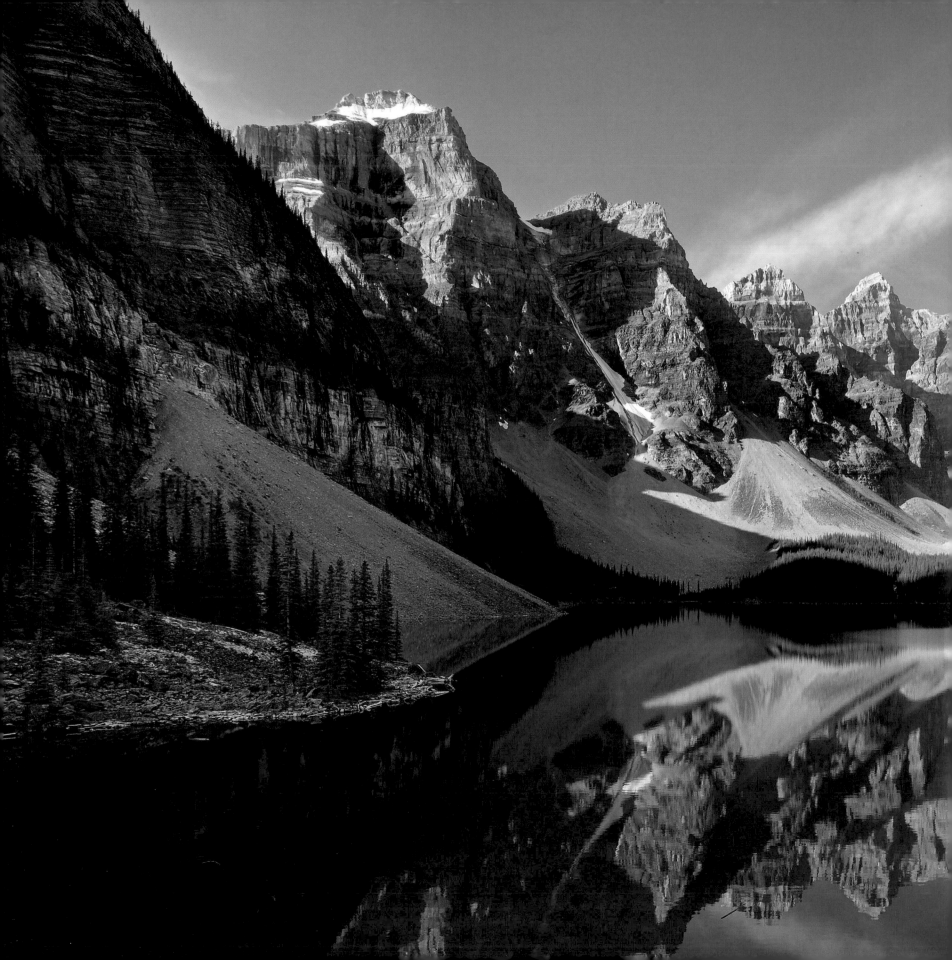

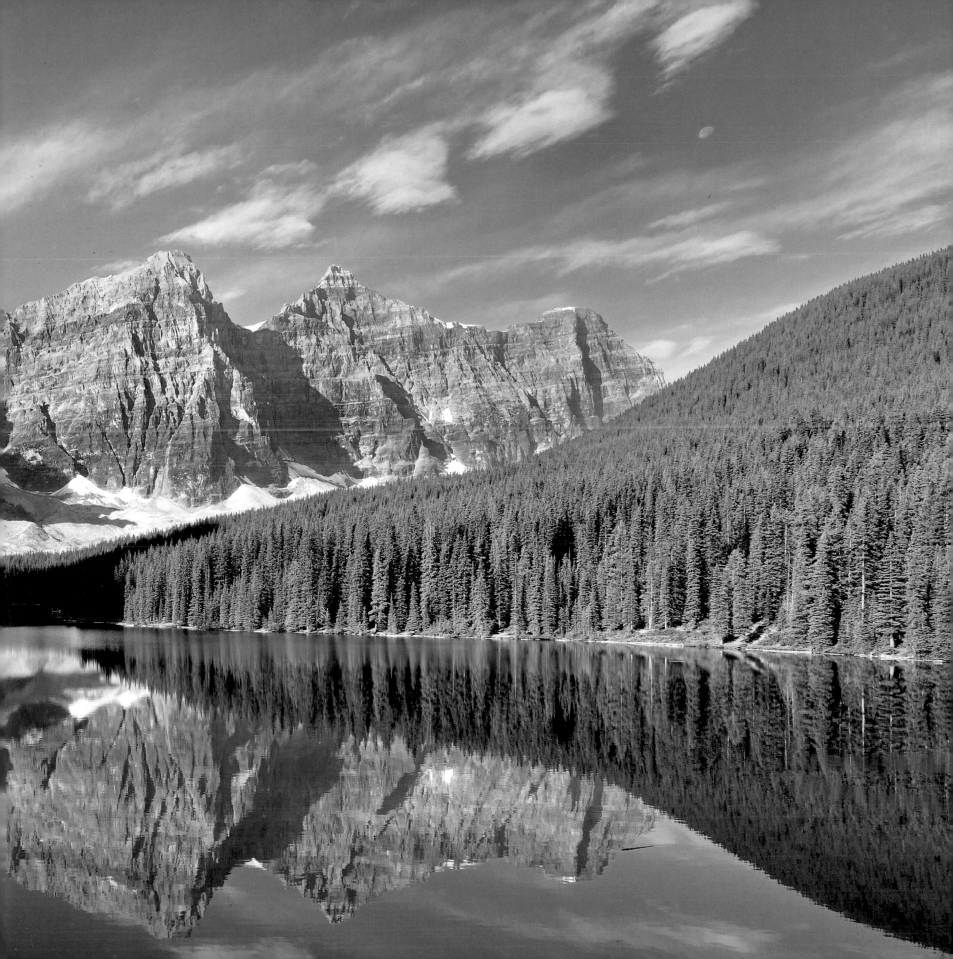

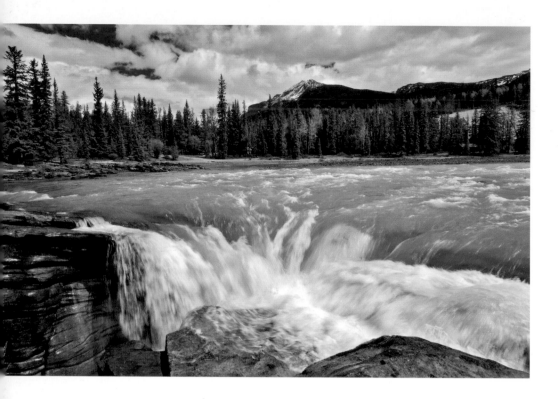

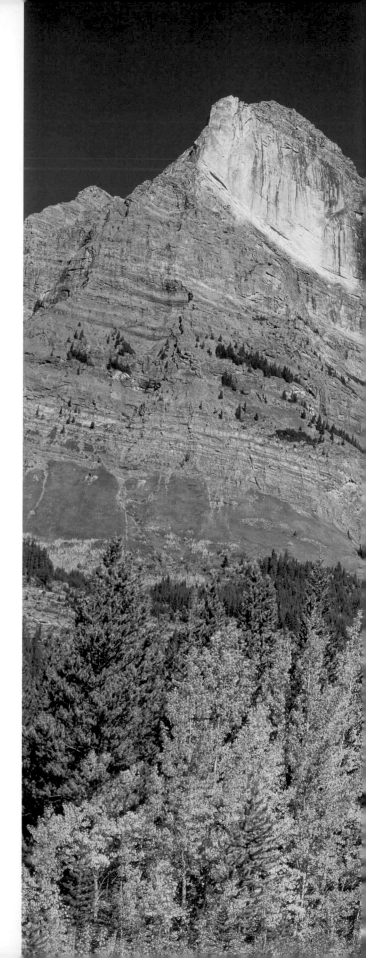

Previous spread: Moraine Lake and the Wenkchemna Peaks, Banff National Park

Above: Athabasca Falls, Jasper National Park

Opposite: Mount Wilson in autumn, Banff National Park

32

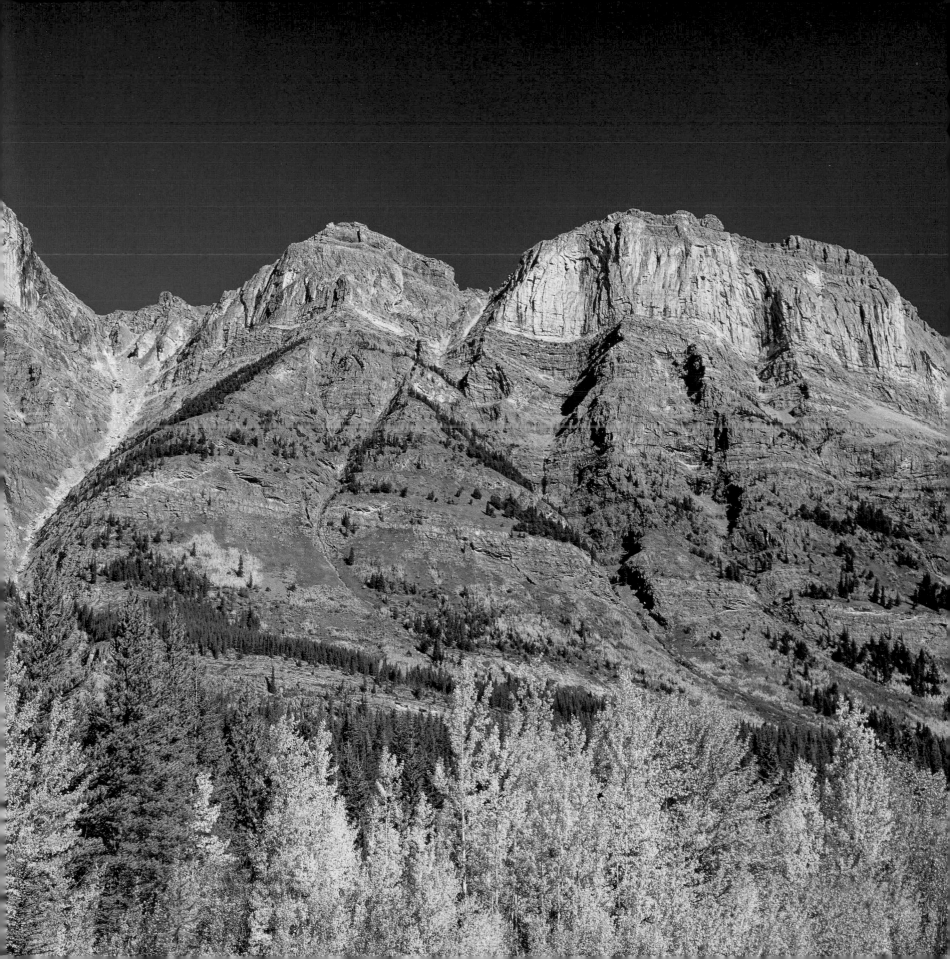

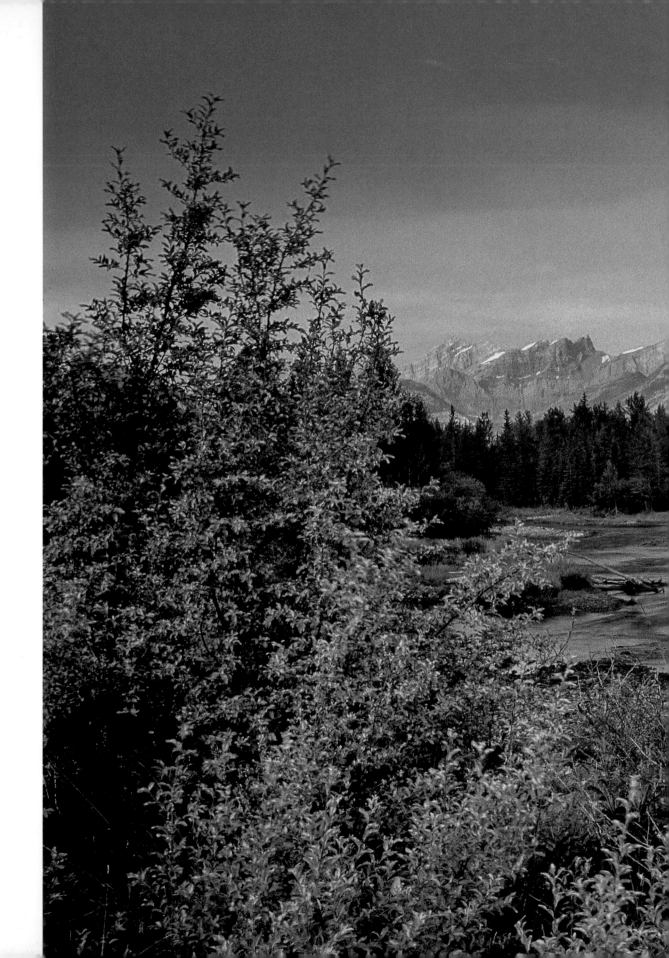

Kananaskis River,
Kananaskis Provincial Park

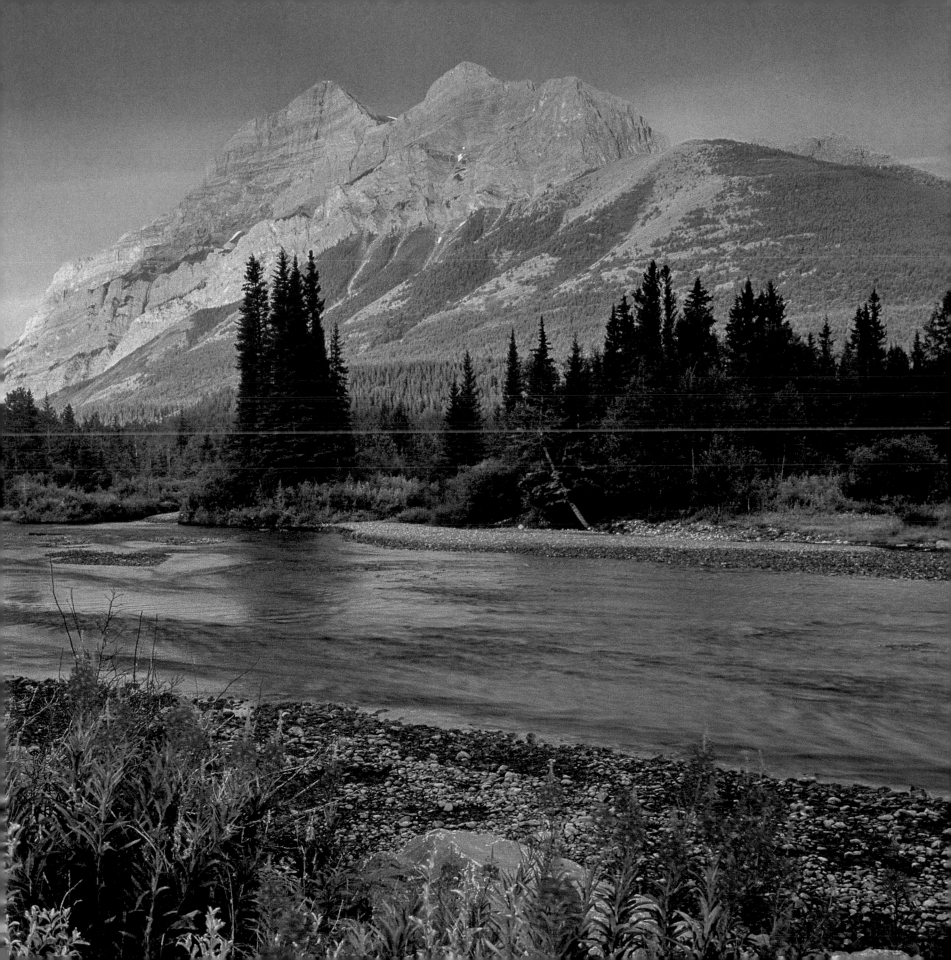

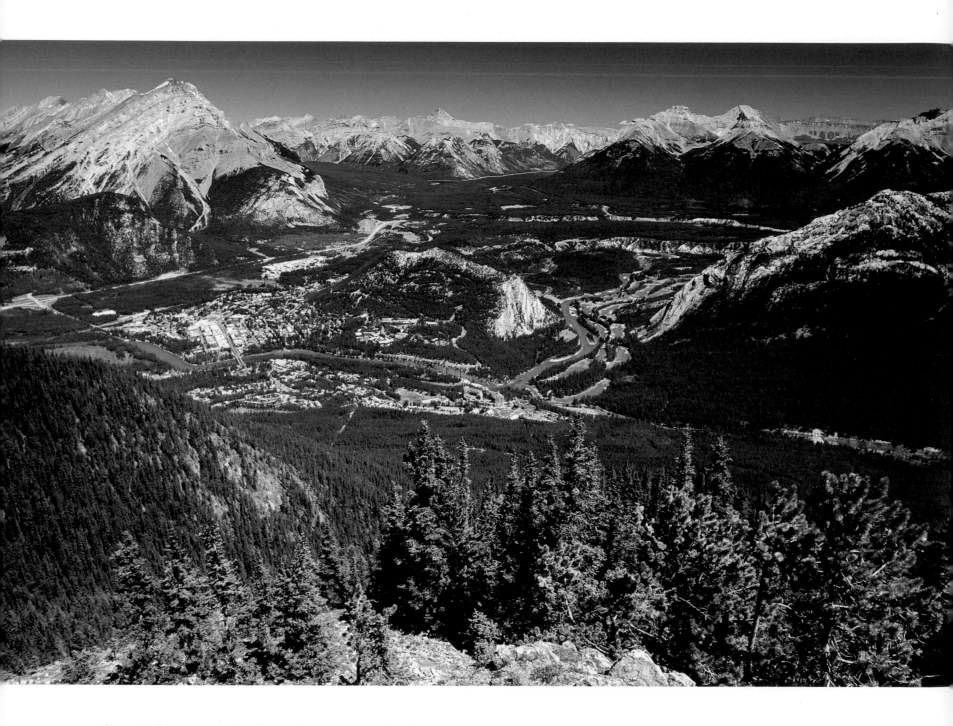

Above: Aerial view of the Banff townsite, Banff National Park

Opposite: Milky Way at "Forget Me Not Pond," Kananaskis Country

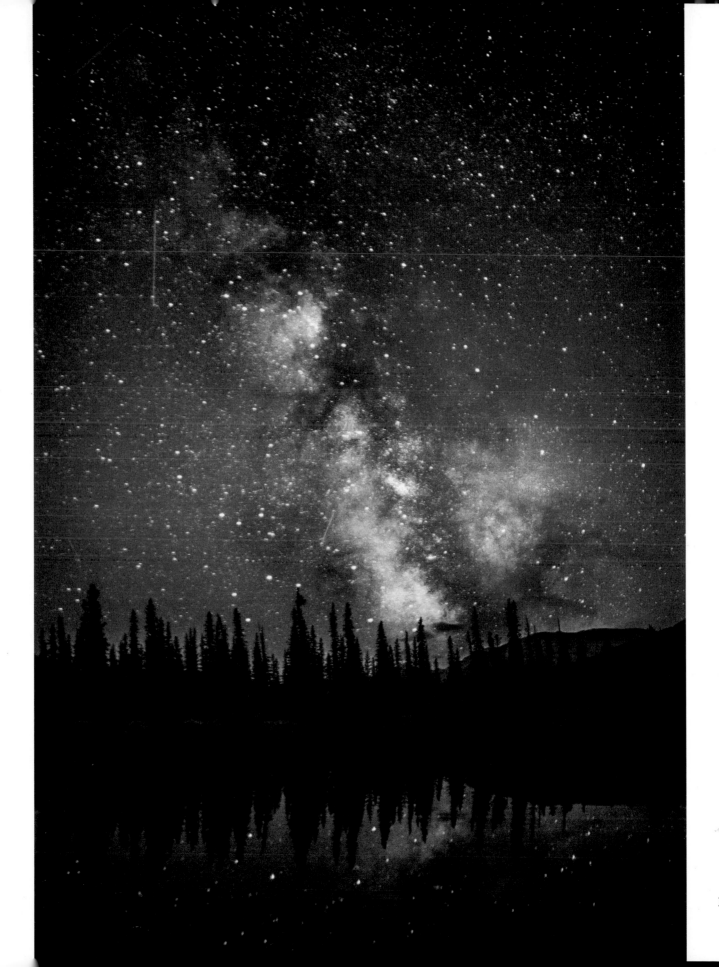

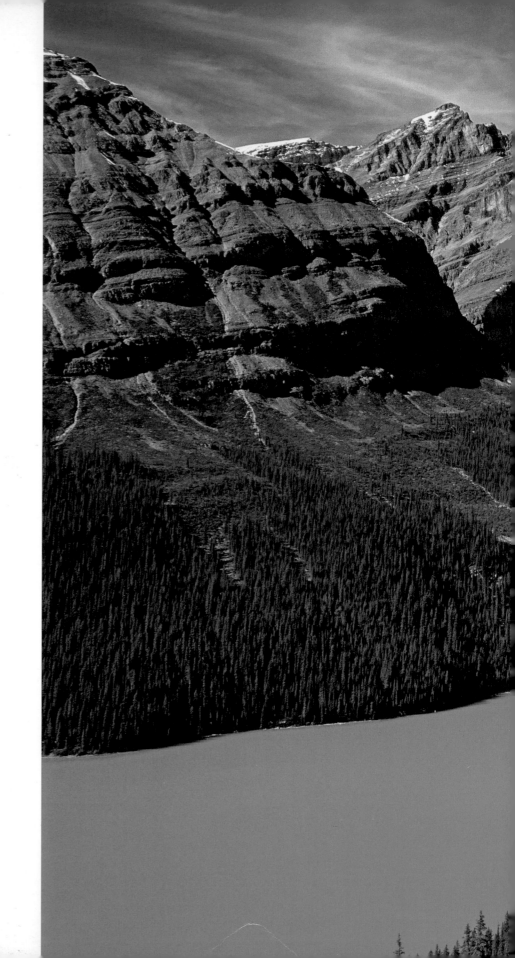

Opposite: Peyto Lake, Banff National Park

Following spread, left:
Lac la Biche, Sir Winston Churchill Provincial Park

Following spread, right:
Boreal forest sunrise, Lesser Slave Lake Provincial Park

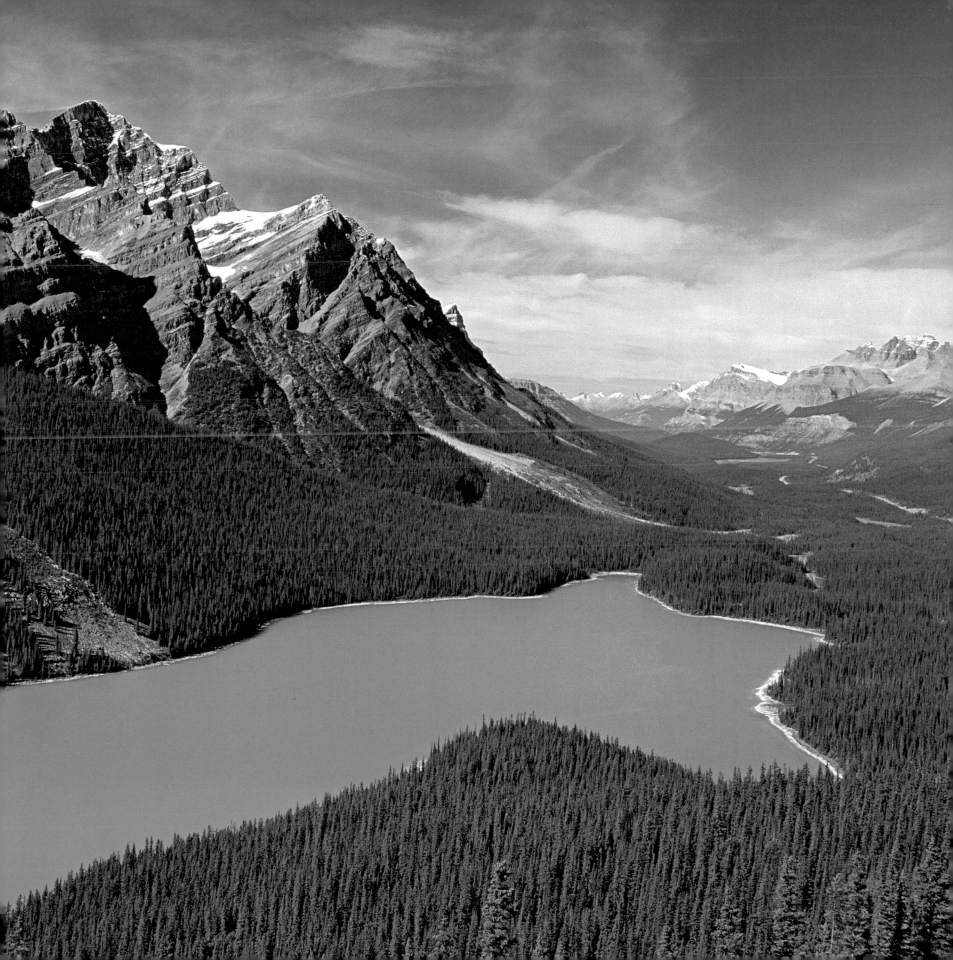

Forests & Lakes

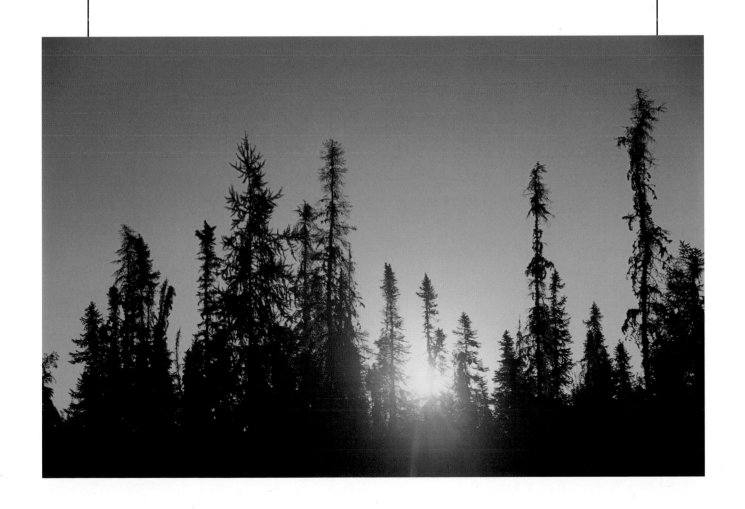

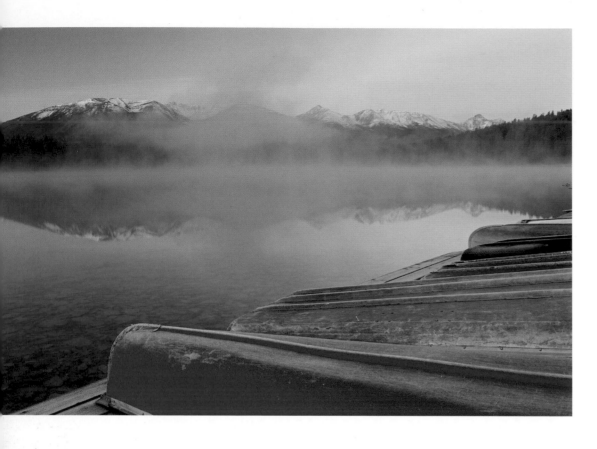

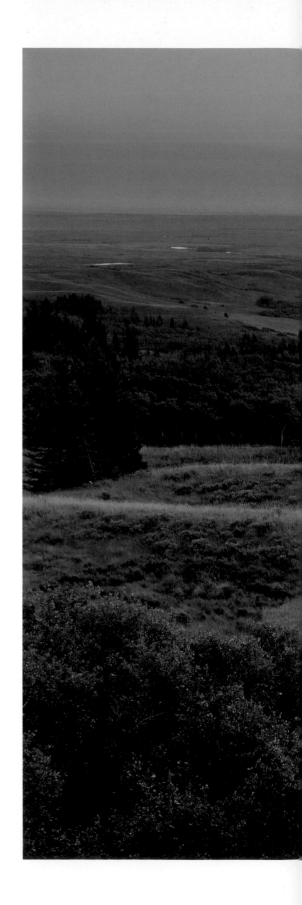

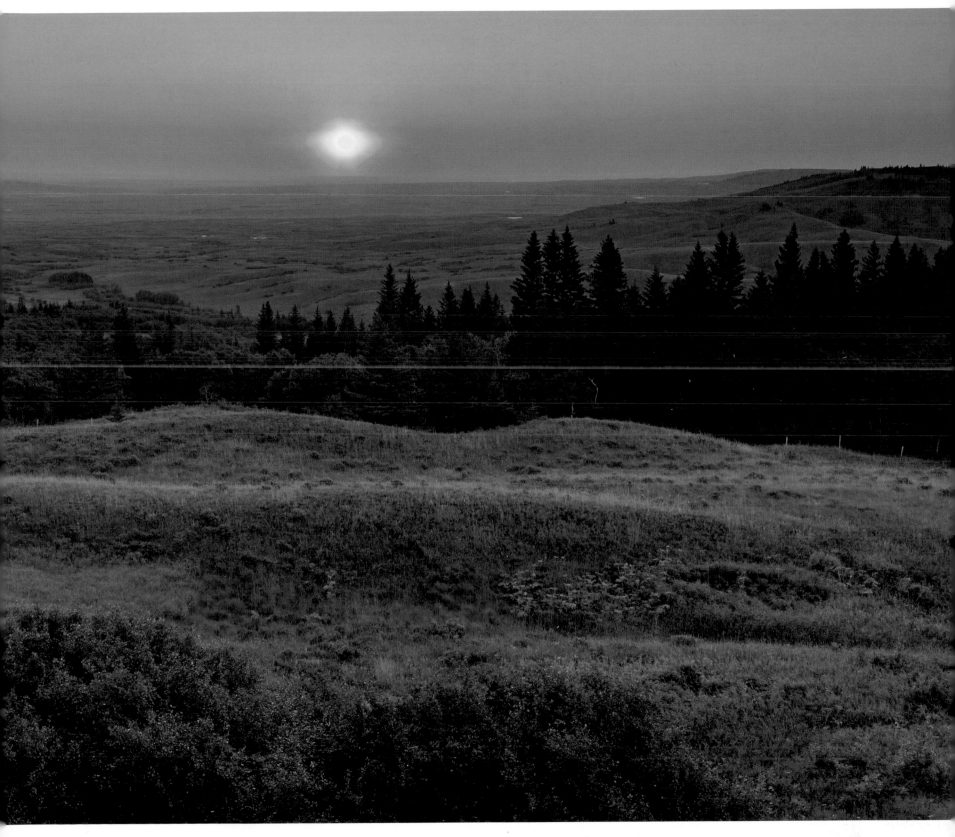

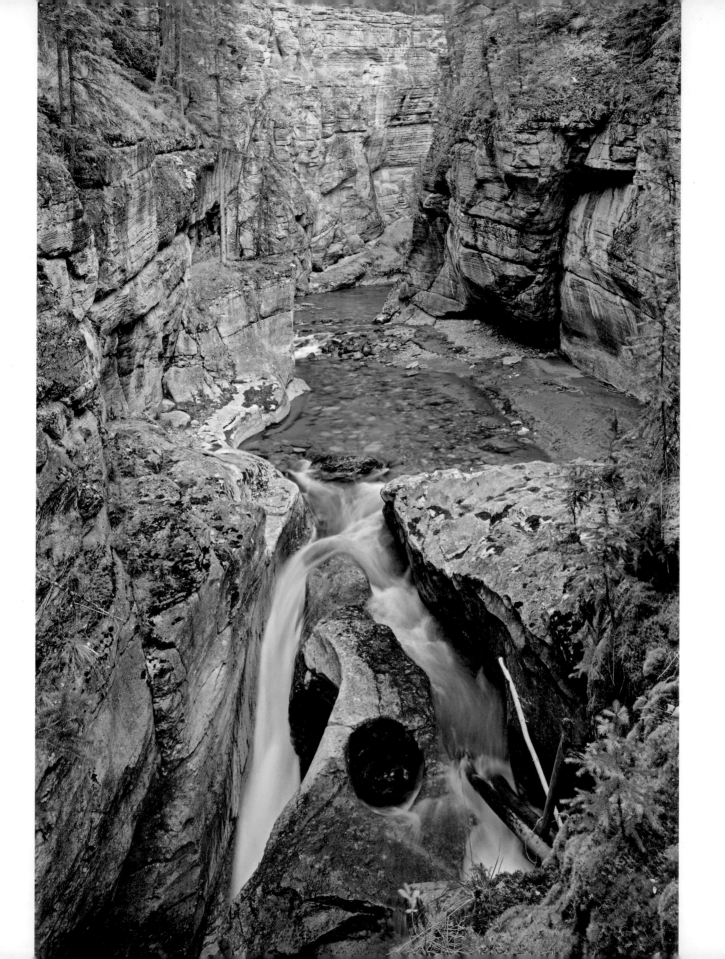

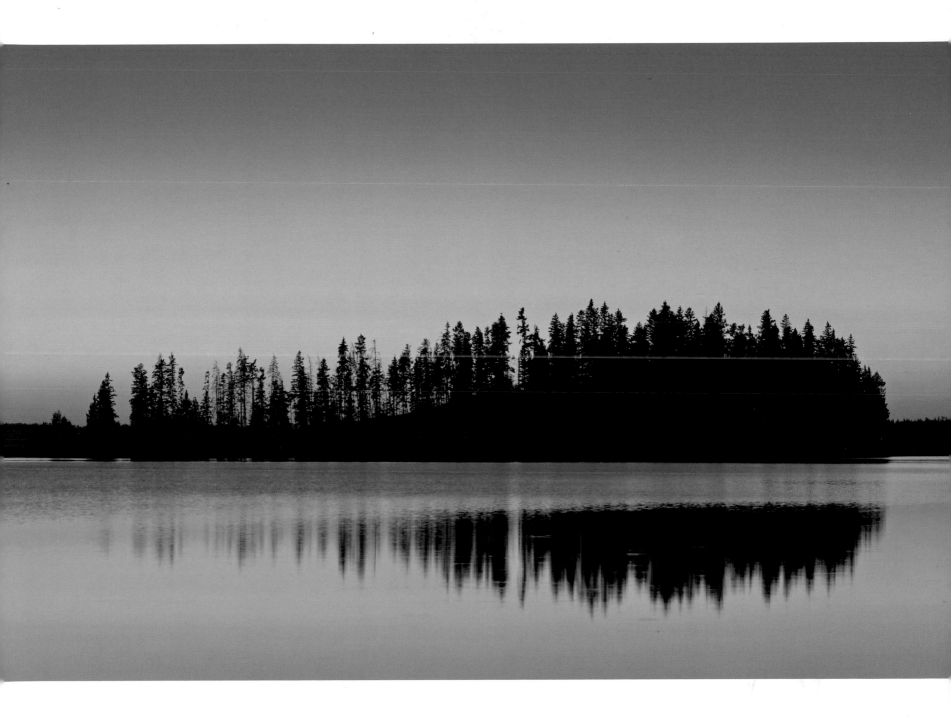

Previous spread, top left: Fog at dawn on Pyramid Lake, Jasper National Park **Previous spread, bottom left**: Bonaparte's gull in Astotin Lake, Elk Island National Park **Previous spread, right**: Sunrise from viewpoint on Reesor Lake Road, Cypress Hills Provincial Park

Opposite: Maligne Canyon, Jasper National Park **Above**: Island reflected in Astotin Lake at sunrise, Elk Island National Park

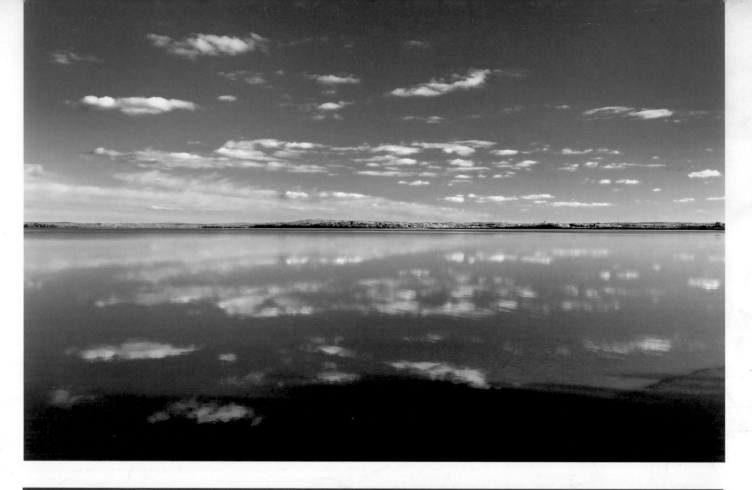

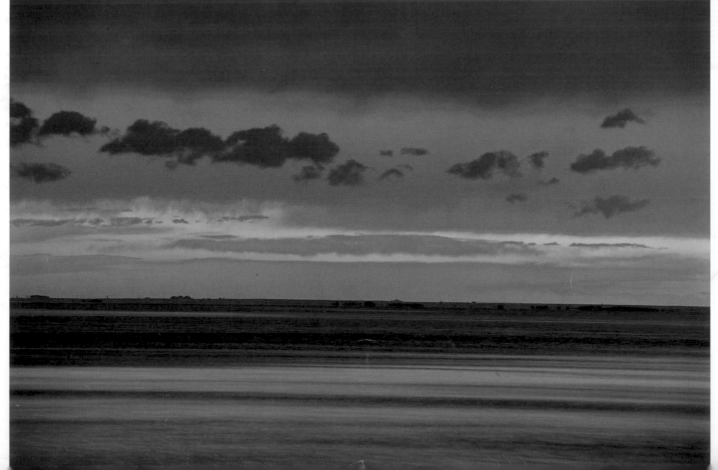

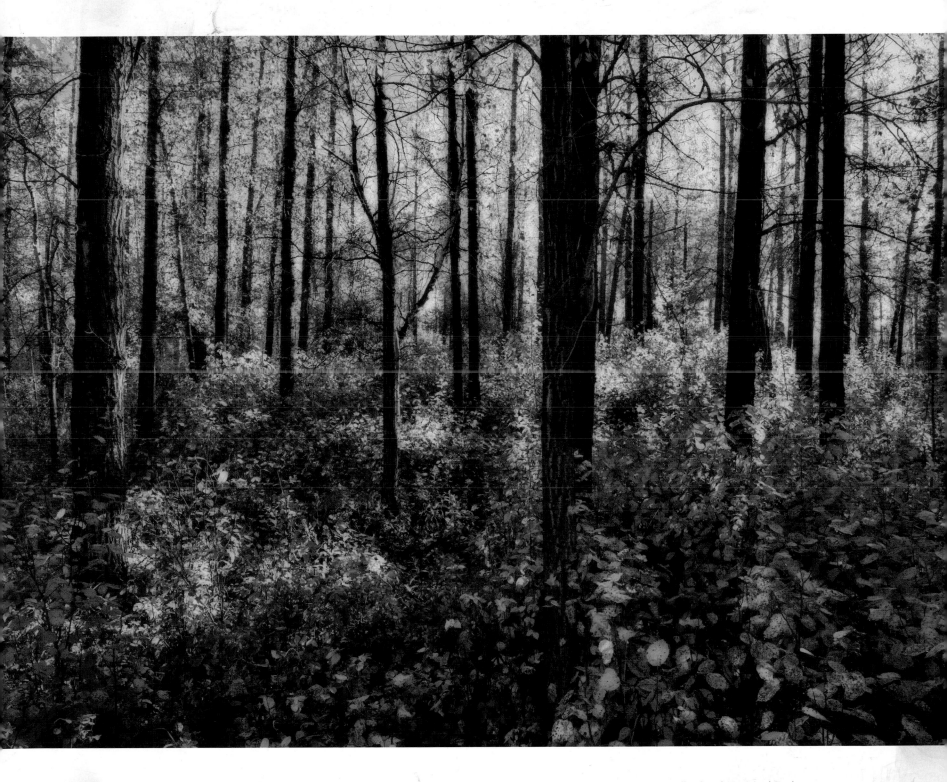

Opposite top: Clouds reflected in Lac la Biche, Sir Winston Churchill Provincial Park **Above**: Aspen forest in autumn, Elk Island National Park
Opposite bottom: Lake Newell at dusk, Kinbrook Island Provincial Park

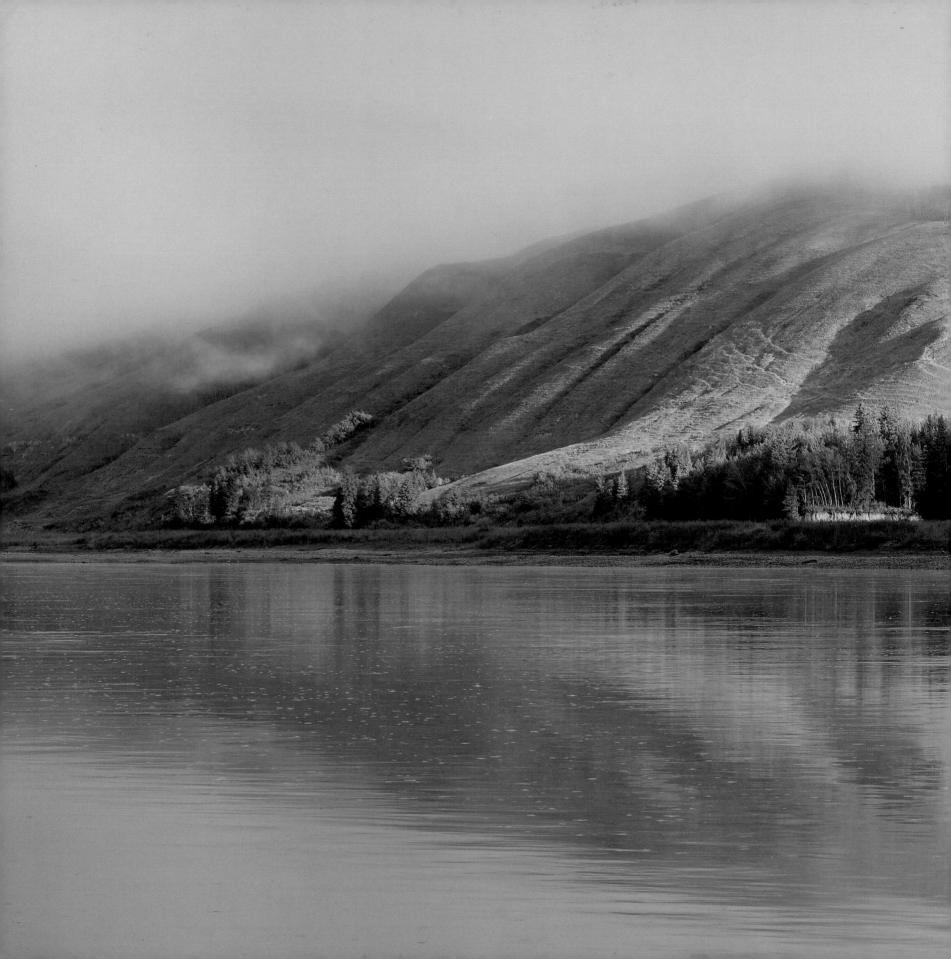

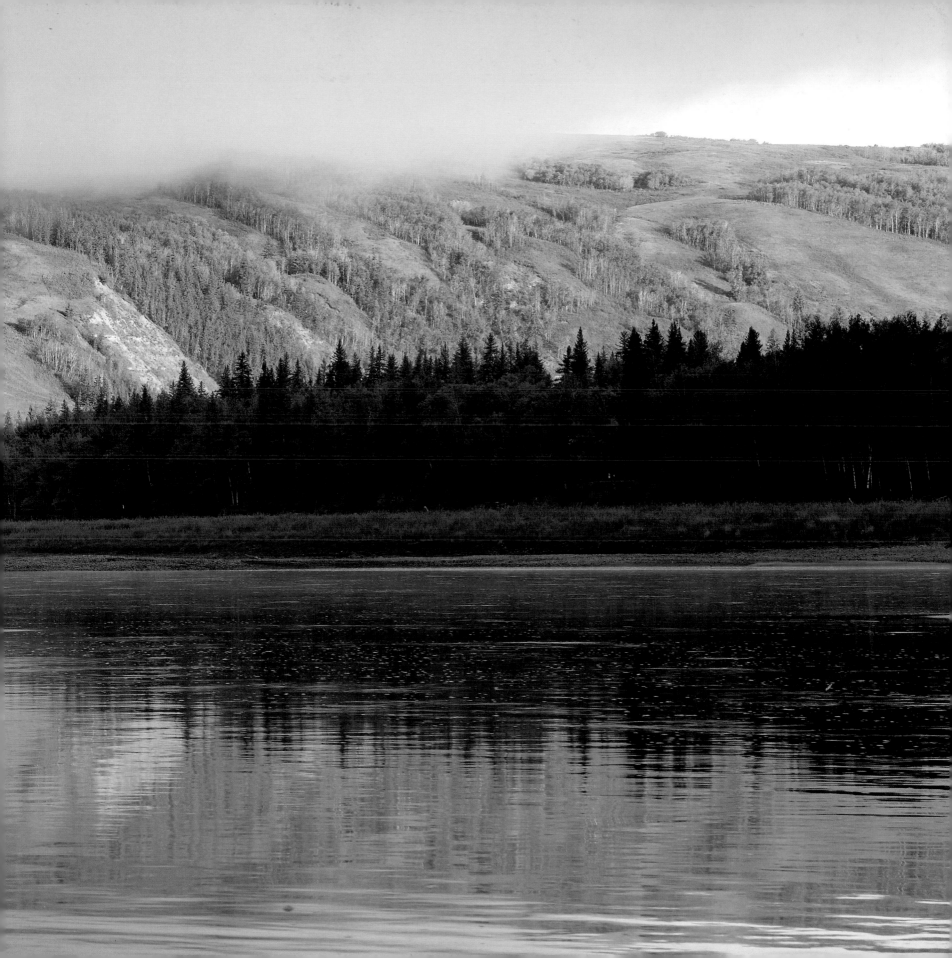

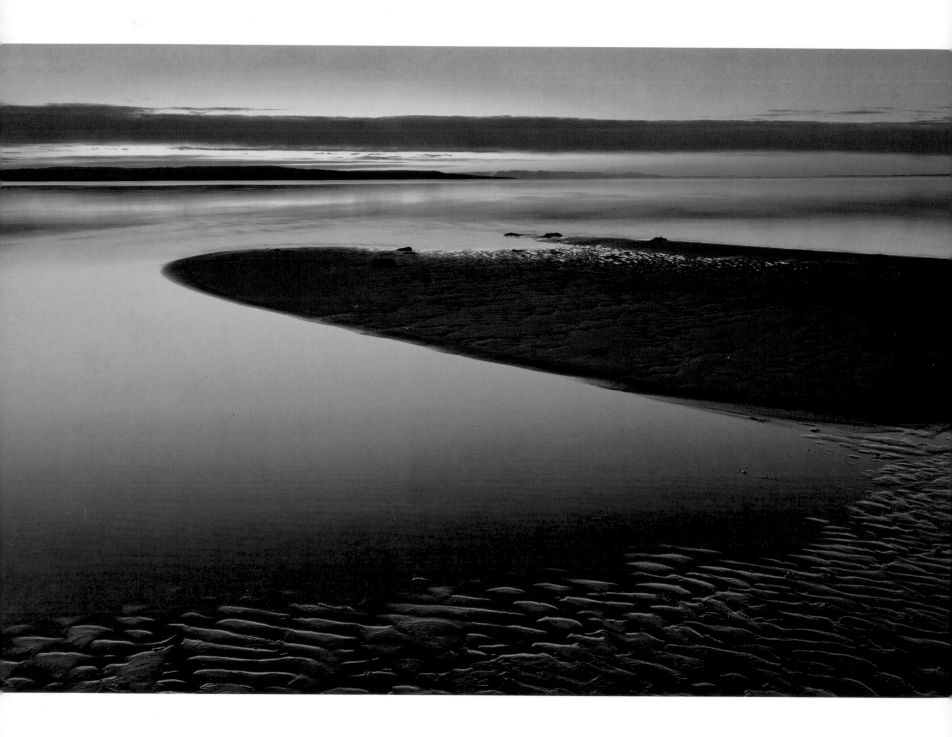

Previous spread: Morning fog along the Peace River, Dunvegan **Above**: Lake and sandbar at dusk, Lesser Slave Lake Provincial Park

Opposite, top: Sunrise reflection over wetland, Grande Prairie **Opposite, bottom**: Misty sunrise over wetland, Trochu

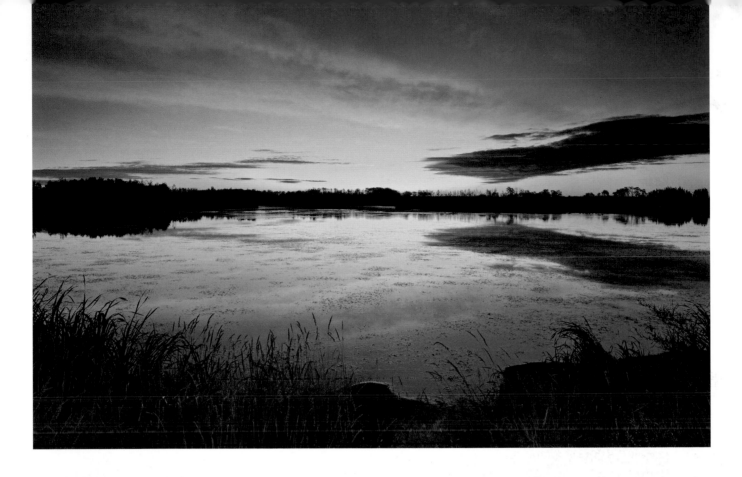

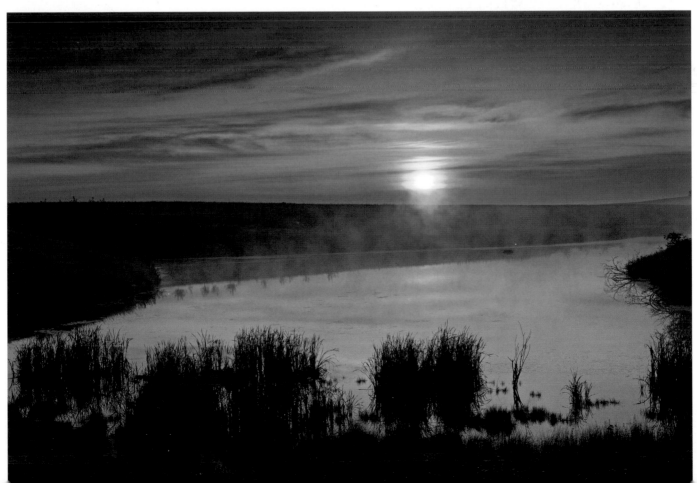

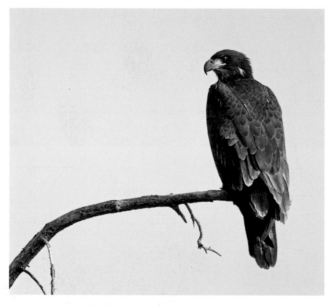

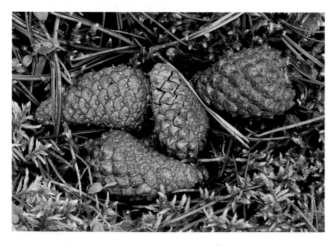

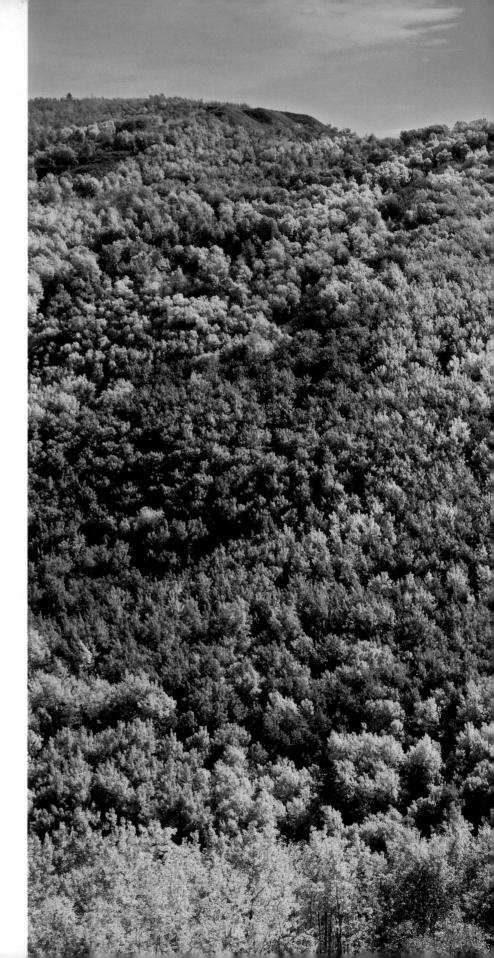

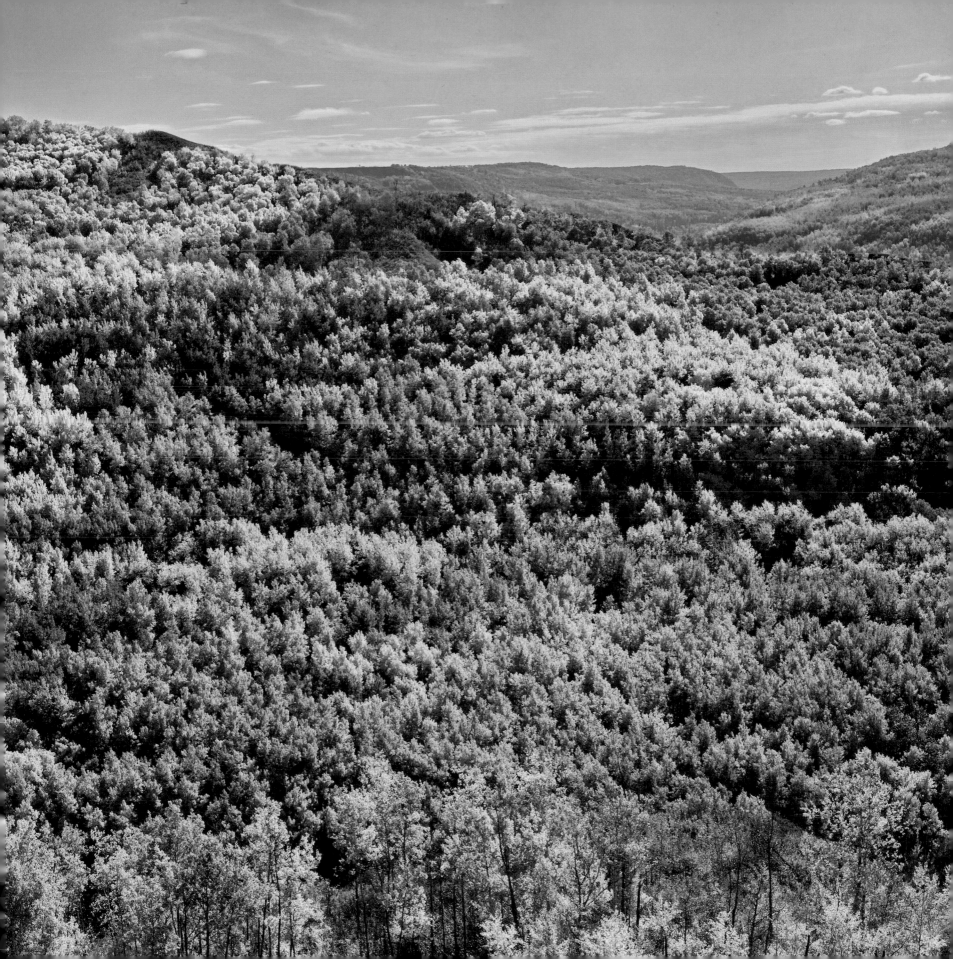

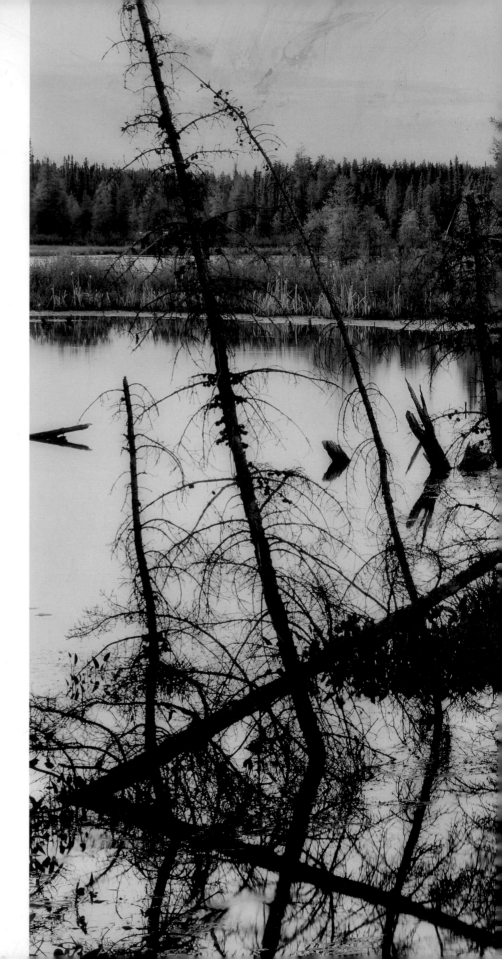

Previous spread, **top left**: Gaillardia blossom, Waterton Lakes National Park
Previous spread, **middle left**: Golden eagle perched on burnt tree, Lesser Slave Lake
Previous spread, **bottom left**: Pine cones and needles on a bed of moss, Fox Creek
Previous spread, **right**: Hills of the Peace River Valley in autumn, Peace River

Opposite: Wetland at sunset, Wood Buffalo National Park

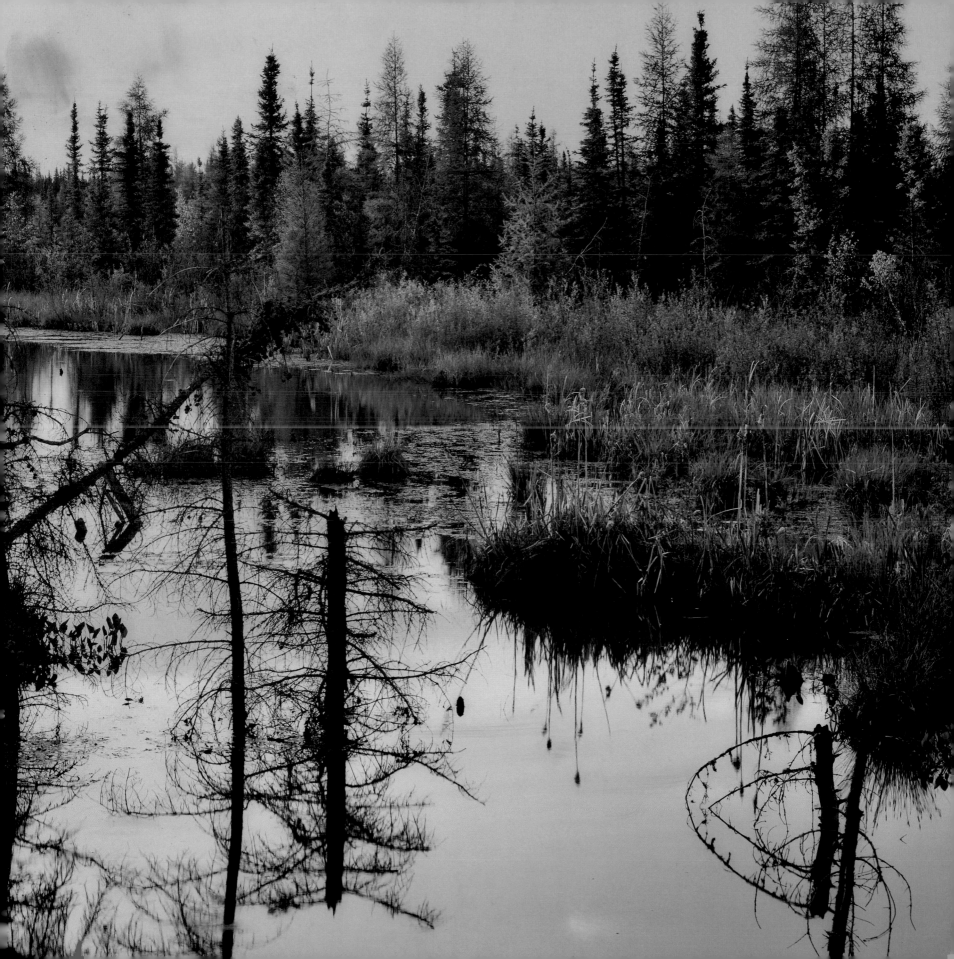

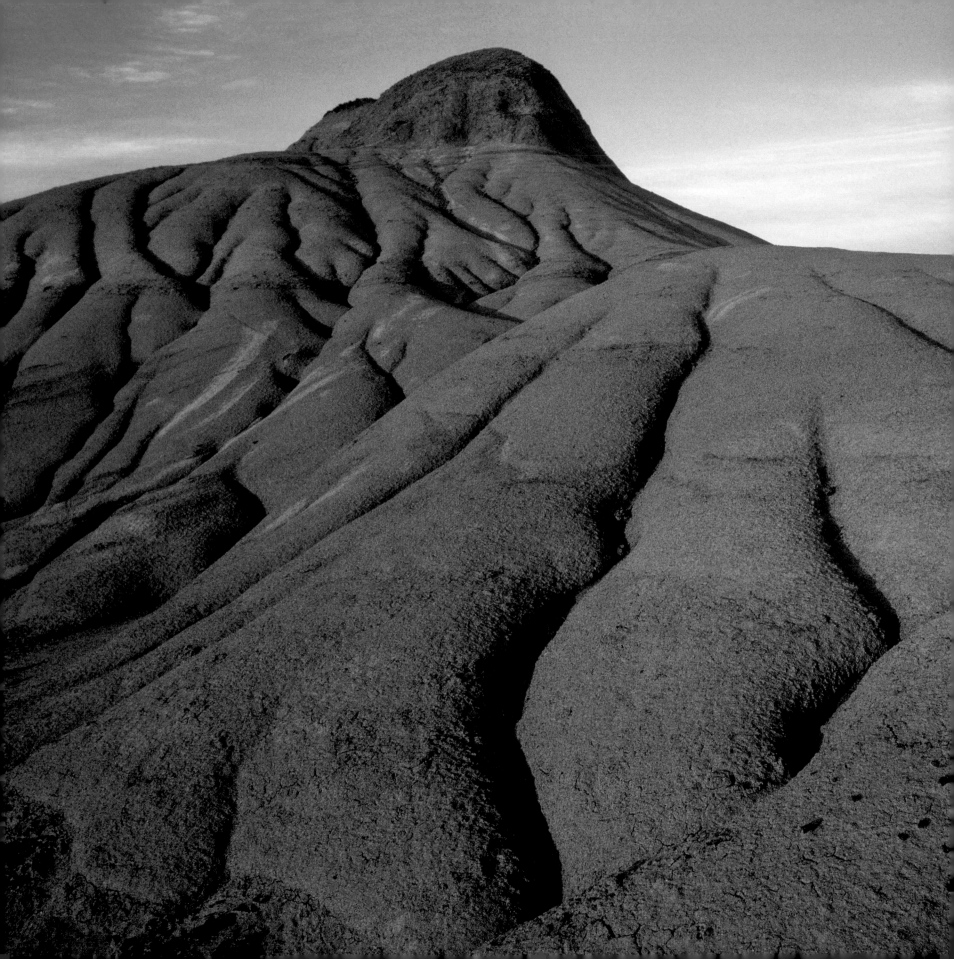

Badlands

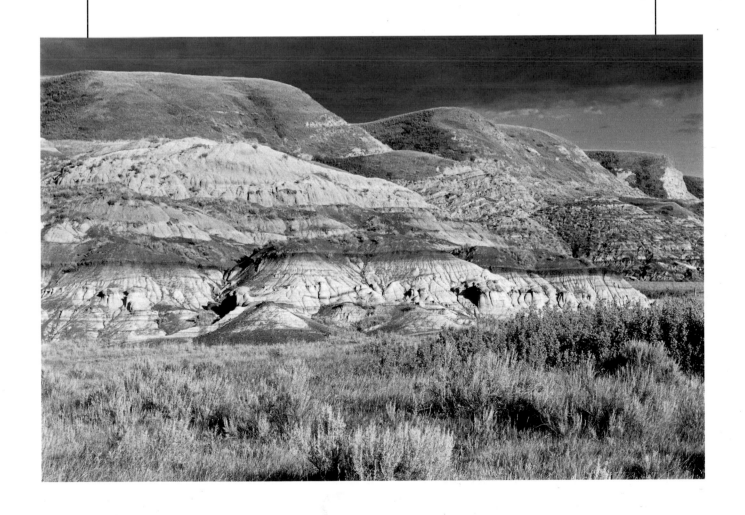

Previous spread, left: Eroded clay of the badlands at sunrise, Dinosaur Provincial Park

Previous spread, right: Badlands along the Red Deer River, near Hannah

Opposite:
Badlands along the Milk River, Writing-On-Stone Provincial Park

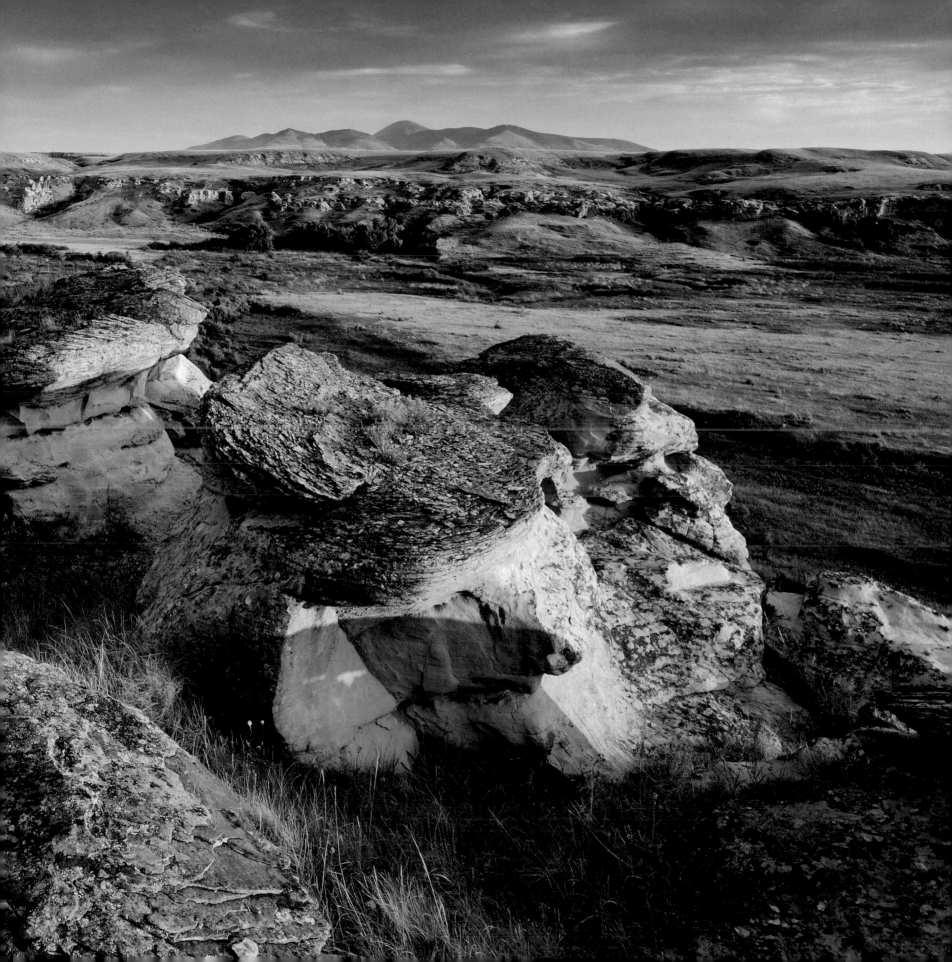

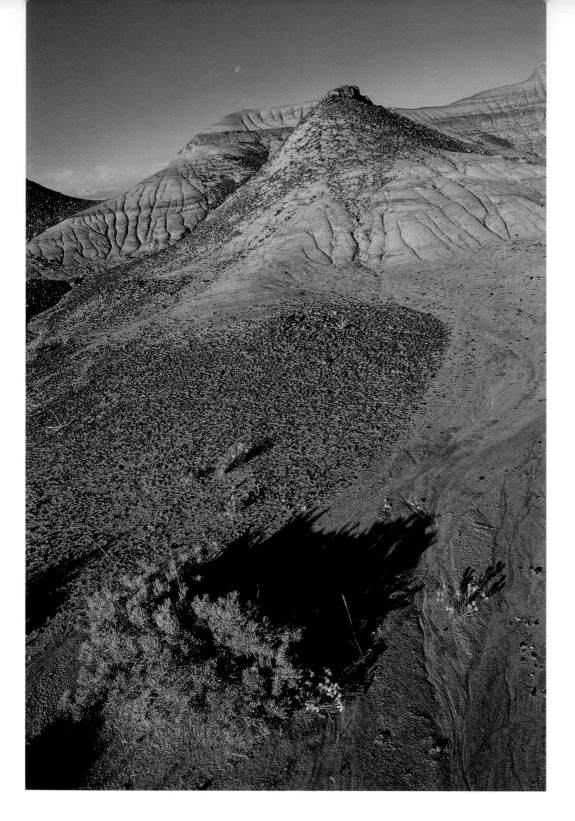

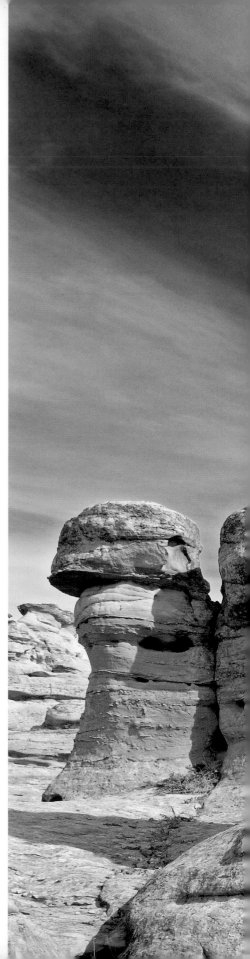

Above: Sparse vegetation in the Badlands, Dinosaur Provincial Park

Opposite: Hoodoos, Writing-On-Stone Provincial Park

Following spread: Badland formations at sunrise, Dinosaur Provincial Park

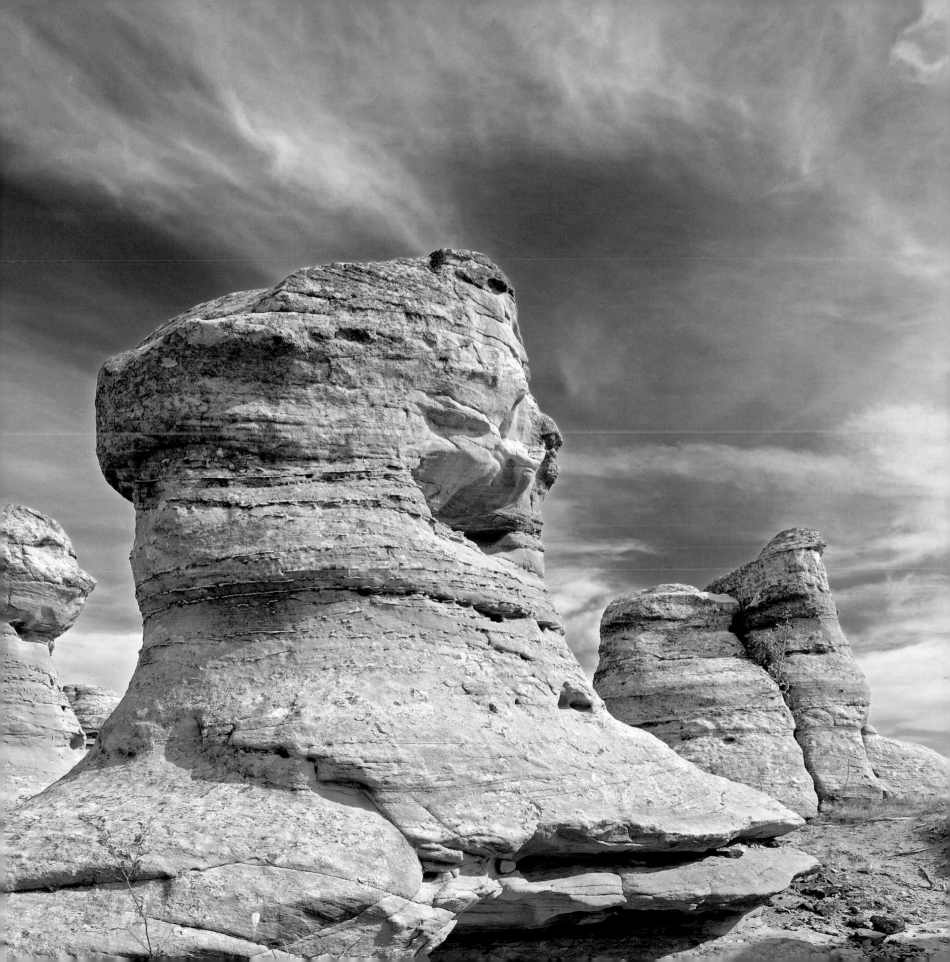

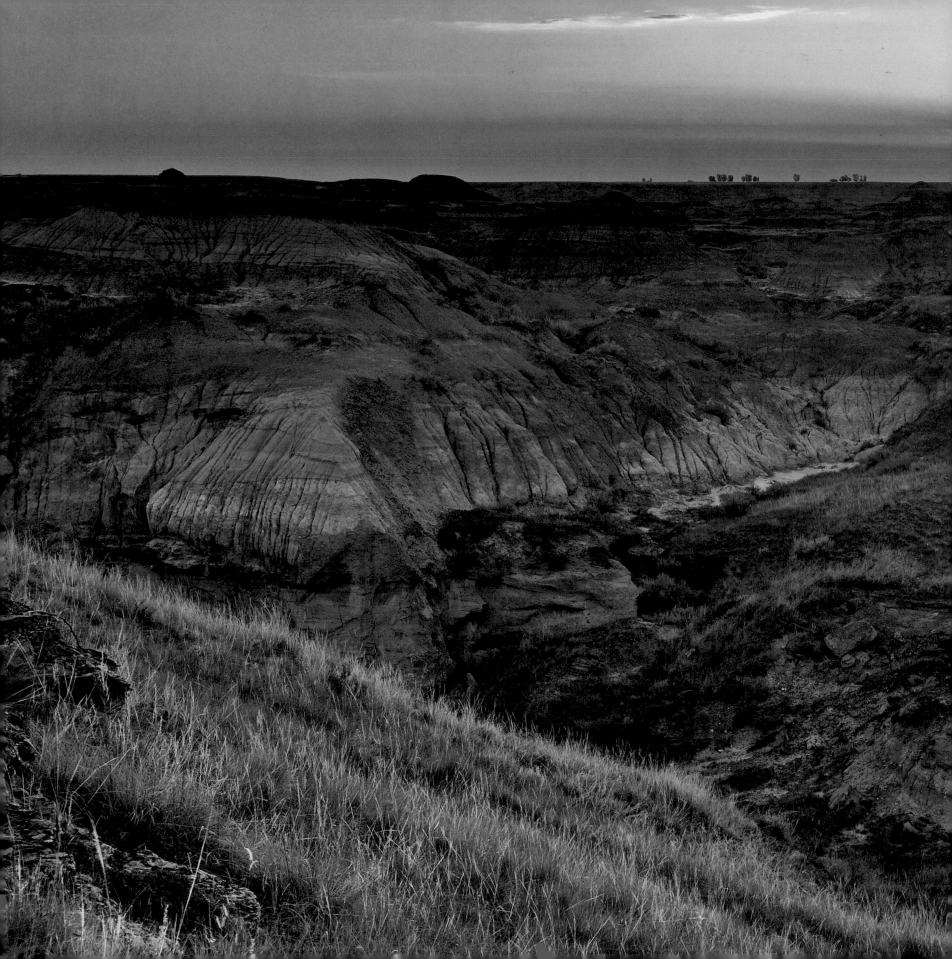

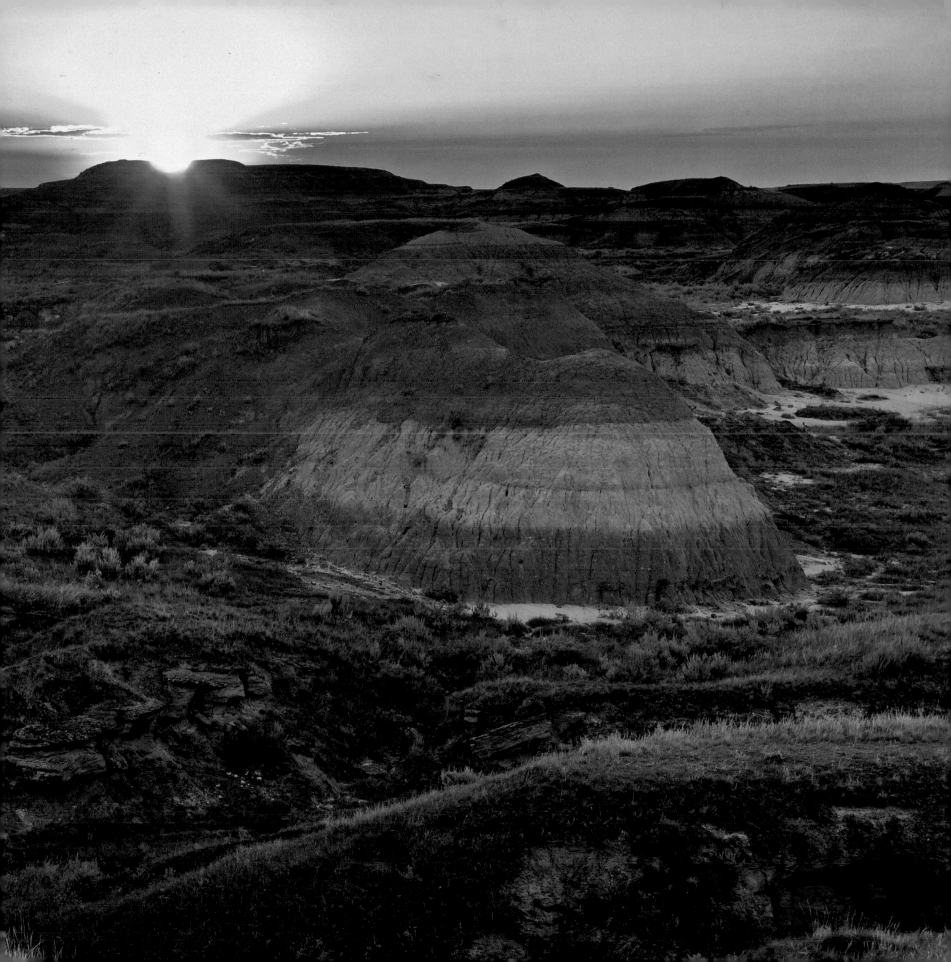

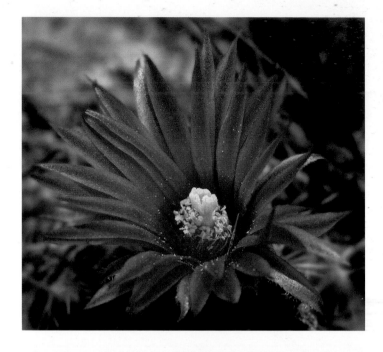

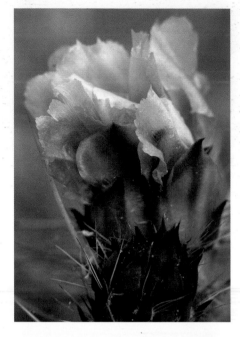

Above left: Pincushion cactus, Dinosaur Provincial Park
Above right: Prickly pear cactus, Dinosaur Provincial Park
Above bottom: Blazingstars, Dinosaur Provincial Park

Opposite: Hoodoo with cap, East Coulee

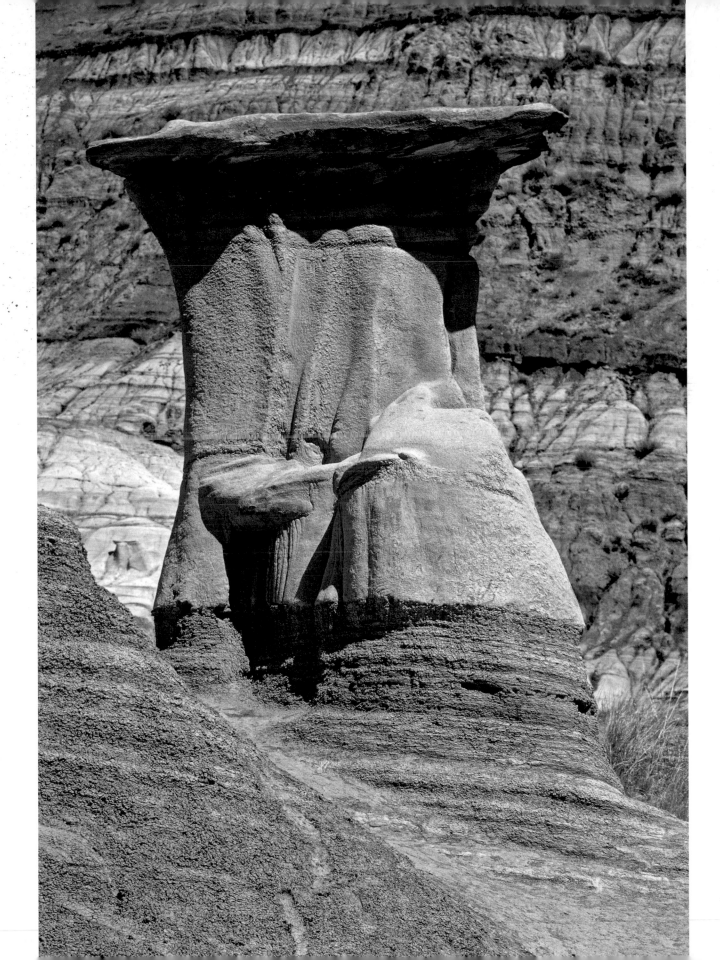

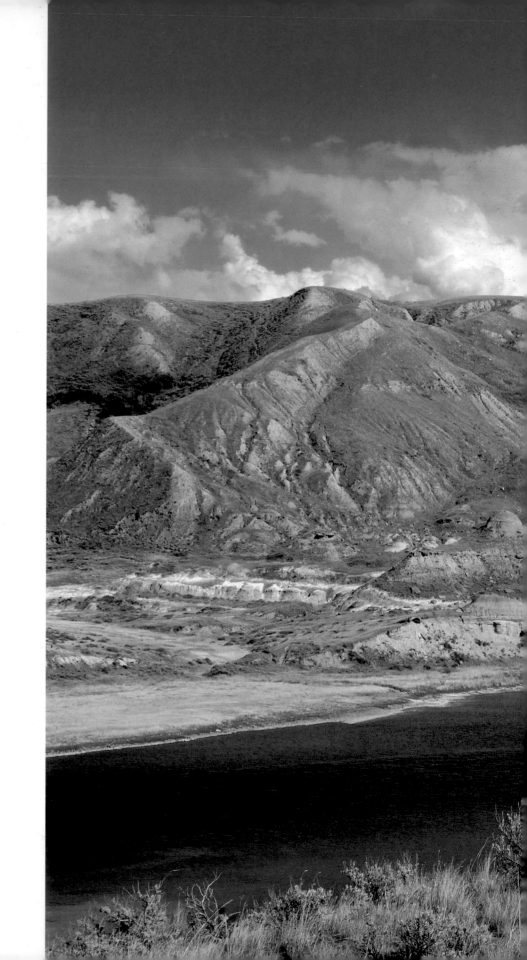

Badlands along the Red Deer River, near Empress

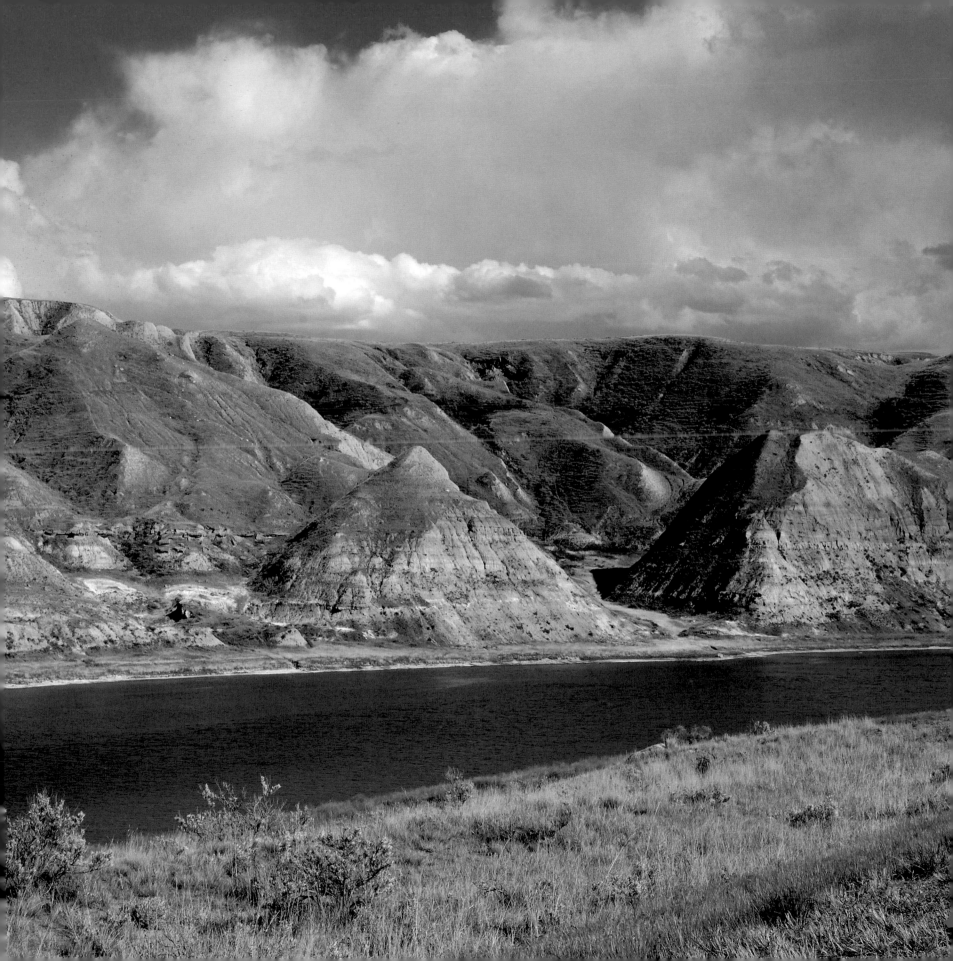

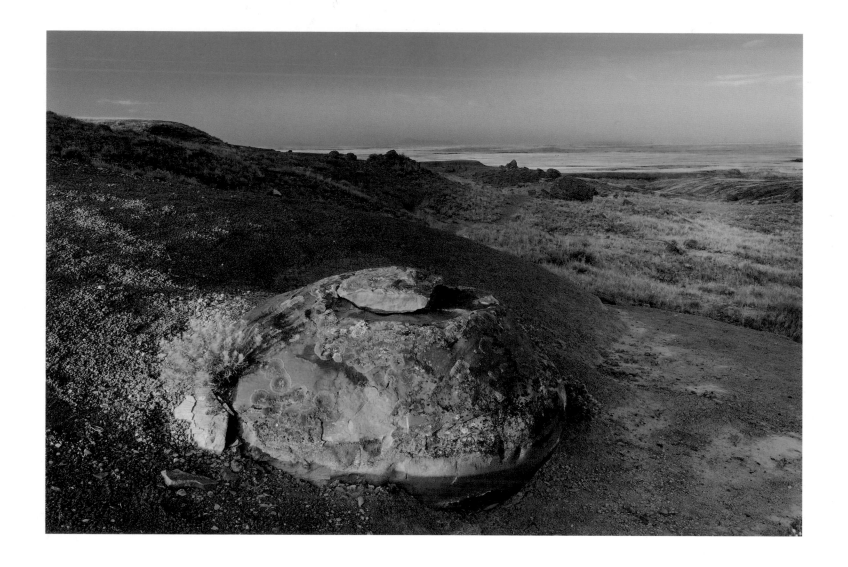

Above: Sandstone concretion at sunrise, Red Rock Coulee Natural Preserve

Opposite: Badland formations, East Coulee

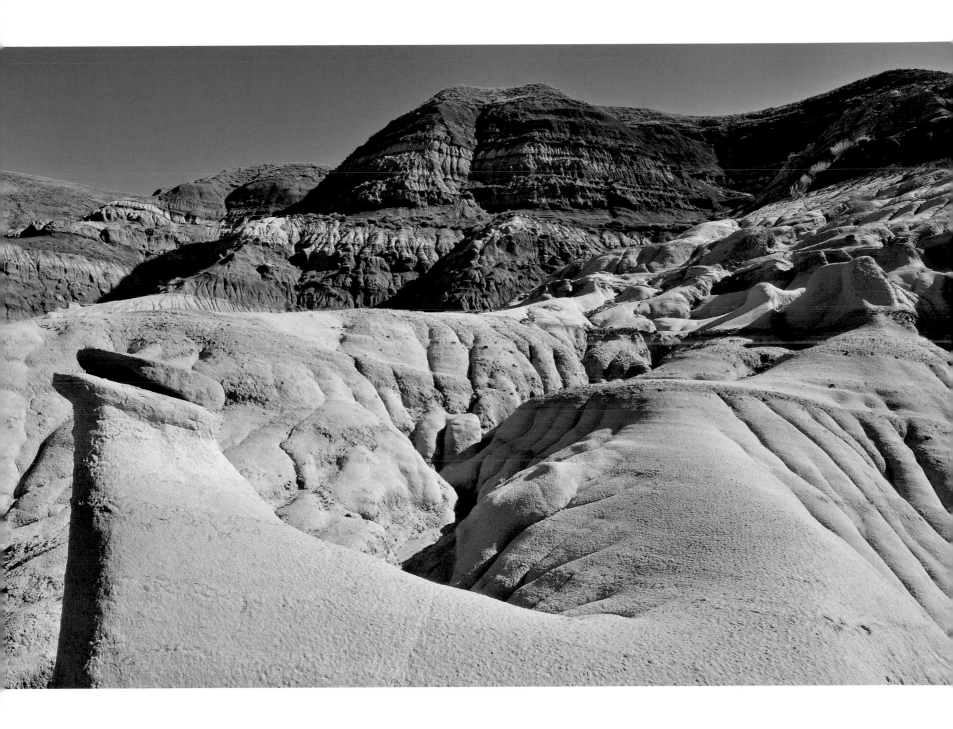

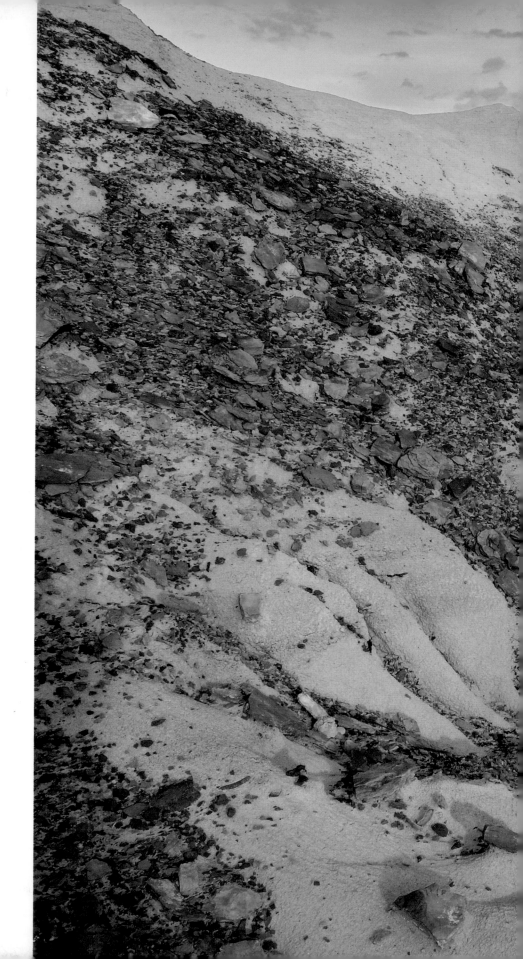

Opposite: Badlands, Dinosaur Provincial Park

Following spread: Badlands and valley bottom, Dry Island Buffalo Jump Provincial Park

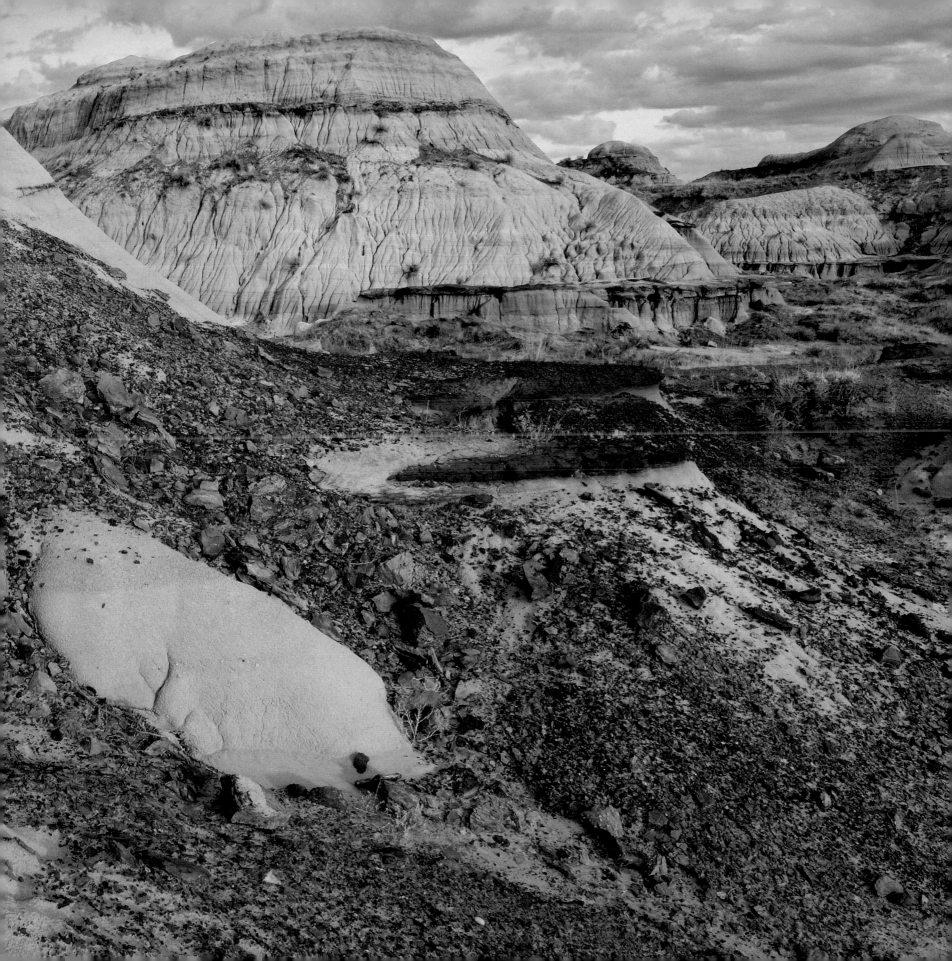

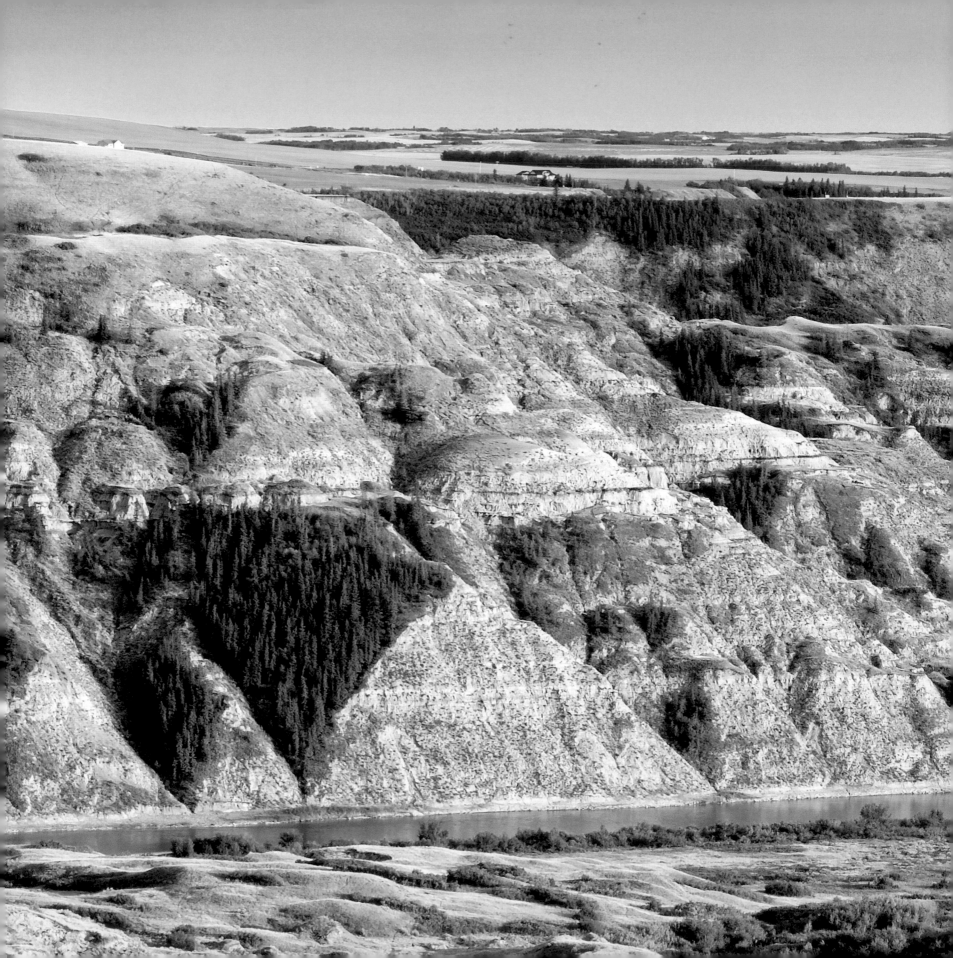

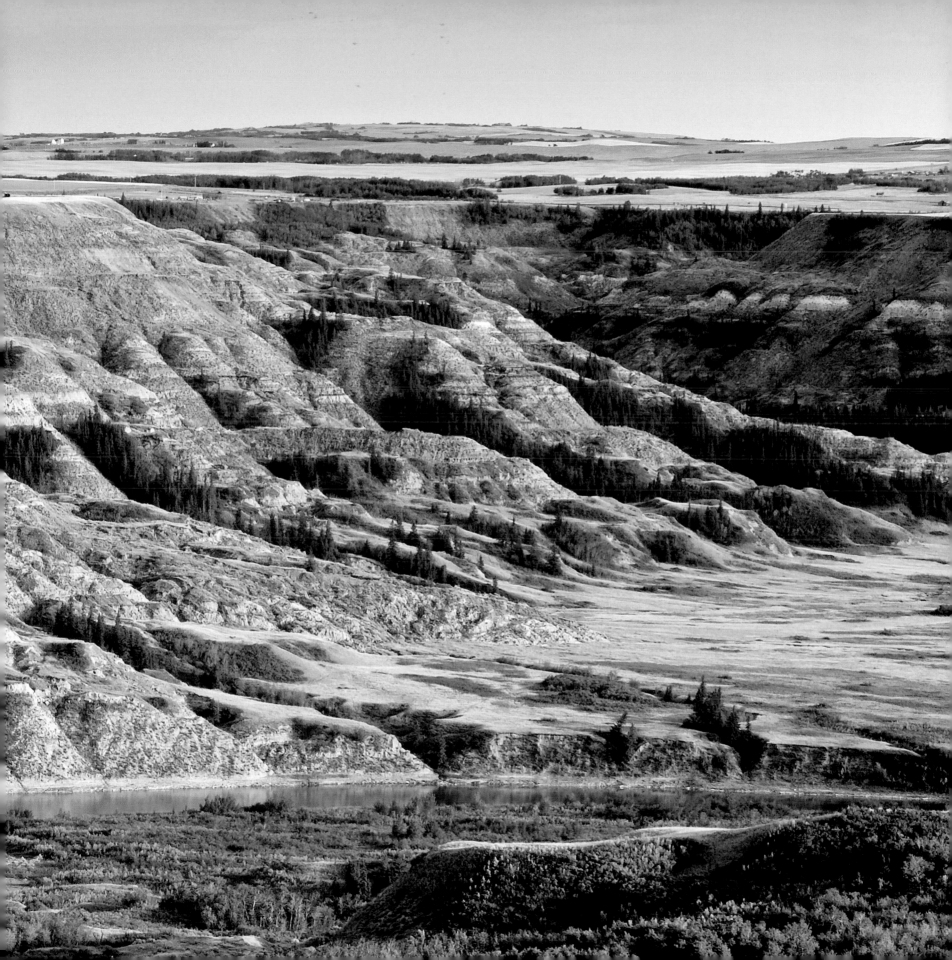

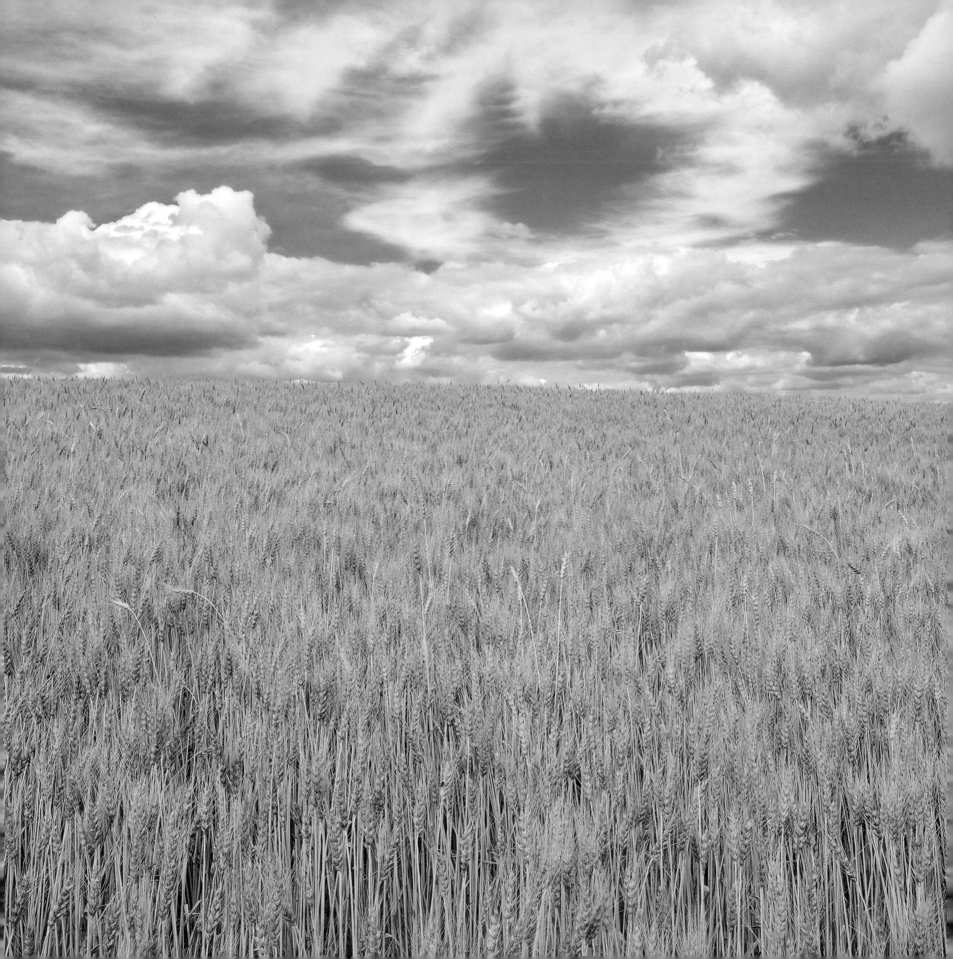

Prairie
&
Farmland

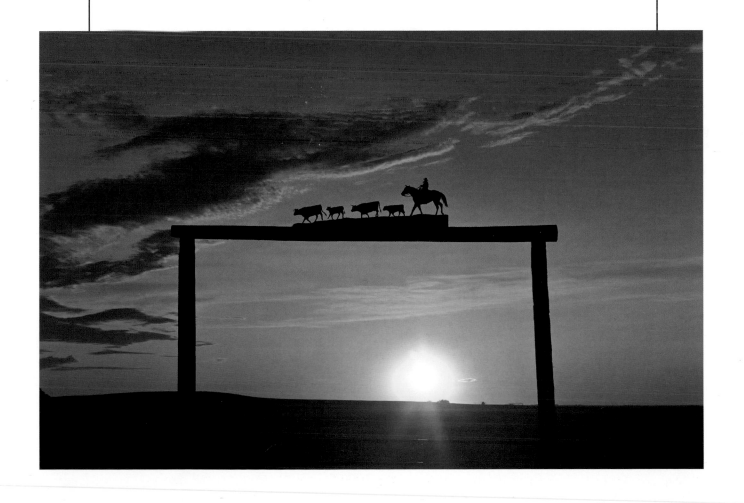

Previous spread, left: Wheat field and clouds, Delburne

Previous spread, right: Farmer's ranch entrance at sunset, Strathmore

Opposite: Swaths of canola drying, Three Hills

Following spread: Curious cattle, Gem

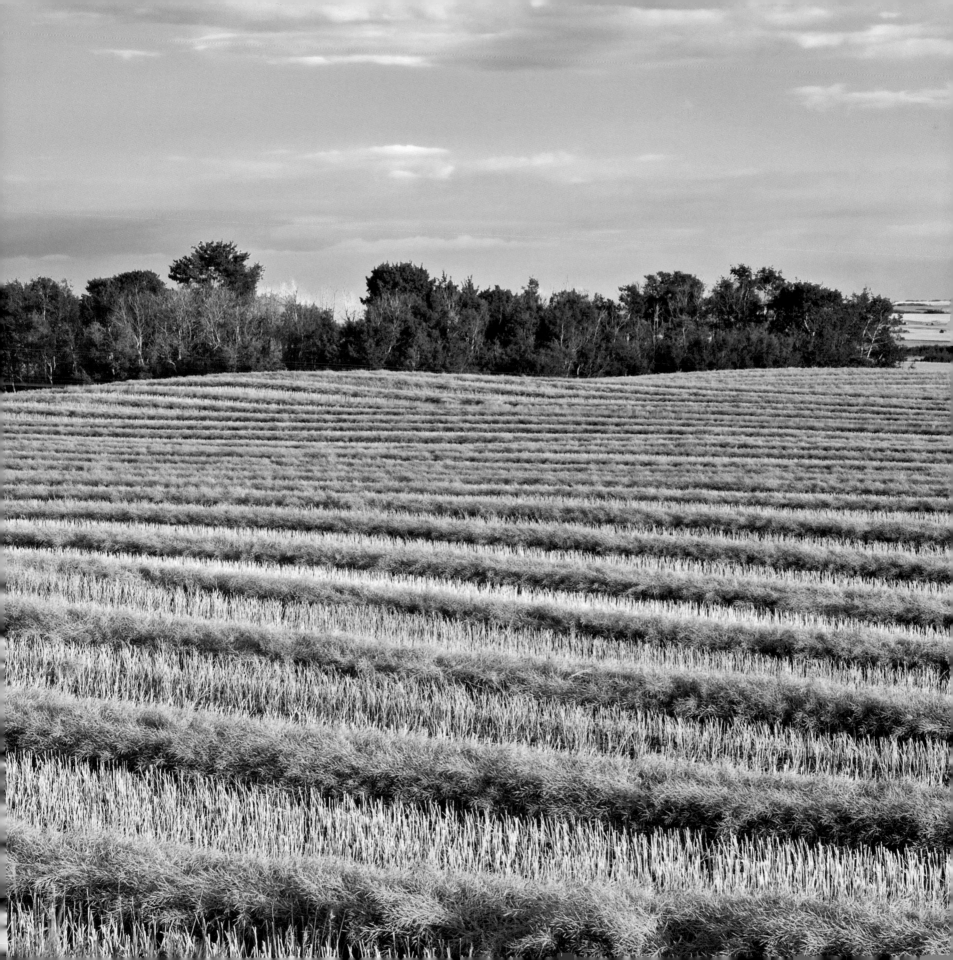

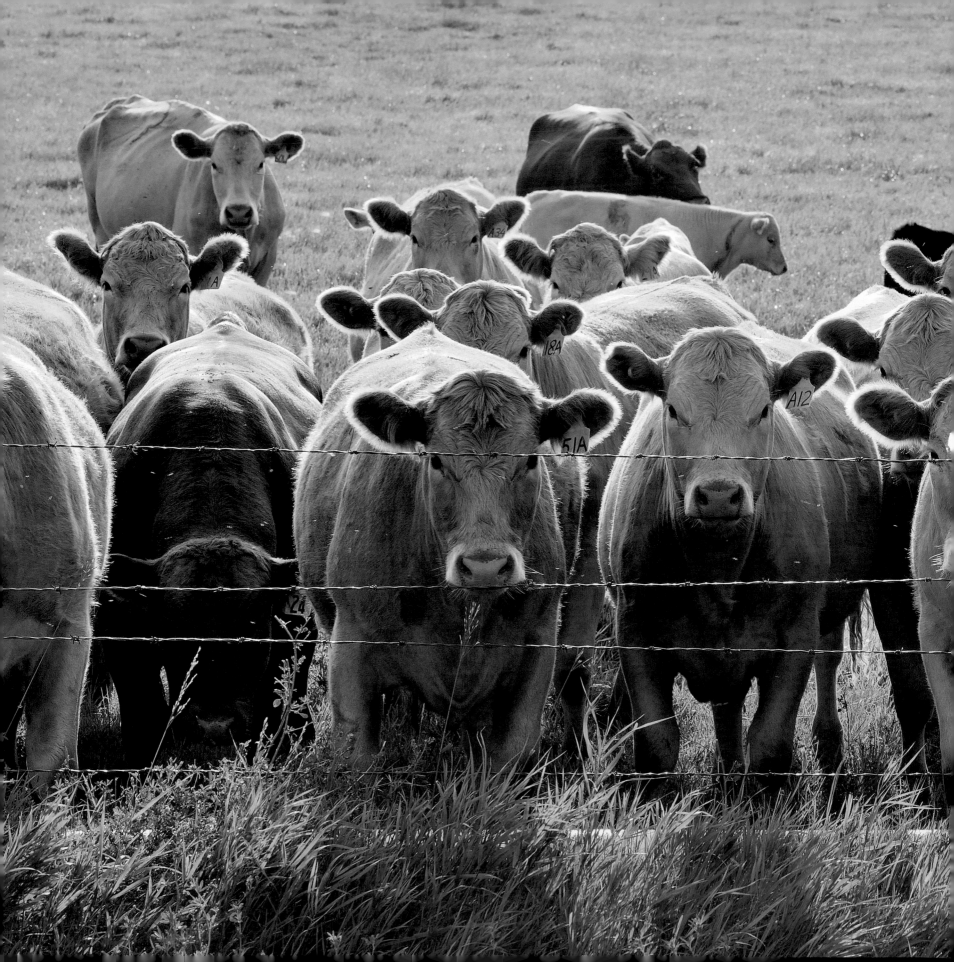

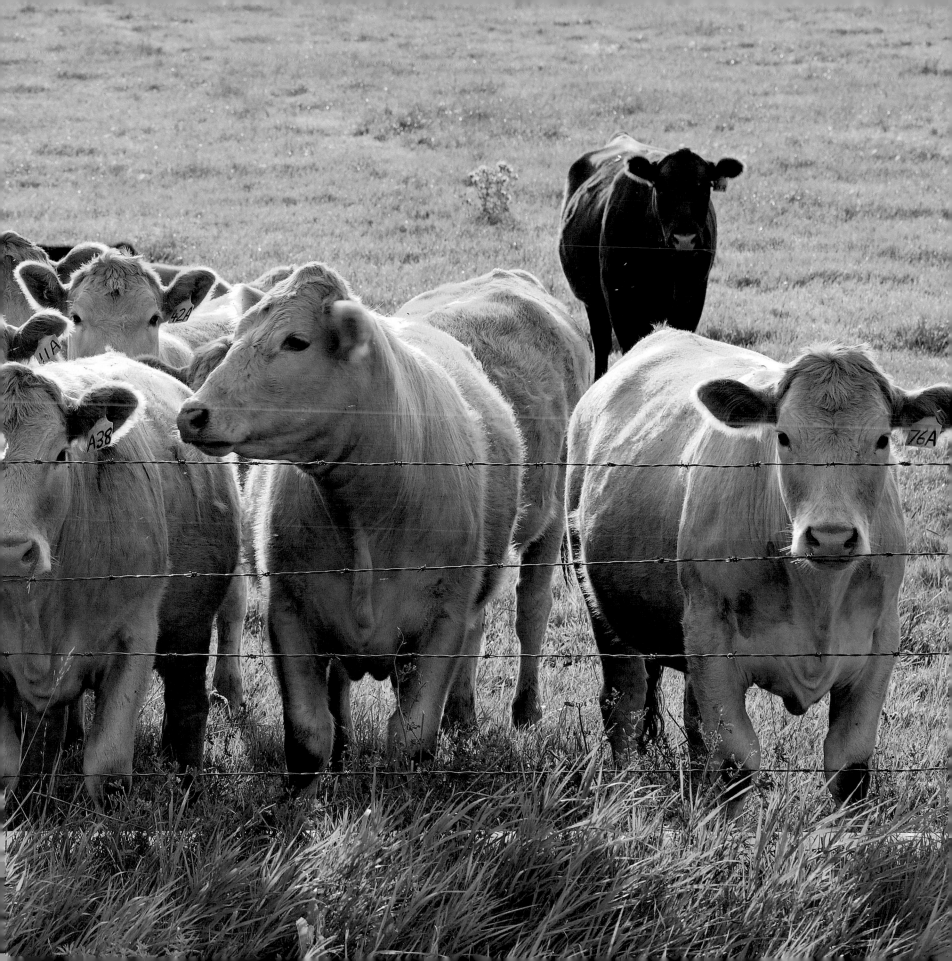

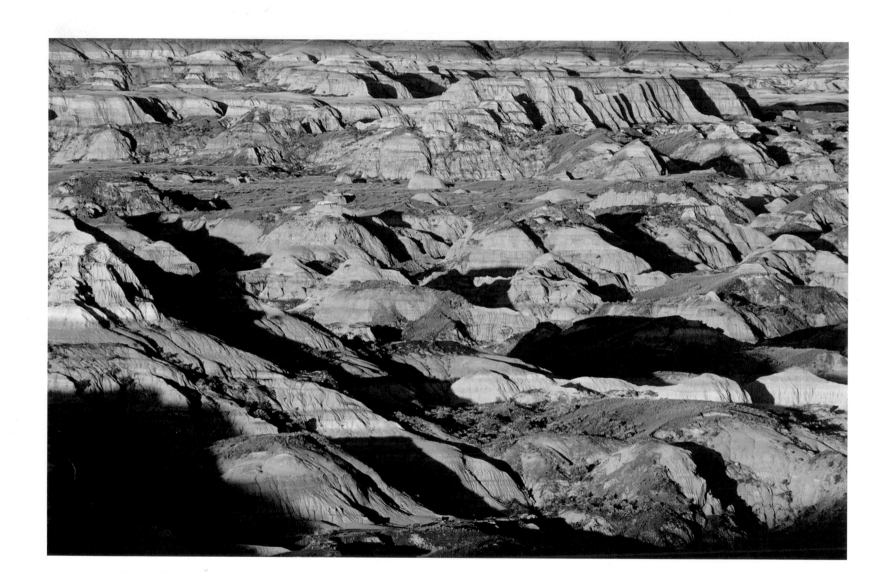

Above: Pattern of badlands from a high vantage point, Dinosaur Provincial Park

Opposite: Hoodoos along a trail, Writing-On-Stone Provincial Park

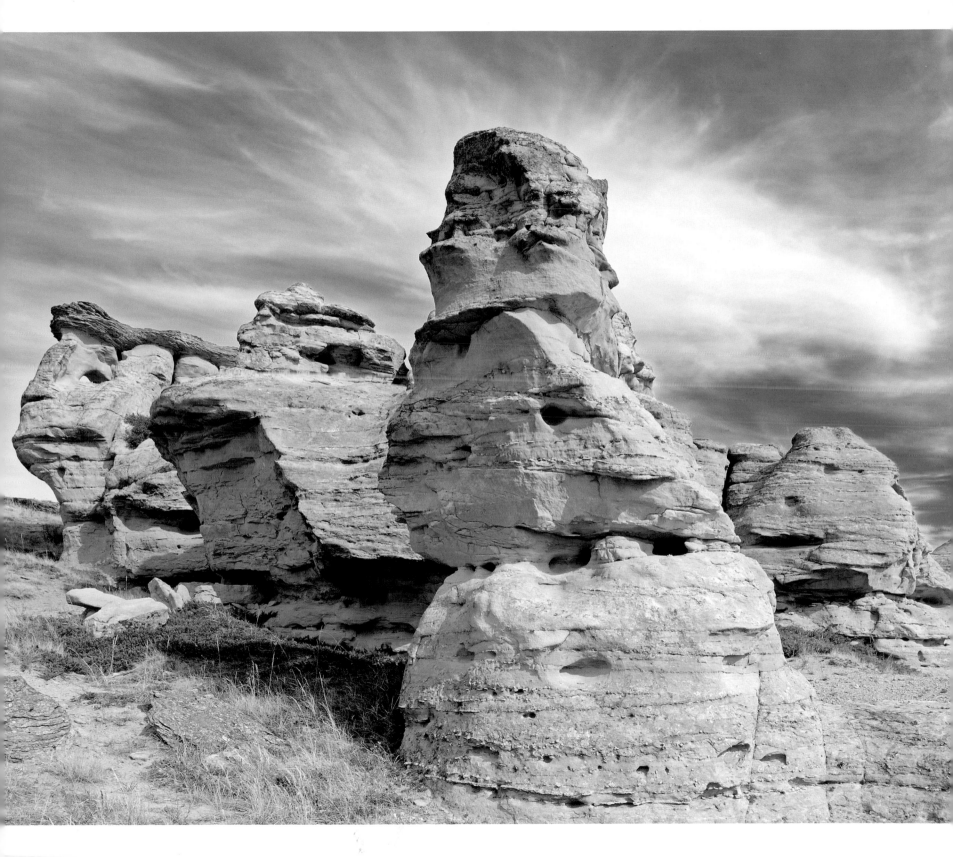

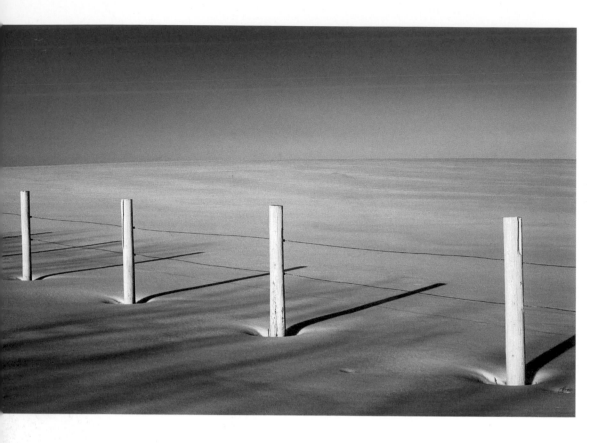

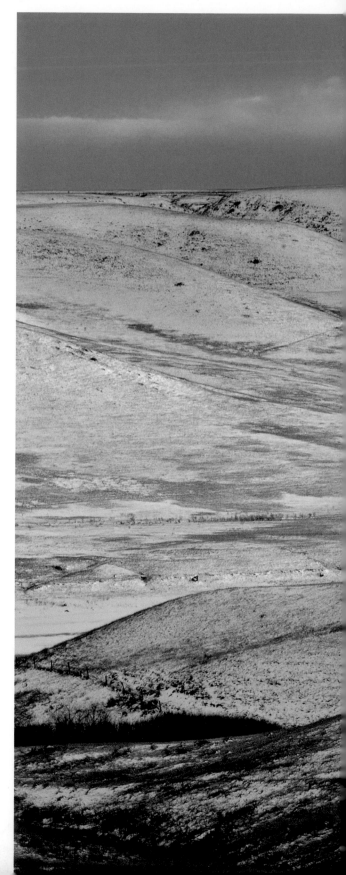

Above: Fence and snow, Tofield

Opposite: Valley surrounding the Oldman River, near Picture Butte

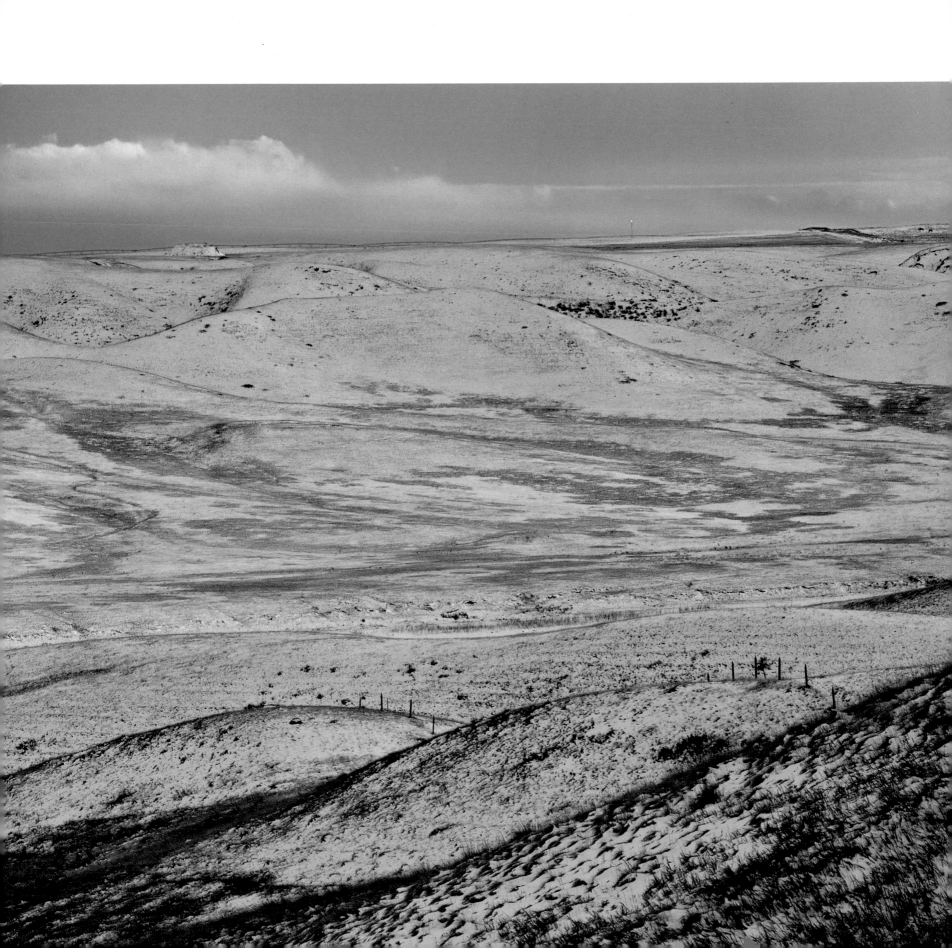

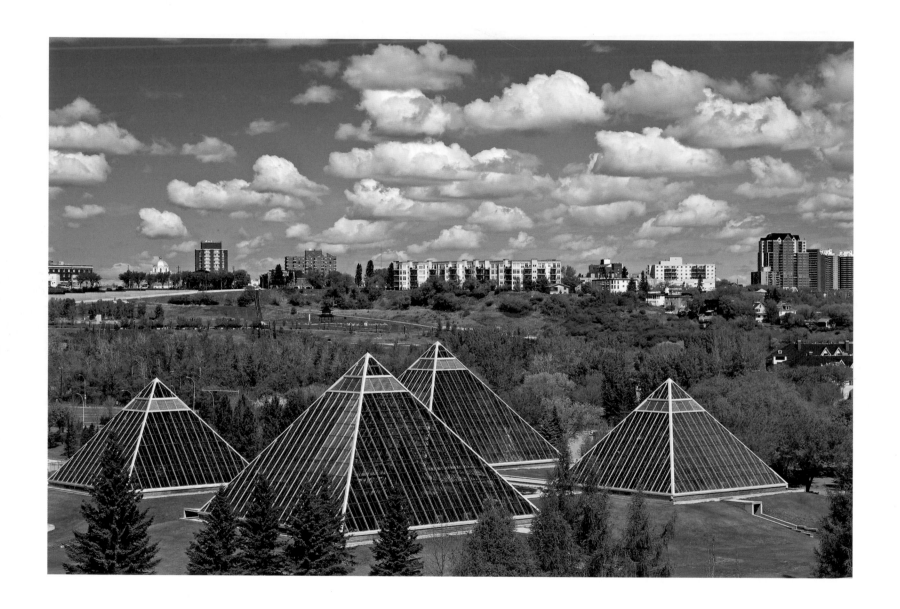

Above: Muttart Conservatory and city skyline, Edmonton

Opposite: Big Rock, Okotoks

84

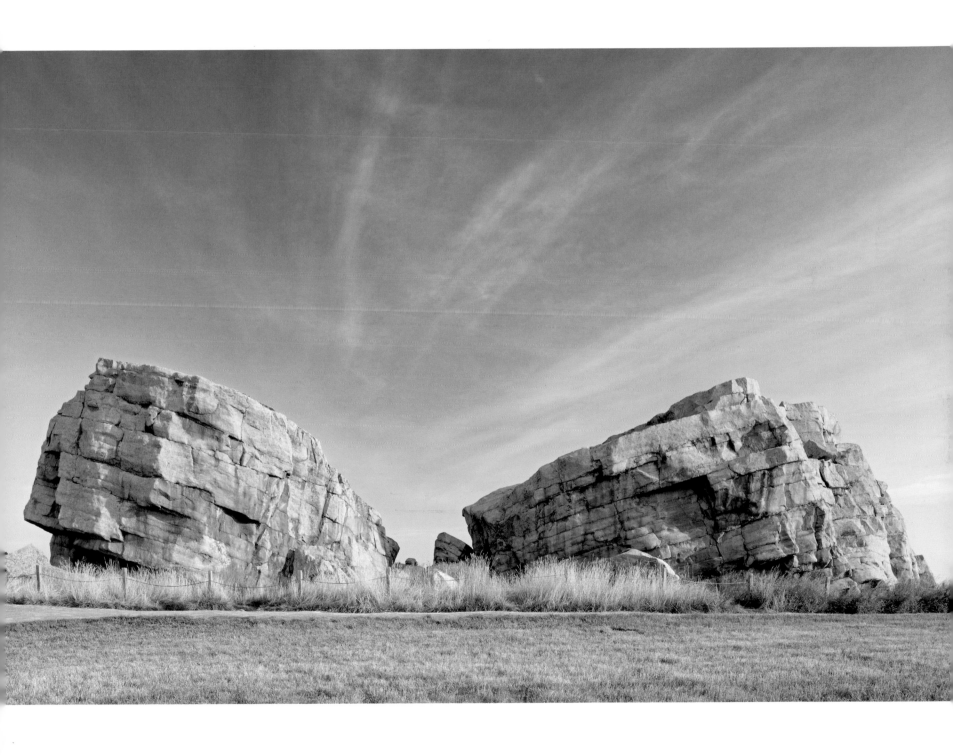

Above: Crops (canola in foreground) and clouds, Morin

Opposite: Historic McDougall Memorial United Church and northern lights, Morley

Following spread: Historic suspension bridge over the Peace River, Dunvegan Provincial Park and Historic Site

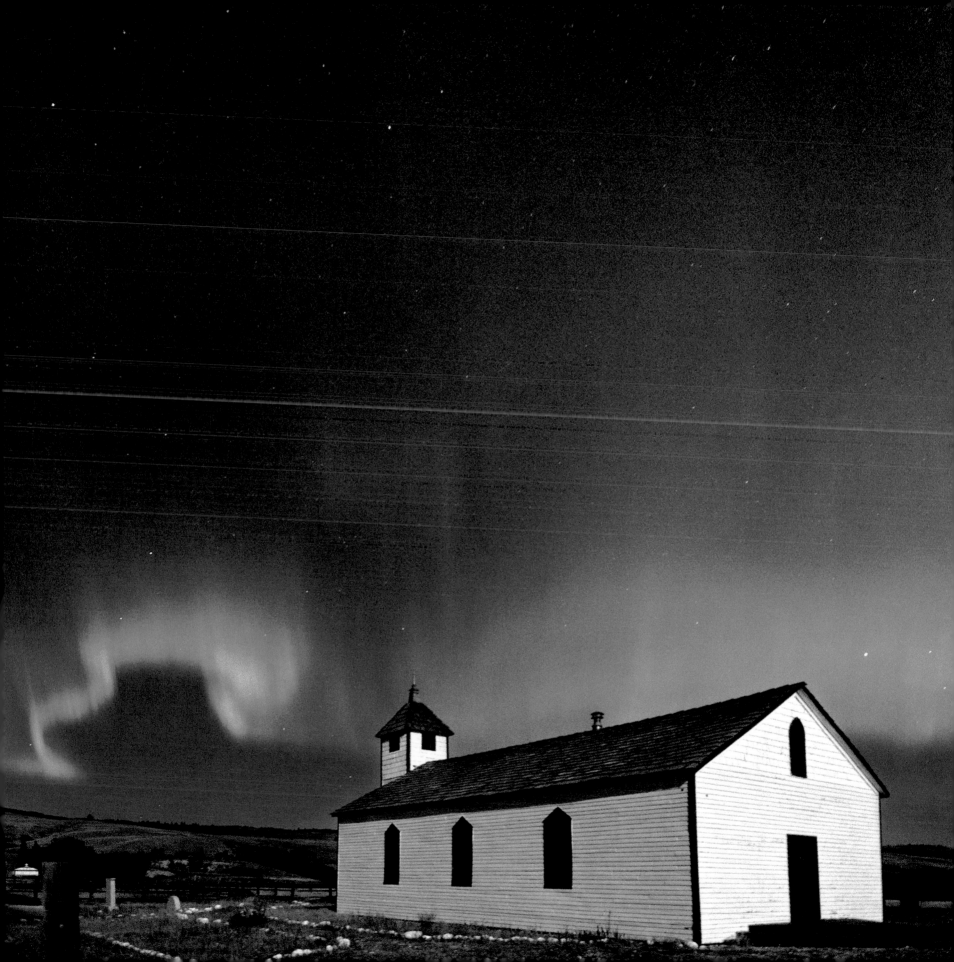

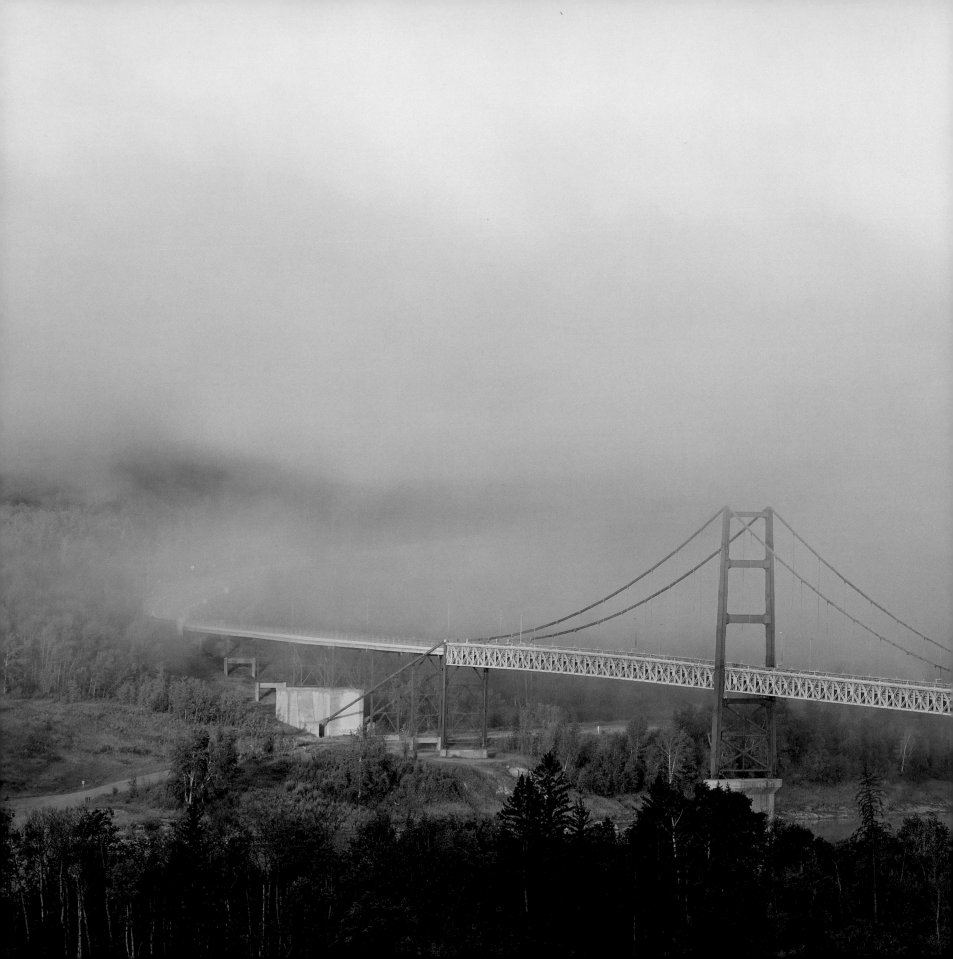

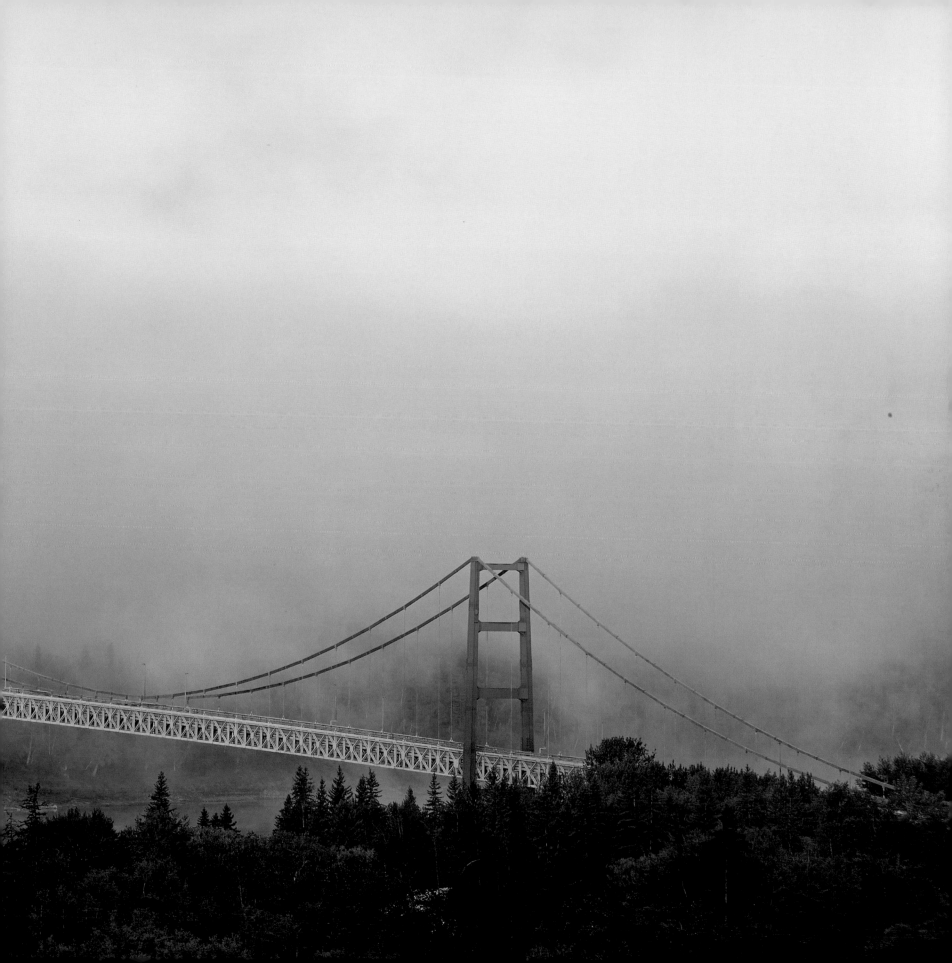

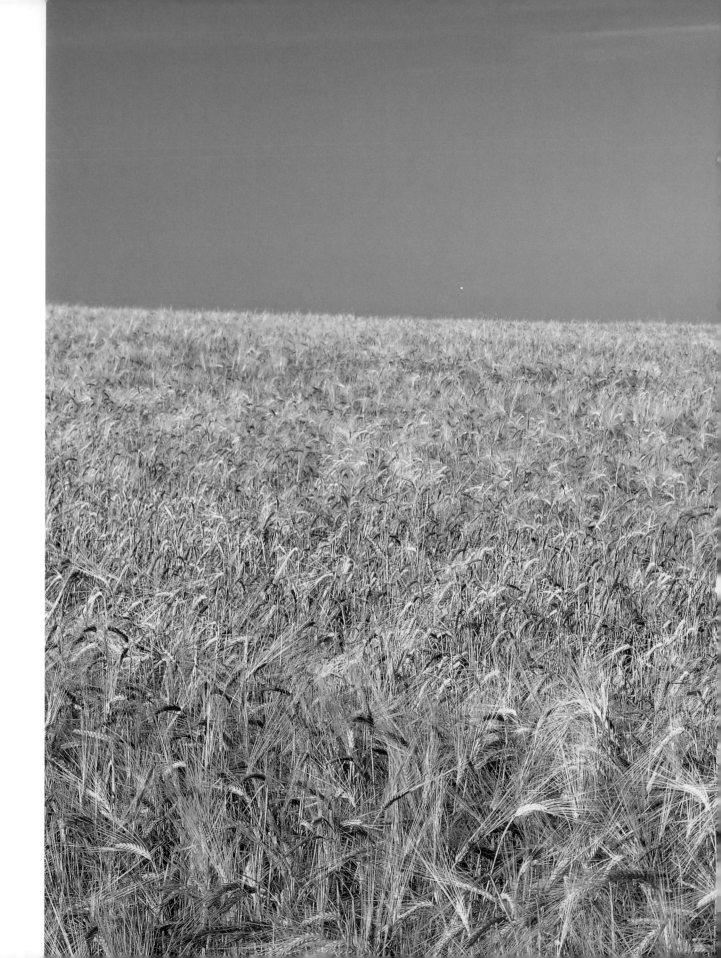

Old barn and barley field,
Trochu

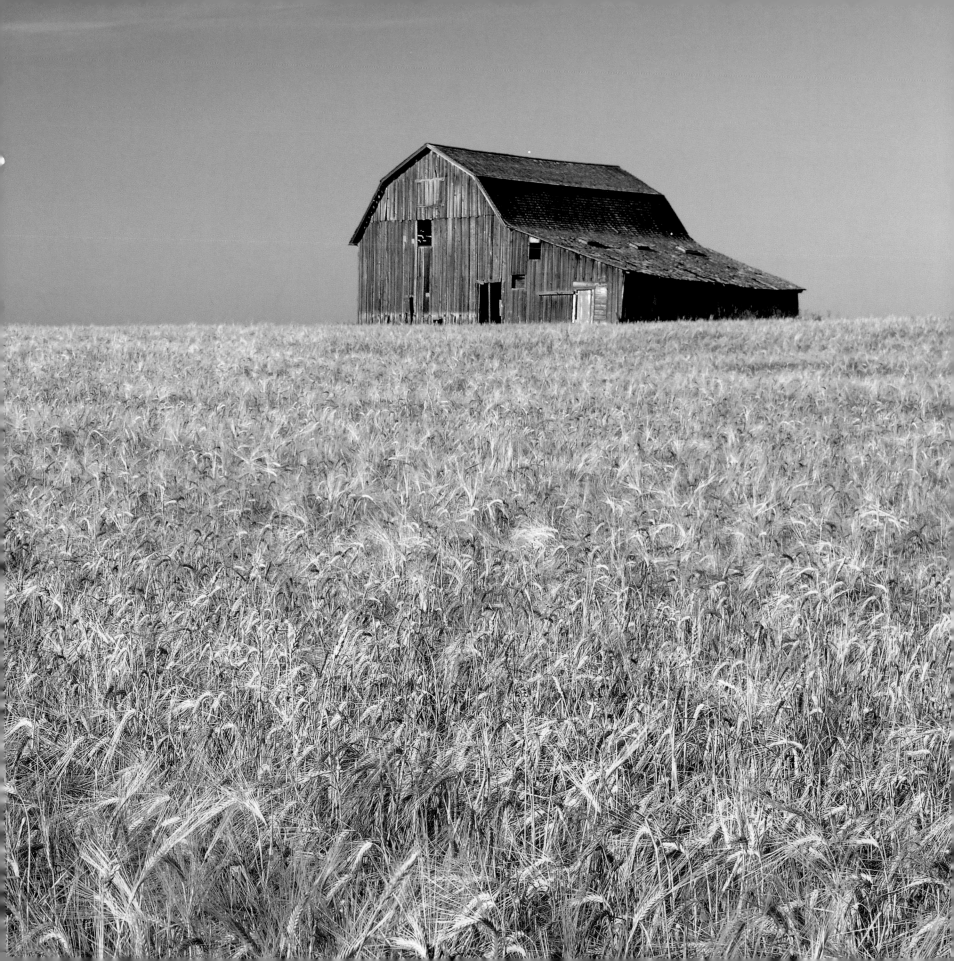

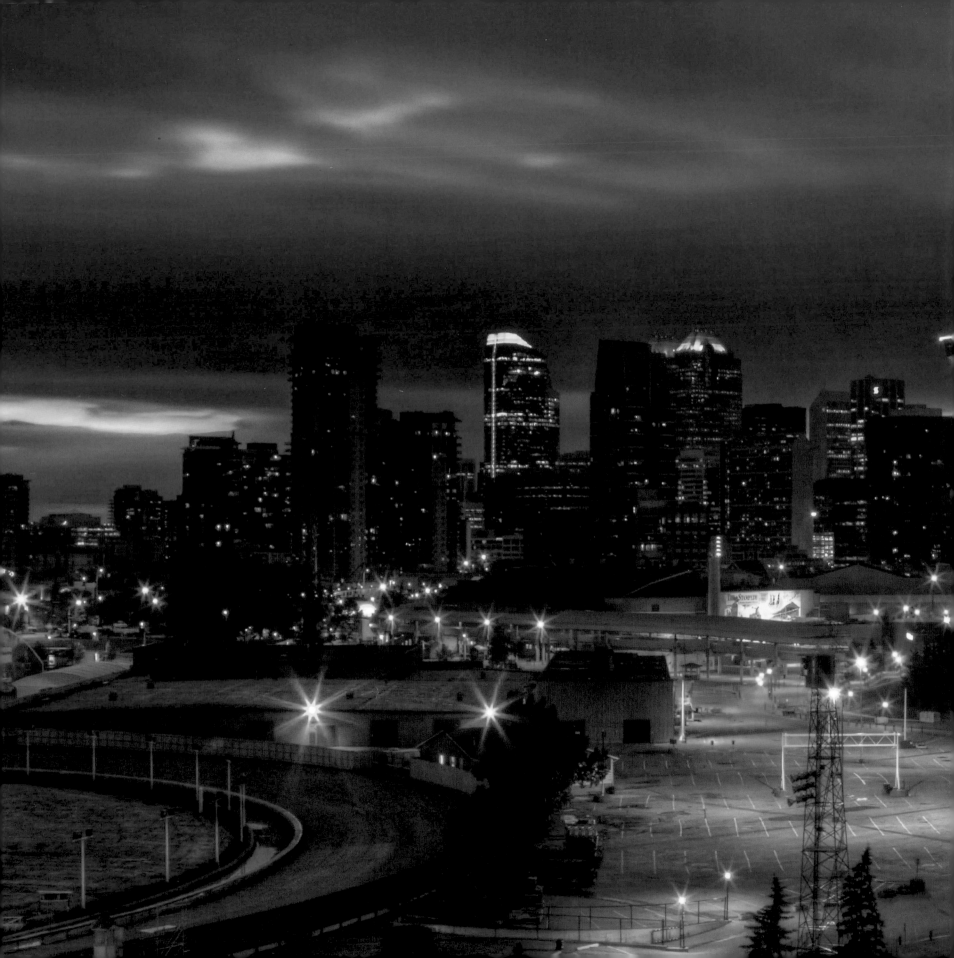

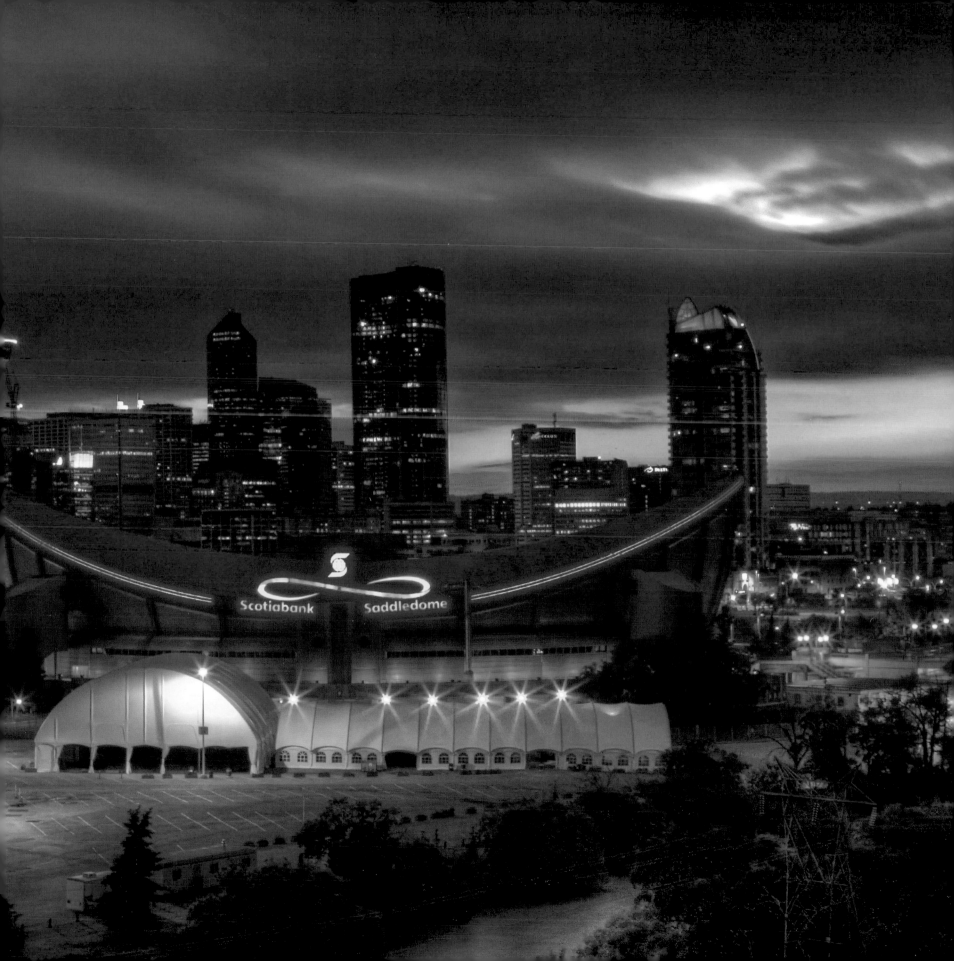

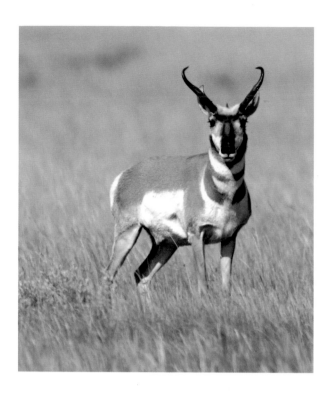

Previous spread: Calgary skyline at night with Calgary Saddledome, home of the Calgary Flames NHL hockey team, in the foreground.

Above: Pronghorn, near Walsh

Opposite: Horses in stubble field, Pincher Creek.

94

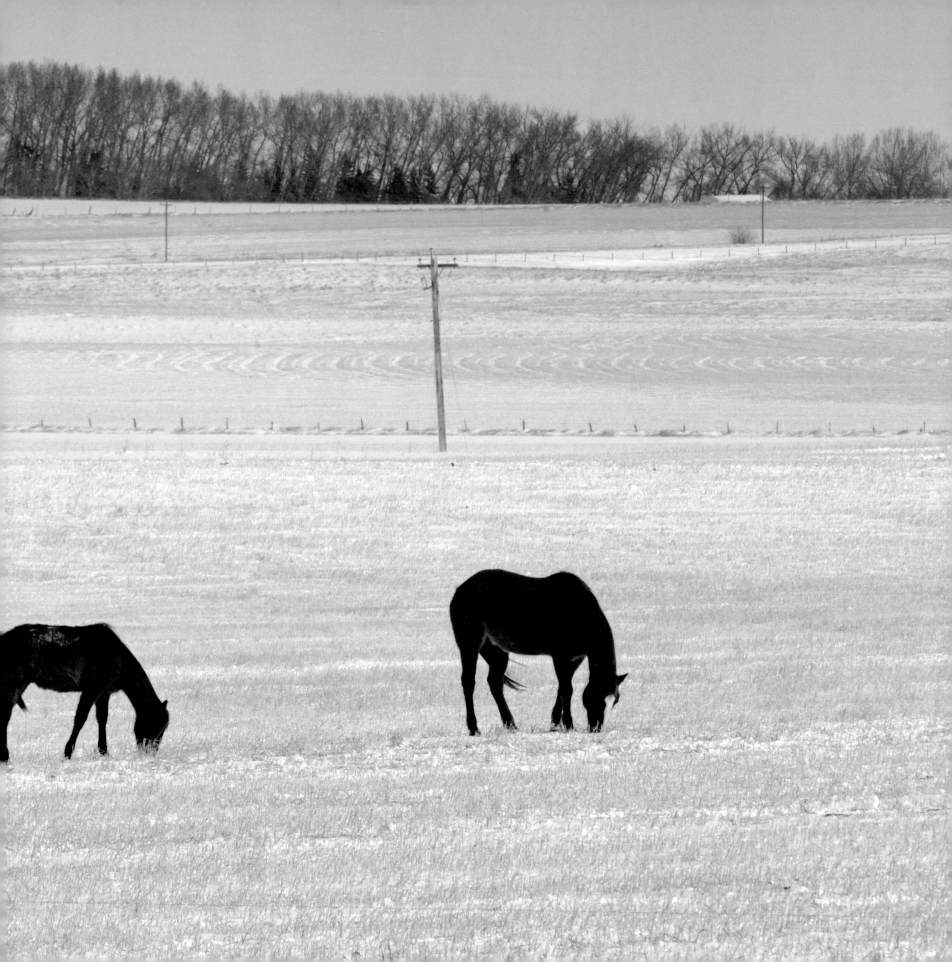

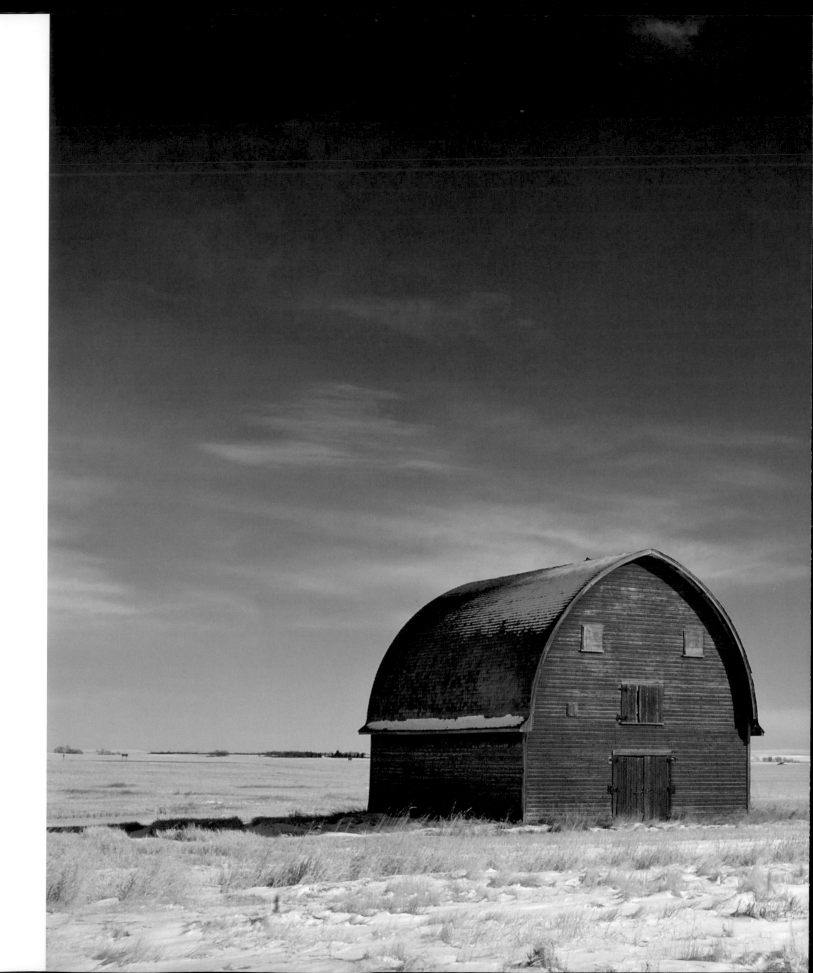

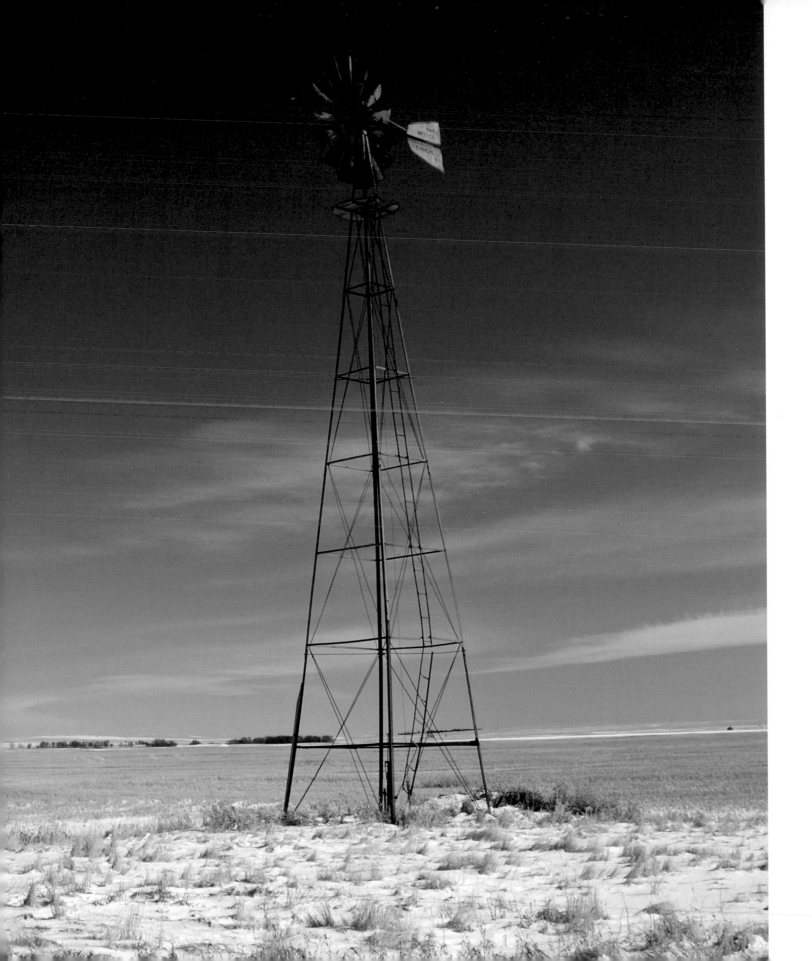

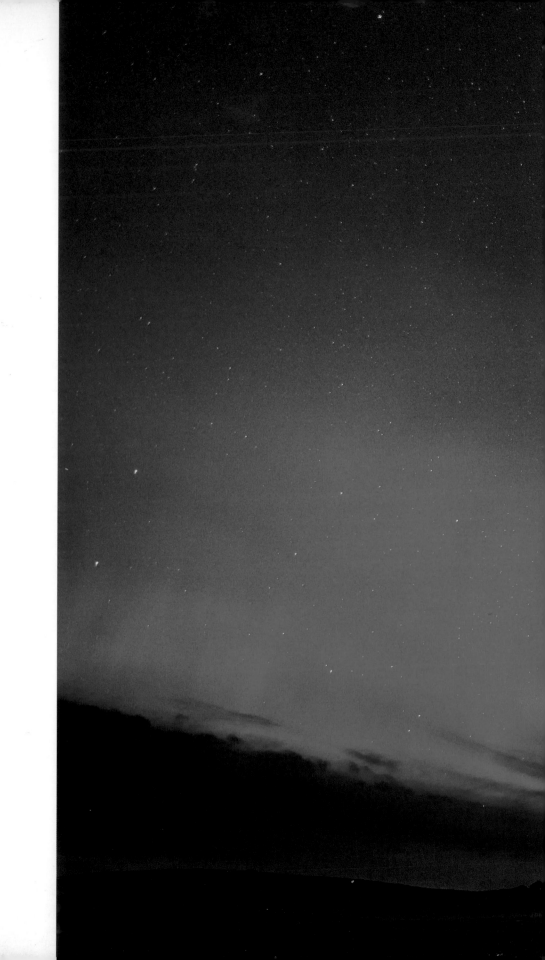

Previous spread: Red barn and old windmill, near Vulcan

Opposite: Northern lights, near Calgary

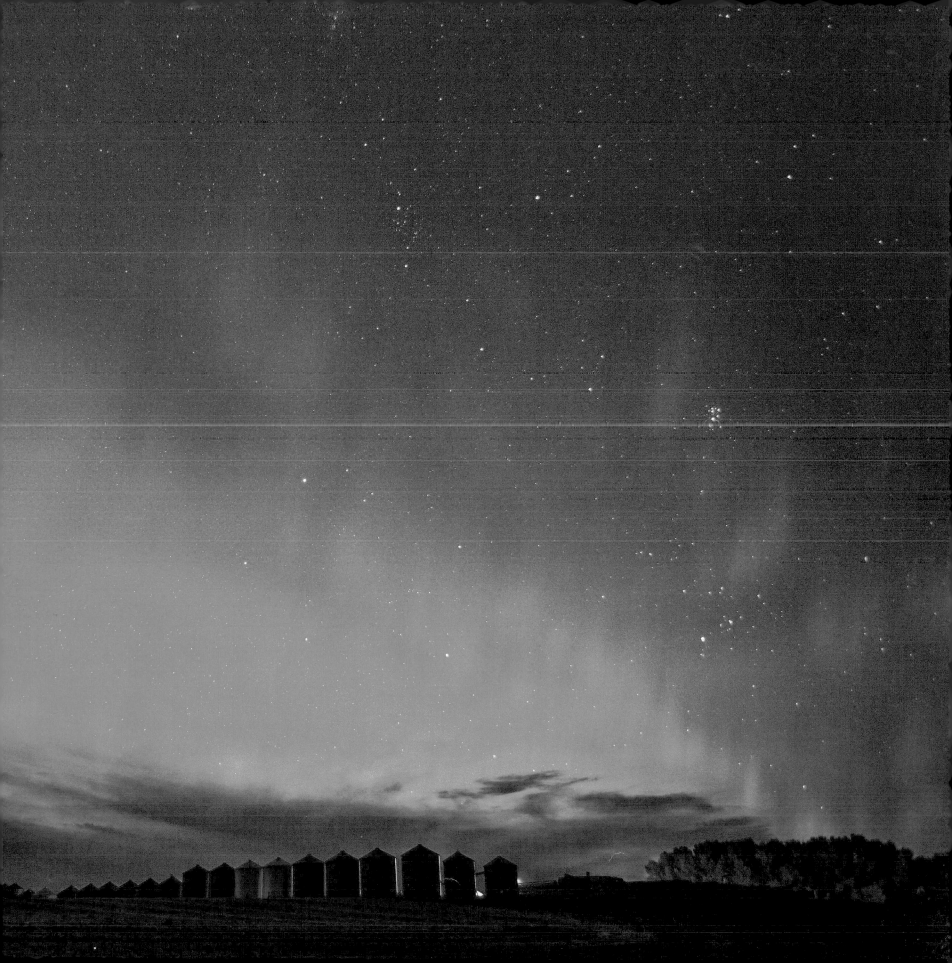

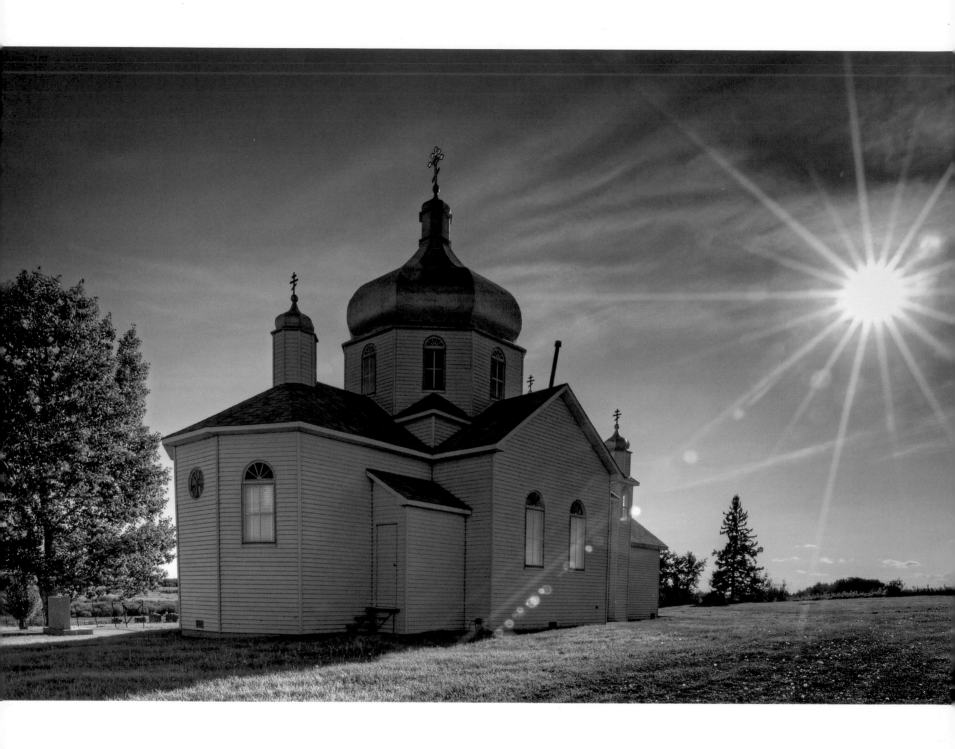

Above: St. John the Baptist Russo-Greek Catholic Orthodox Church, Farus

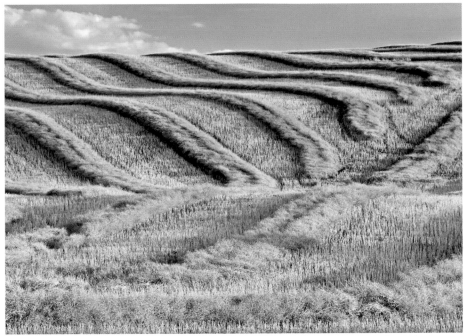

Top: Harvesting peas, near Little Bow **Bottom:** Swaths of canola, Trochu

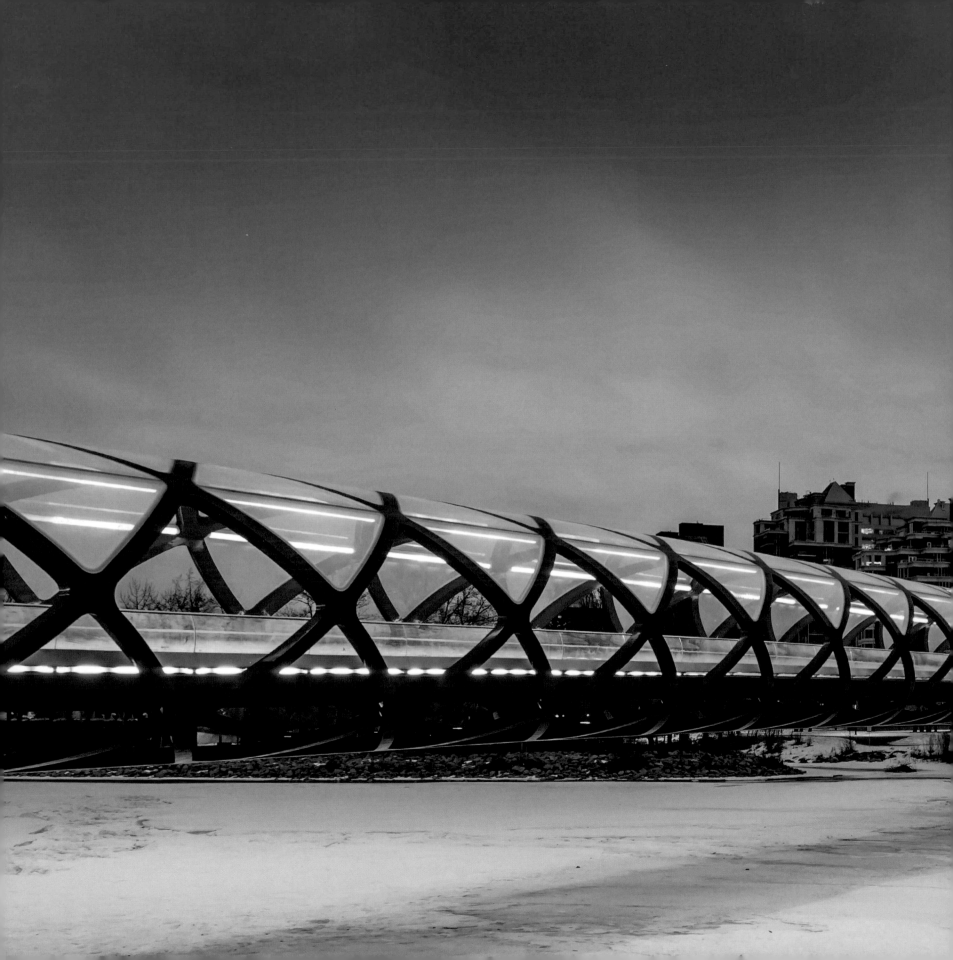

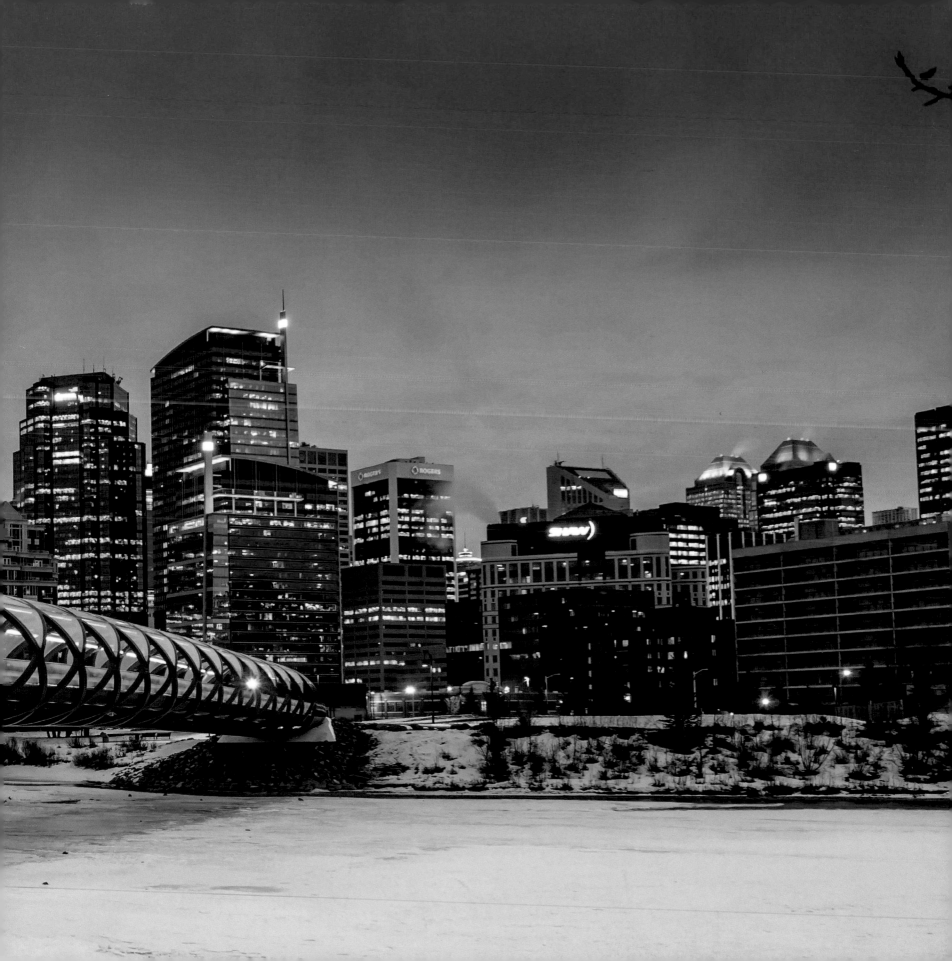

Previous spread: The Peace Bridge, a pedestrian walkway in Calgary, spans the Bow River

Opposite: Old farmstead and clouds, near Jenner

Following spread: City skyline at night, Calgary

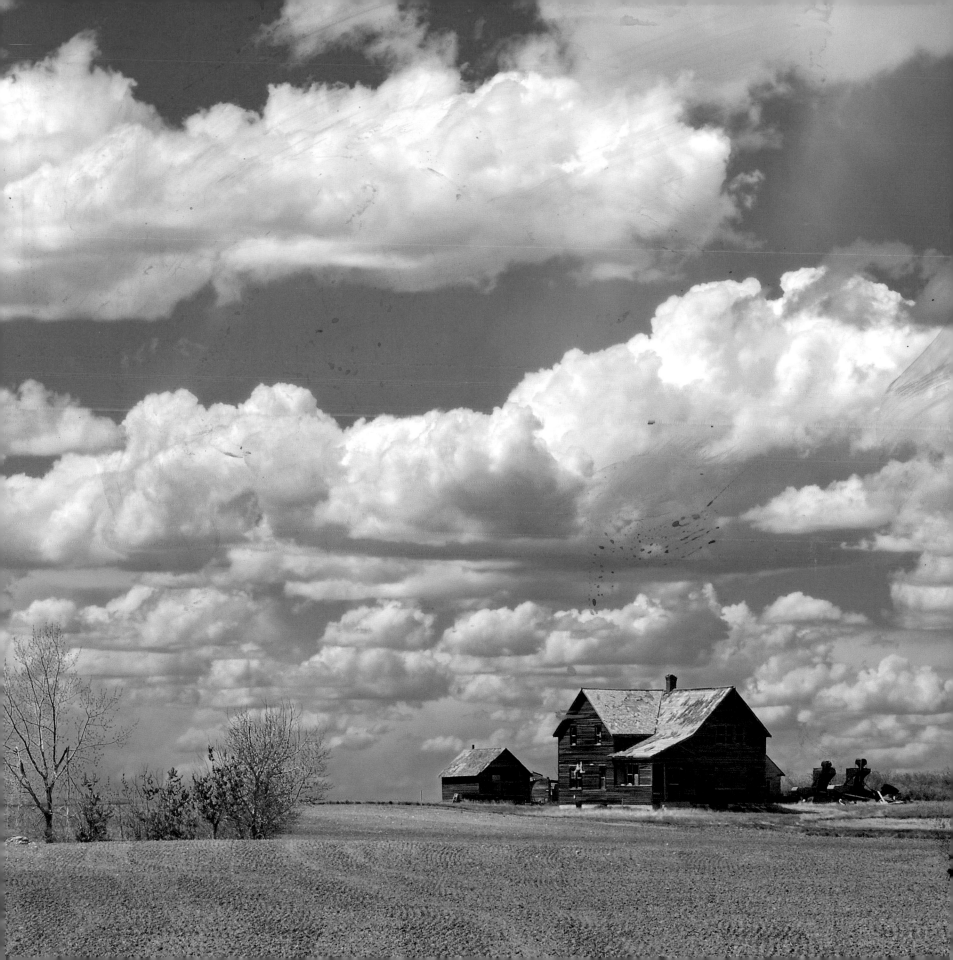

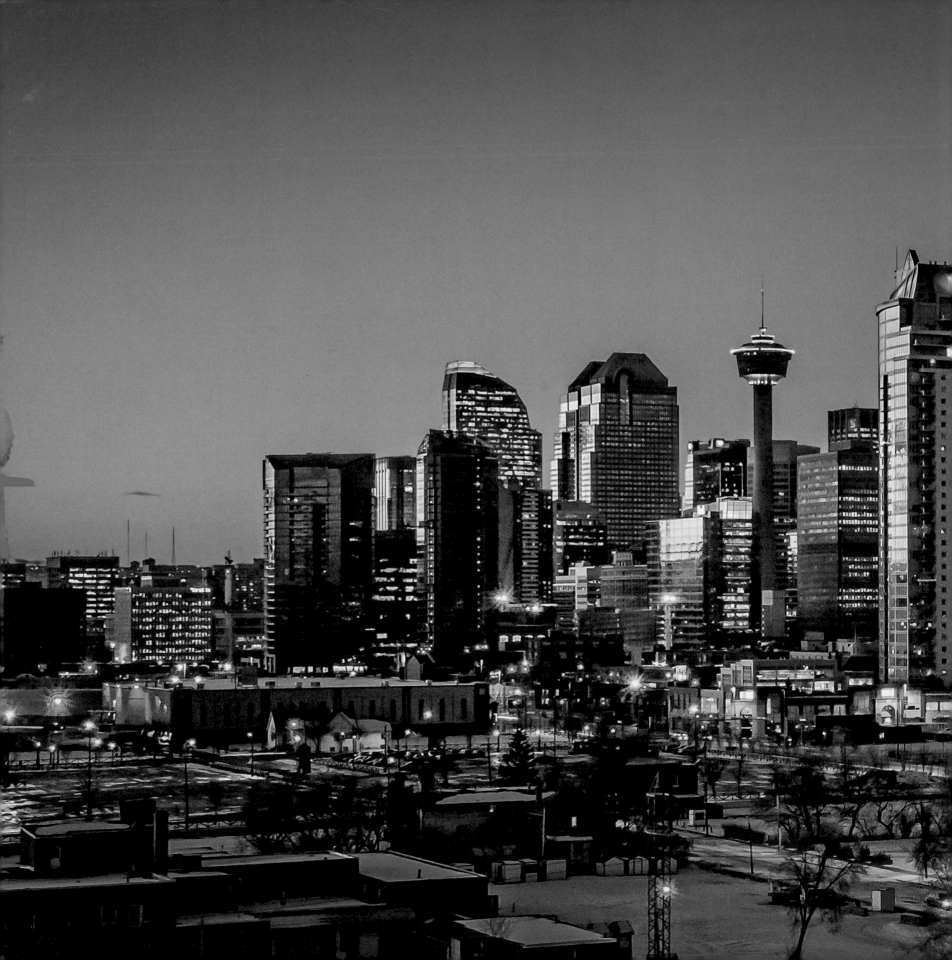

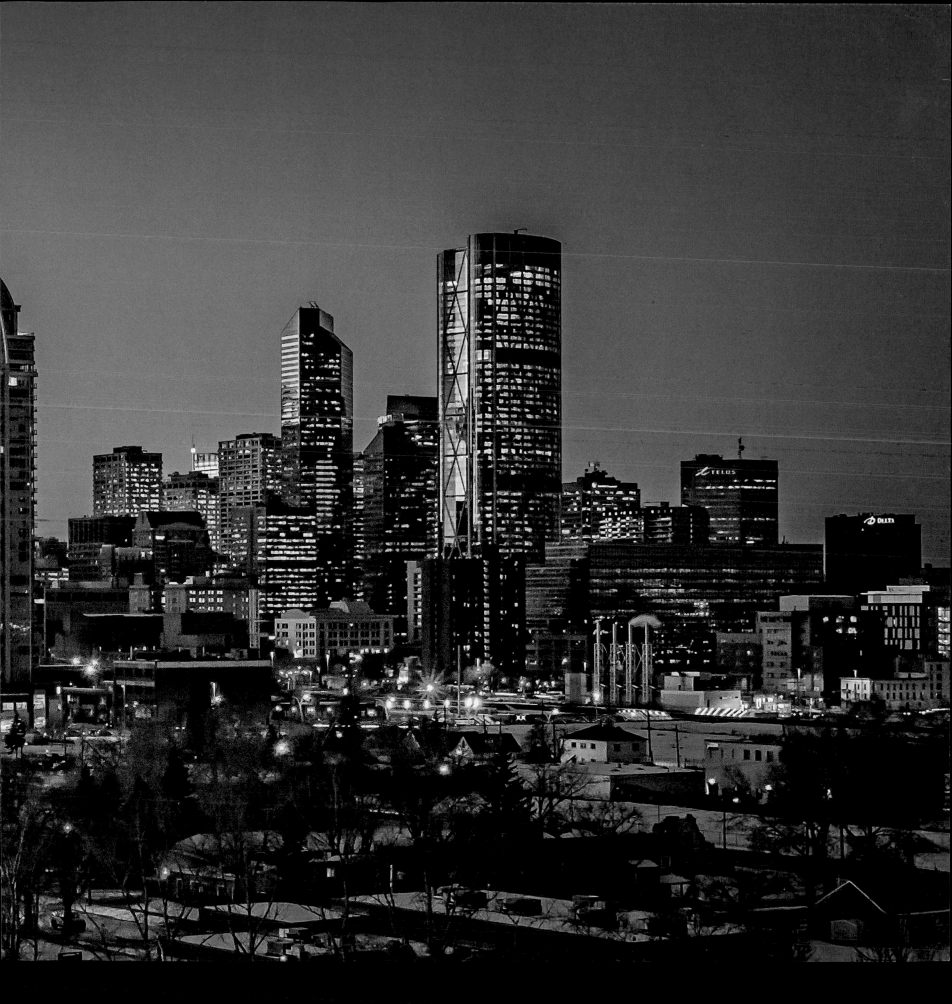

Opposite: St. Nicholas Ukrainian Greek Catholic Church, Cultural Ukrainian Heritage Village, Vegreville

Following spread: Lightning in the night sky, Edmonton

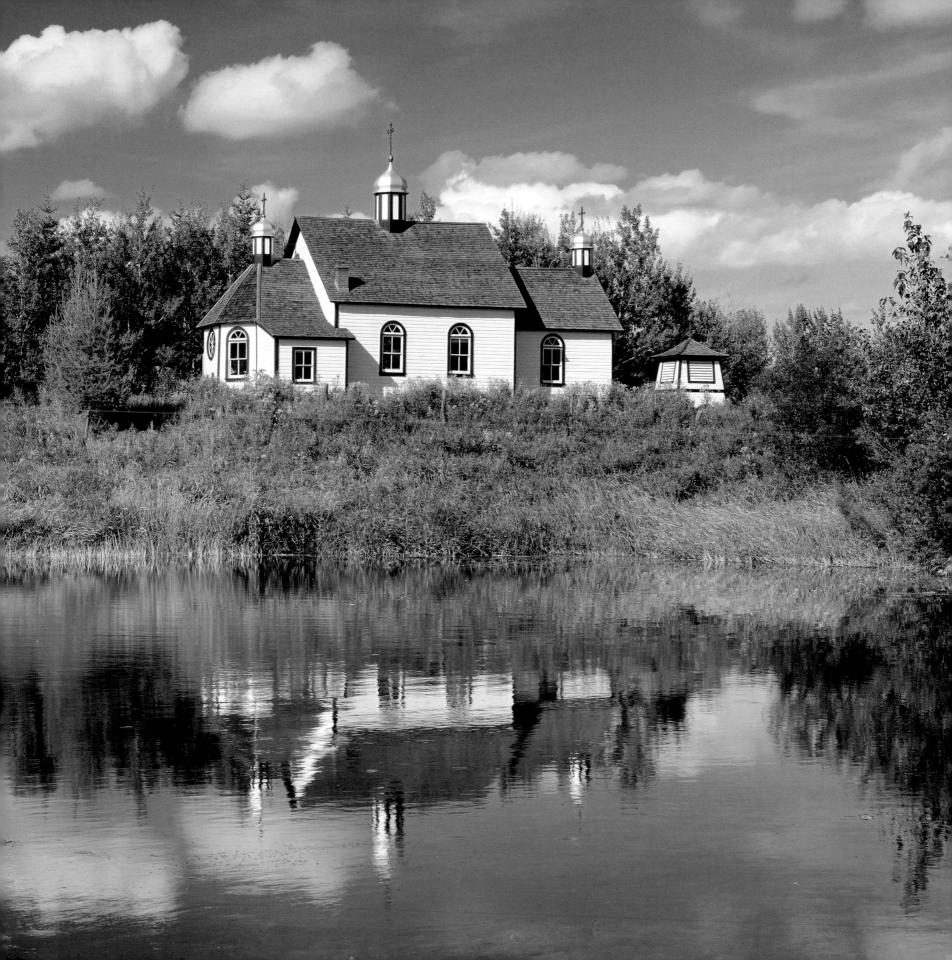

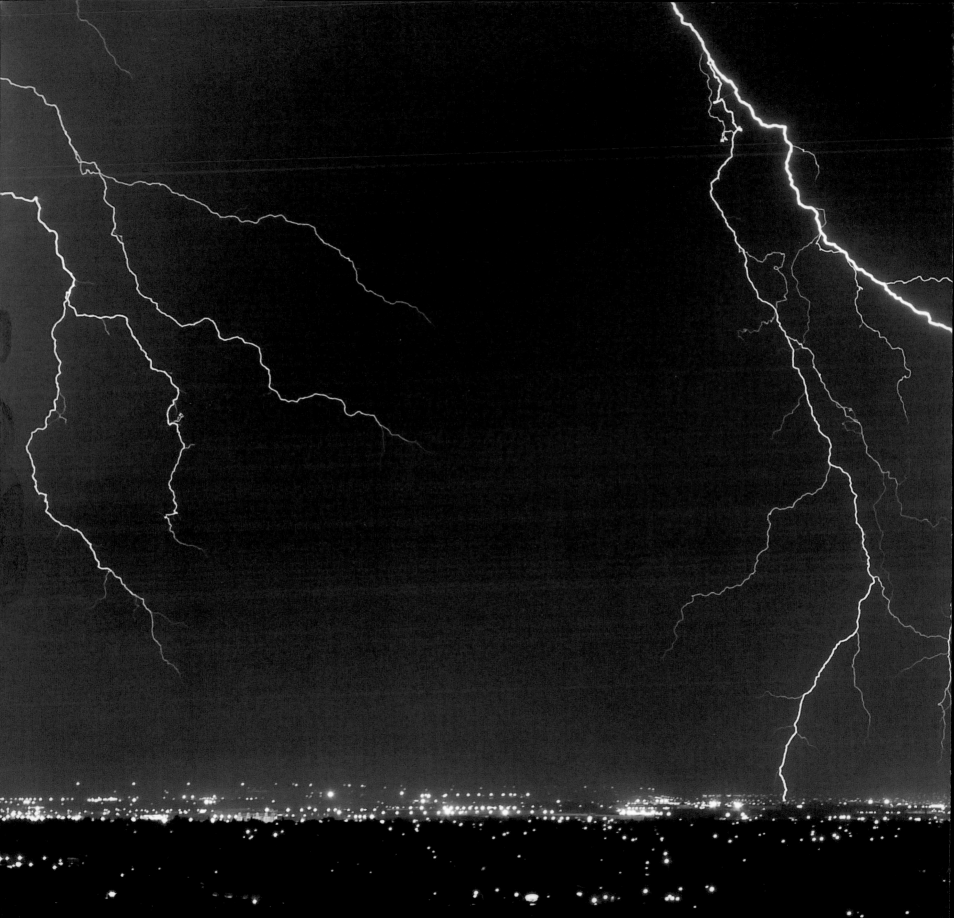

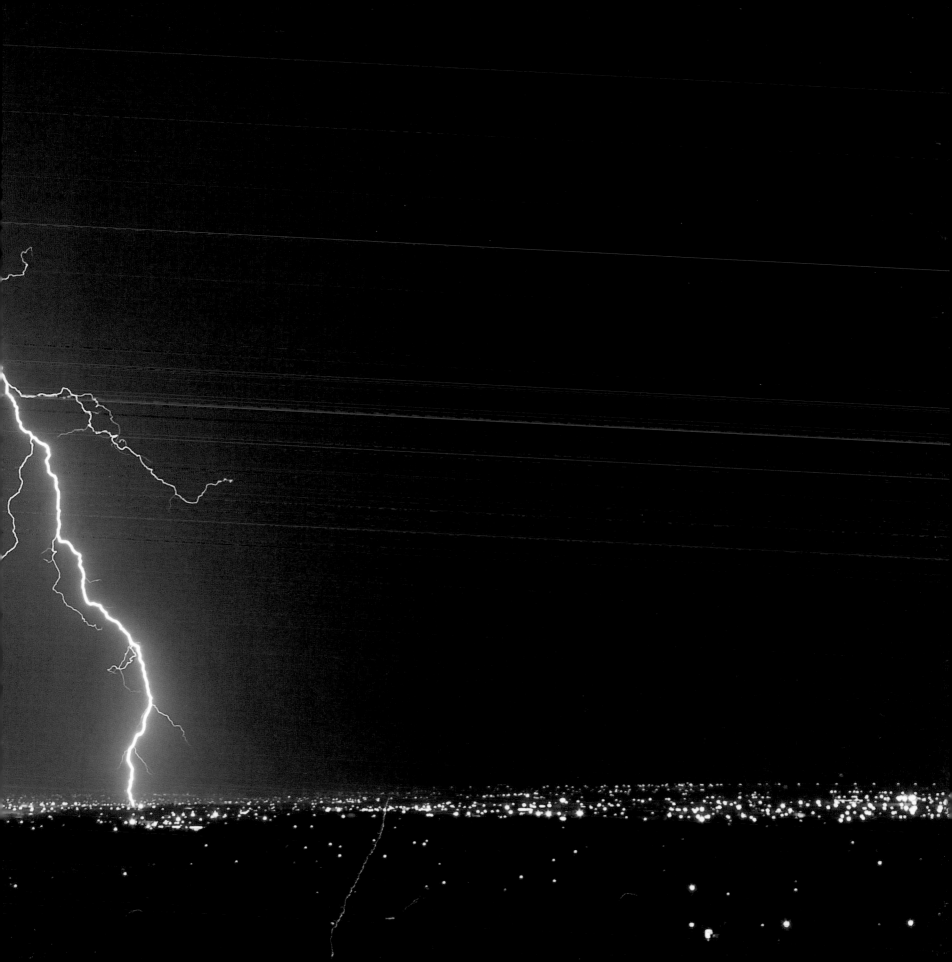

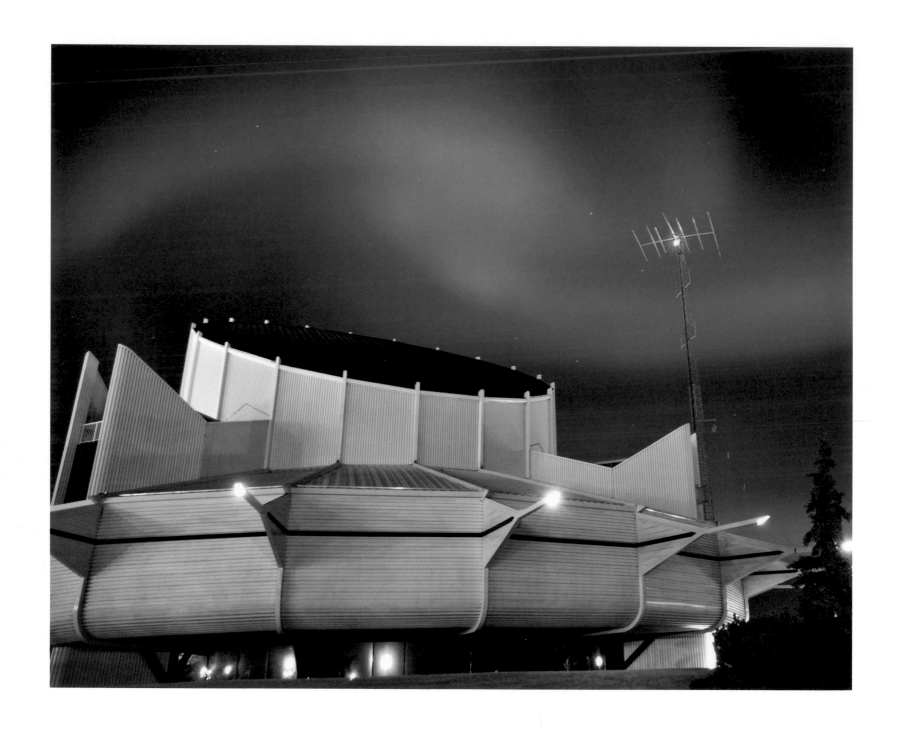

Above: Northern lights above the Science Centre, Edmonton

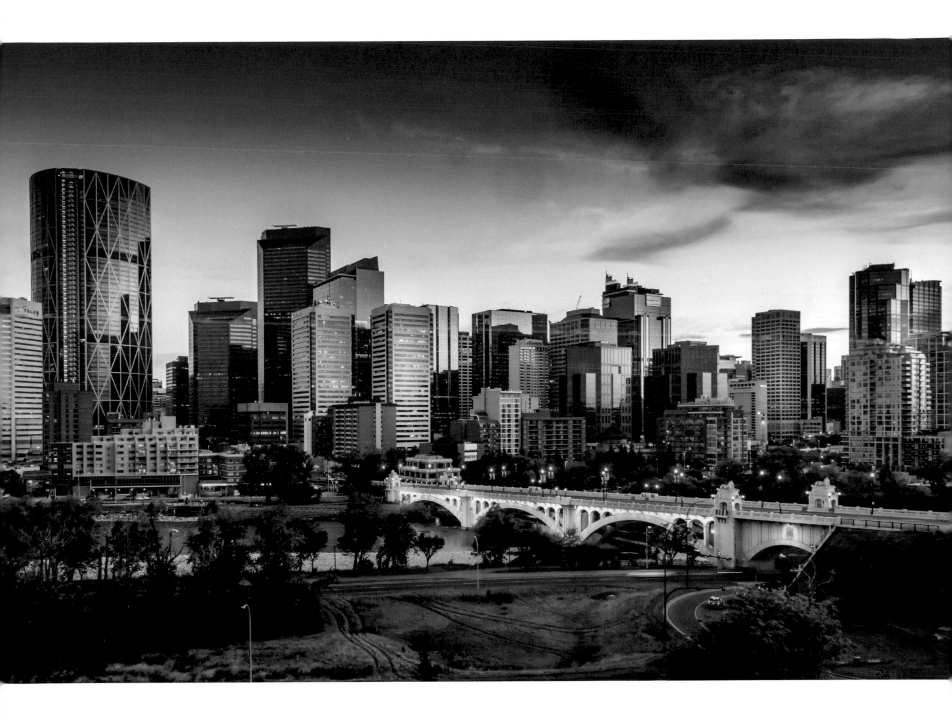

Above: Calgary skyline in evening with the Bow River and Centre Street Bridge

Following spread: Irrigating crops, Monarch

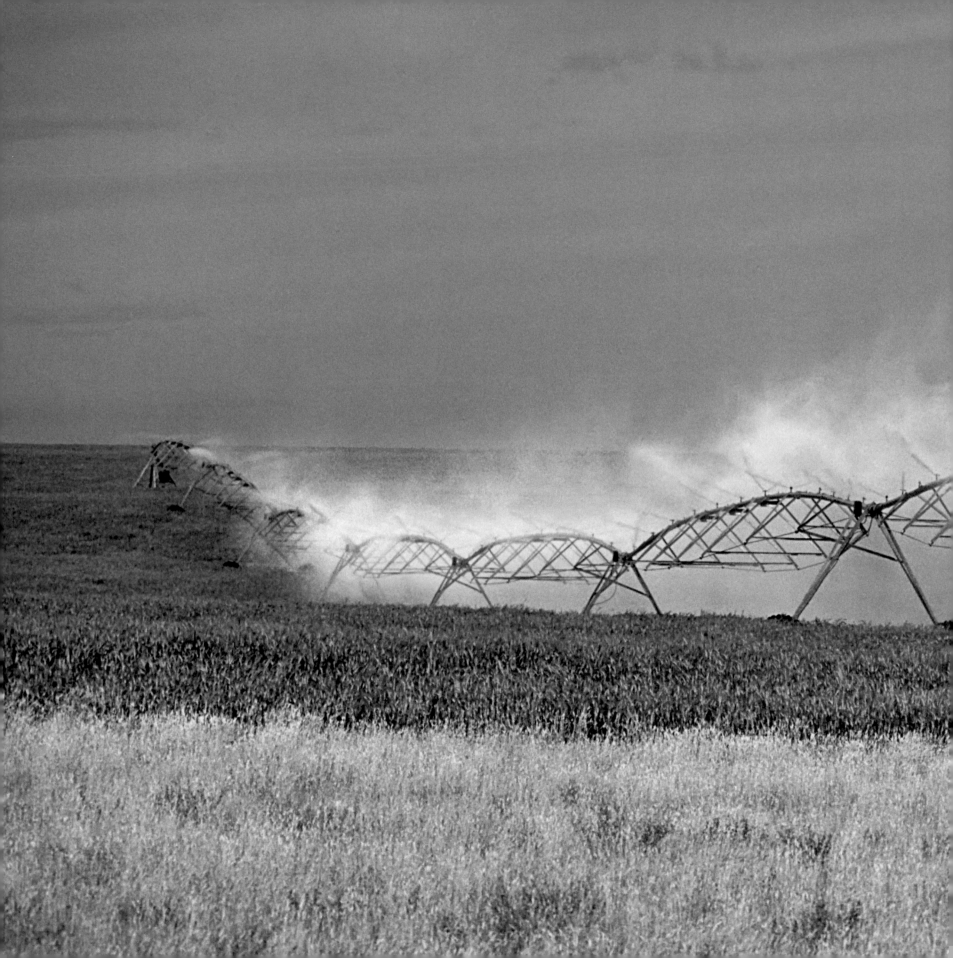

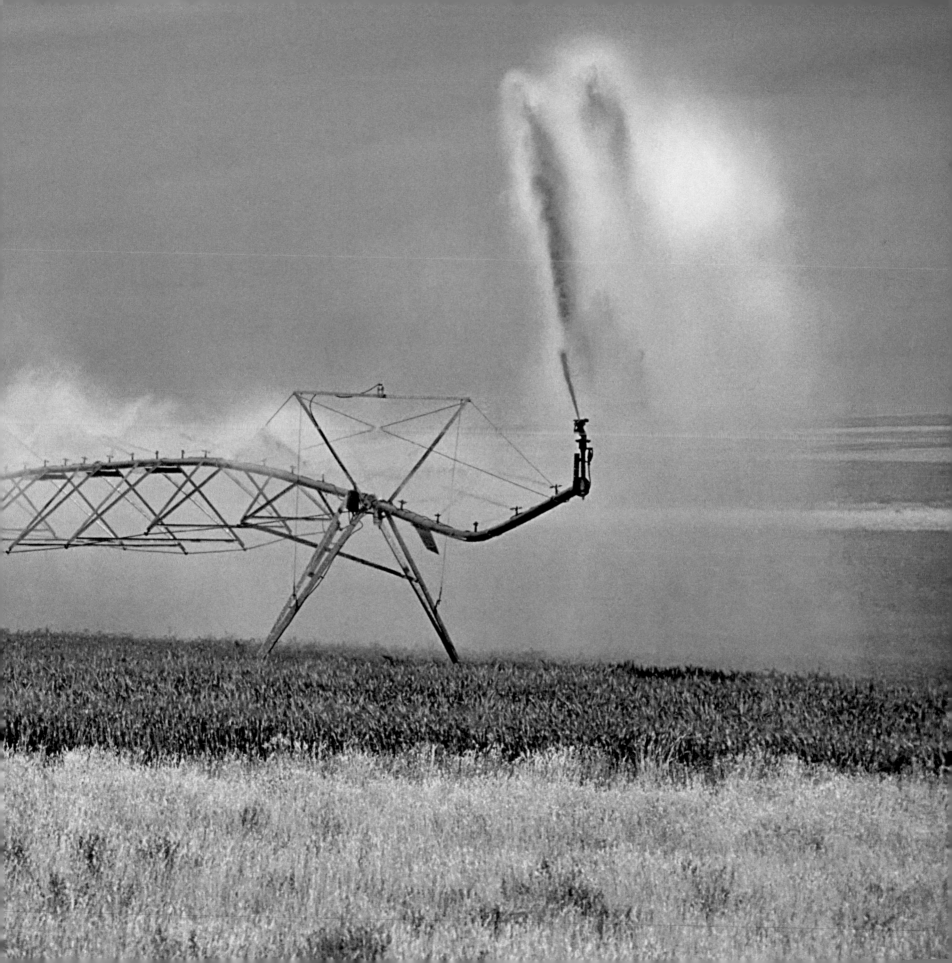

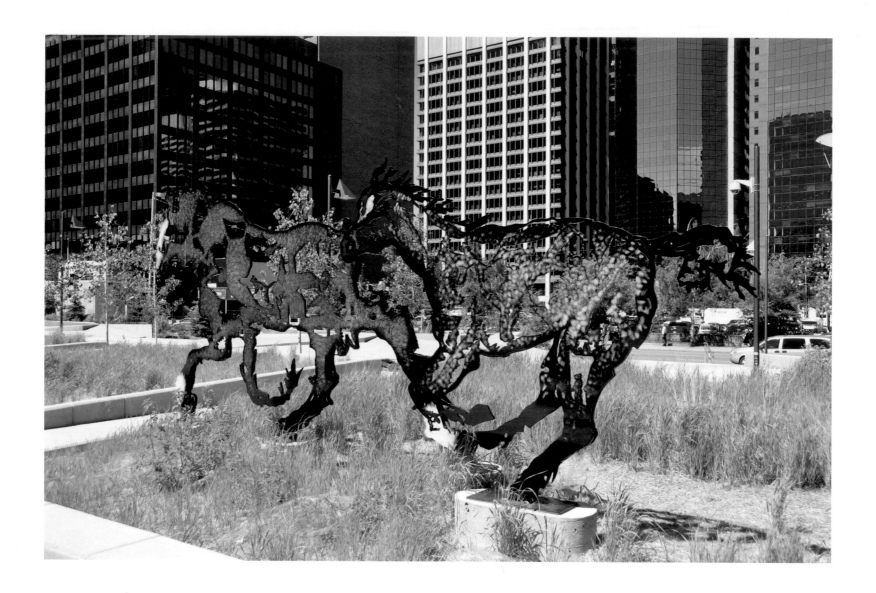

Above: Galloping horses art installation, part of an urban park in Calgary's financial district

Opposite: The Bow Tower in Calgary, decorated with a Blackfoot tepee for the Calgary Stampede

Following spread: Storm and graneries, near Jenner

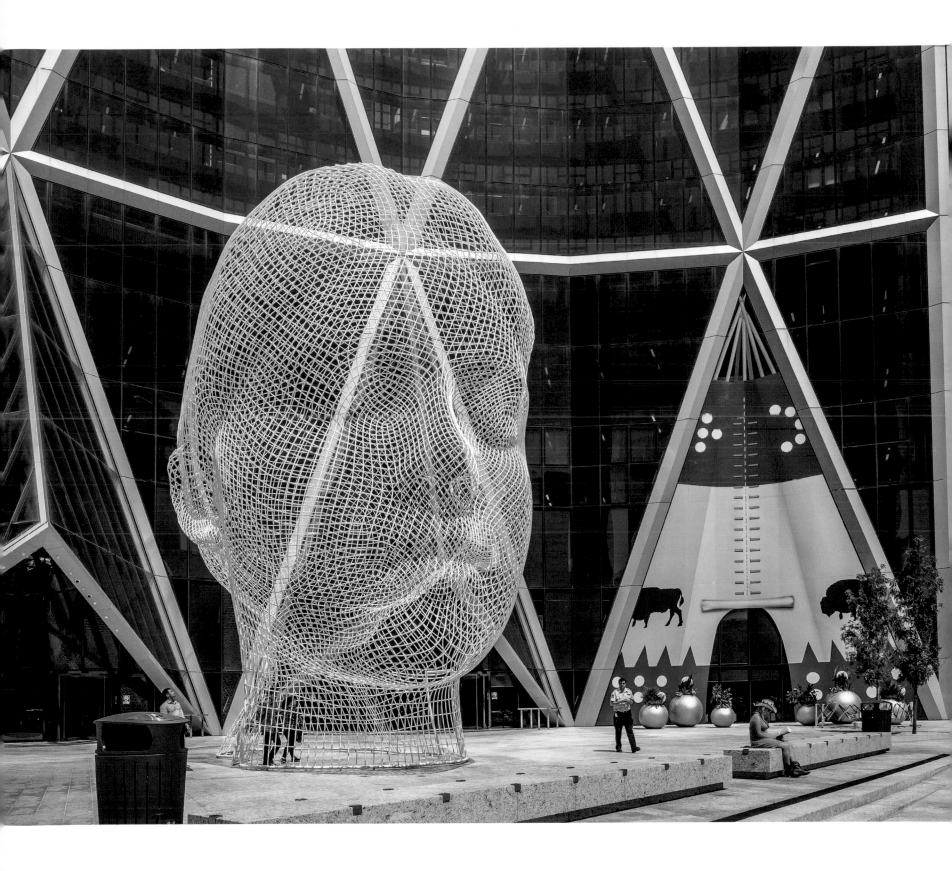

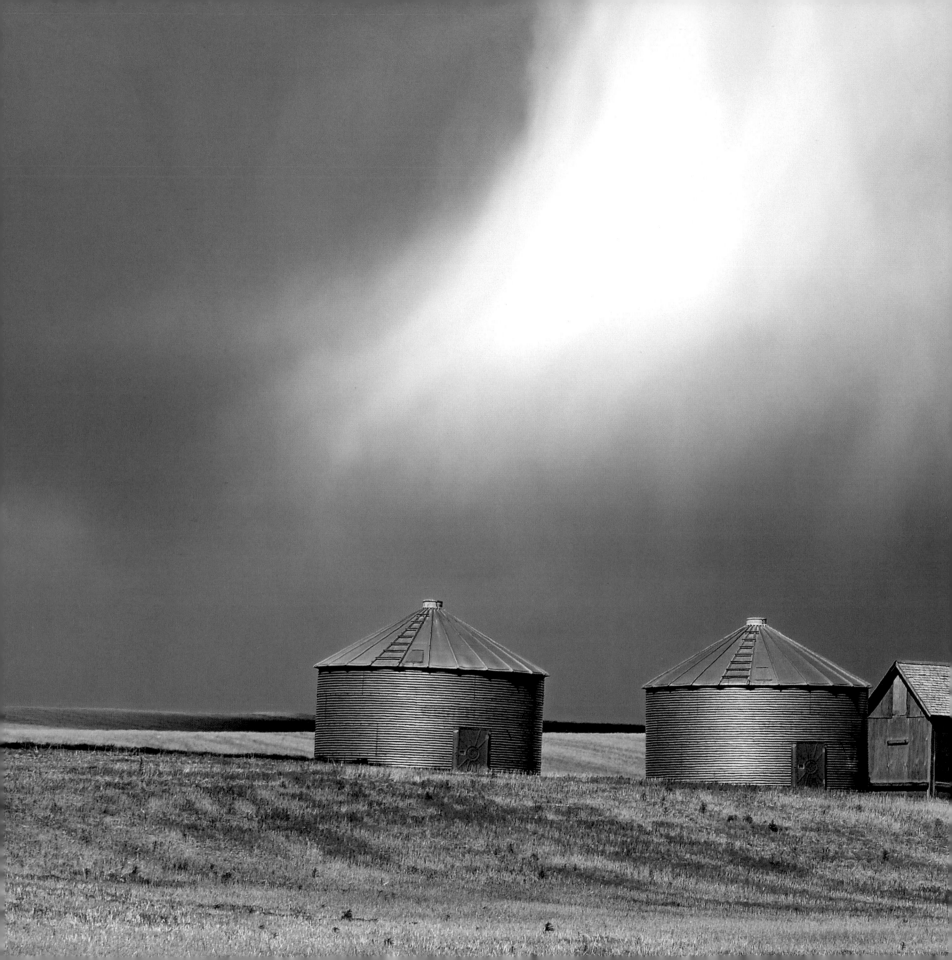

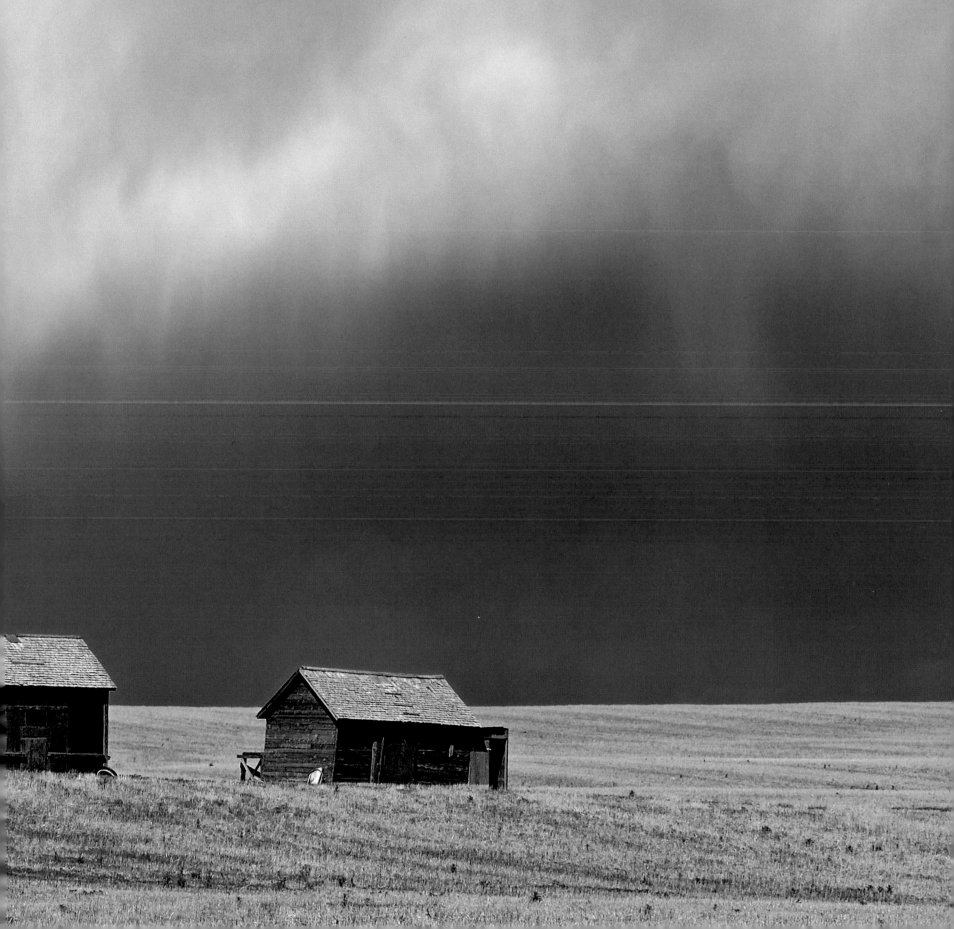

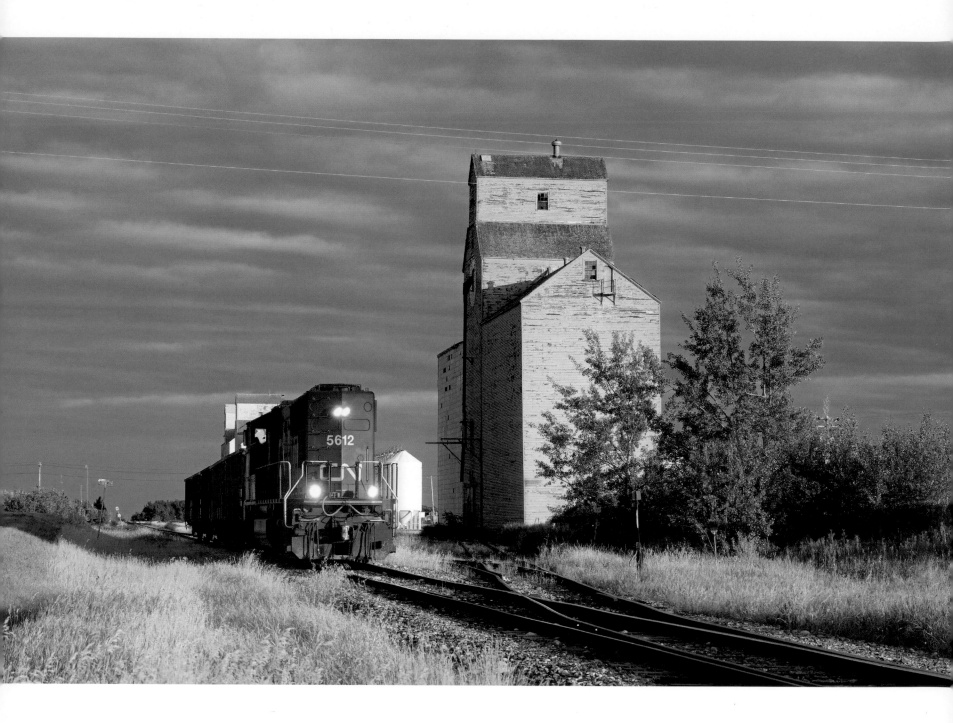

Above: Grain elevators, Sexsmith

Opposite: Grain elevators, Mossleigh

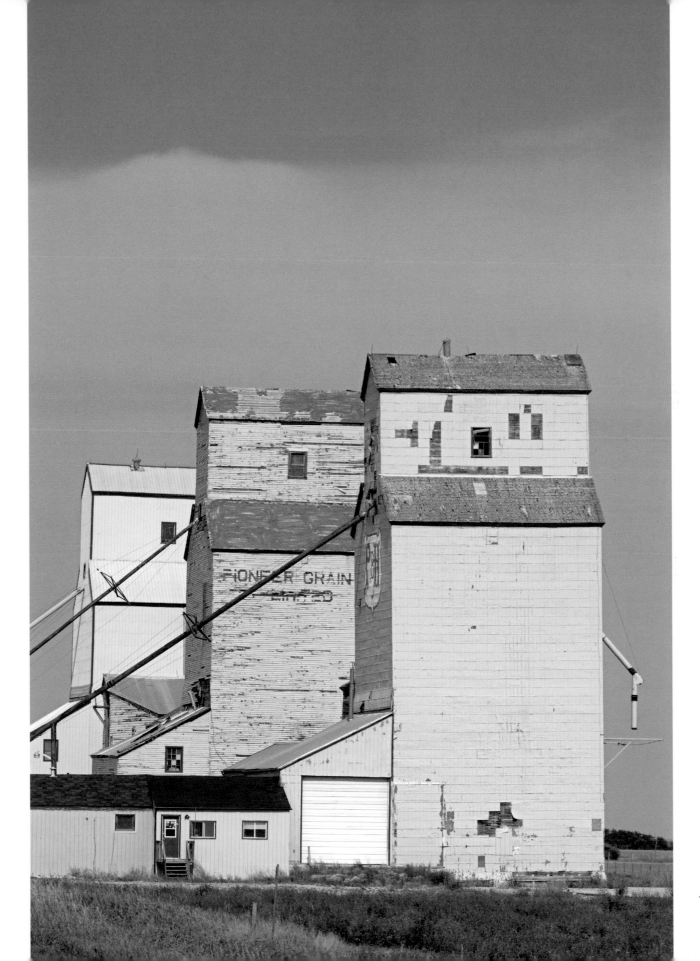

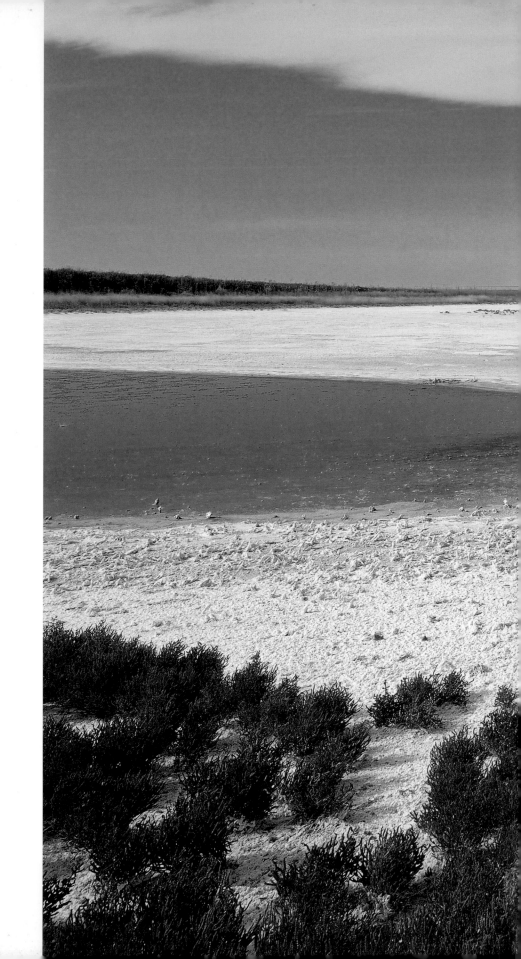

Red samphire at the edge of an alkali lake, Foremost

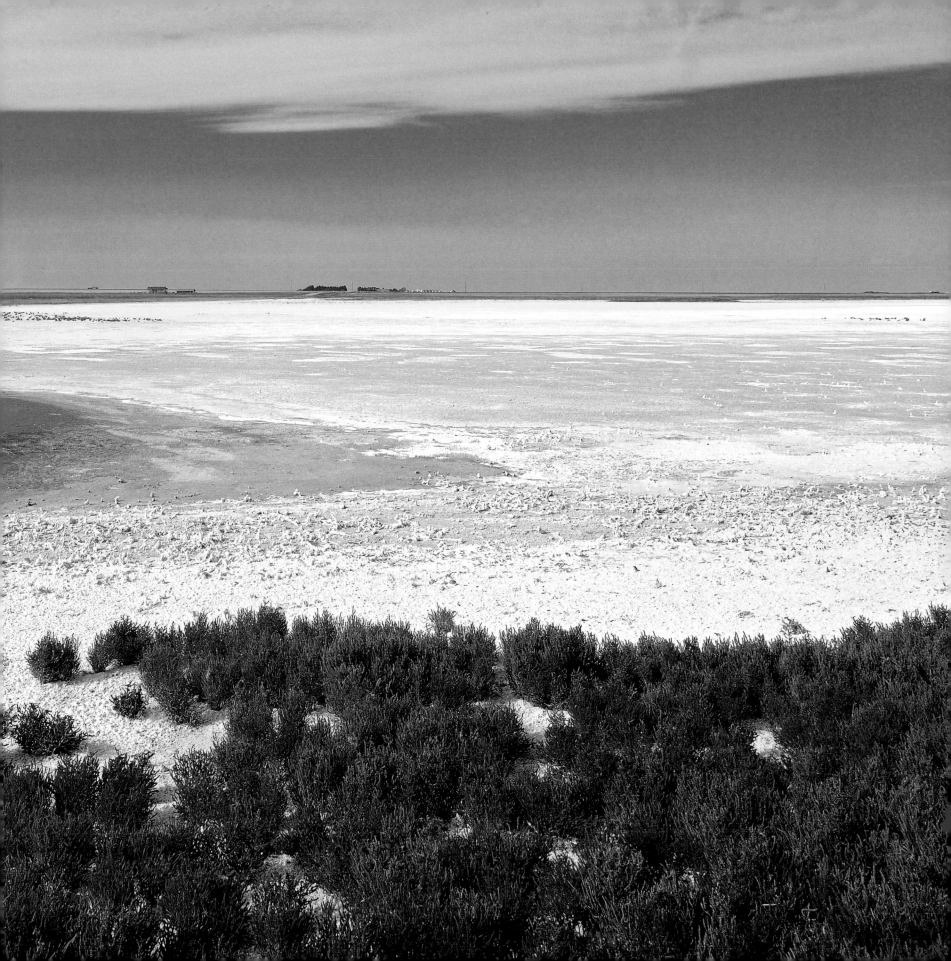

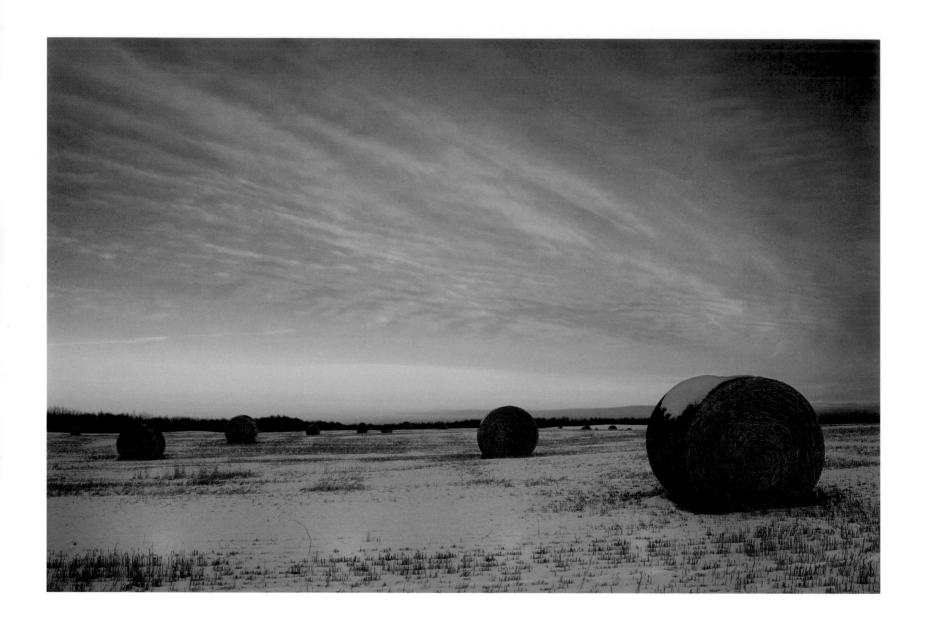

Above: Bales at sunset, Stony Plain

Opposite: McDougall Memorial United Church, Morley

Following spread: Highway 24 cutting across the prairie, near Mossleigh

124

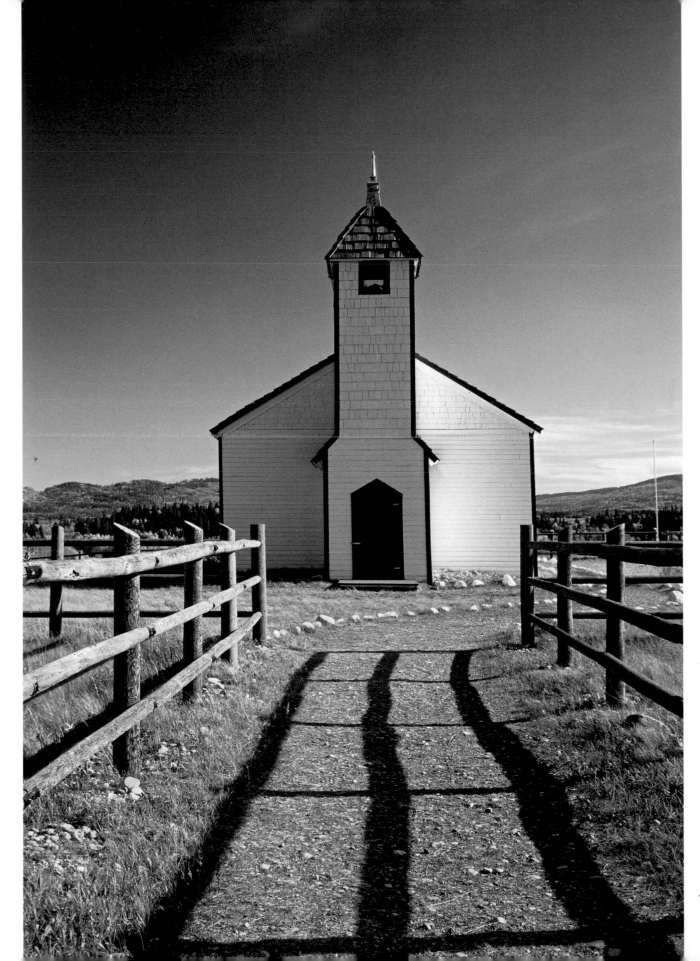

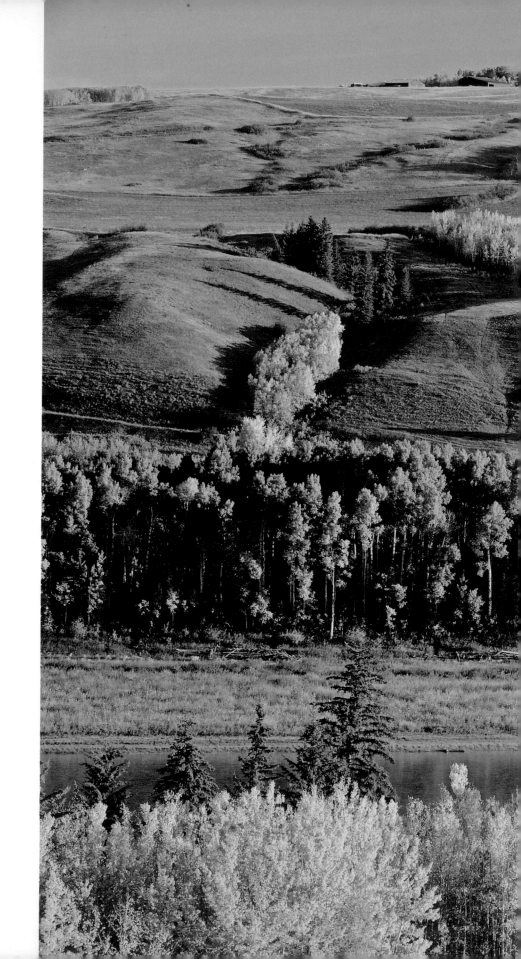

Coulees in autumn, Dunvegan

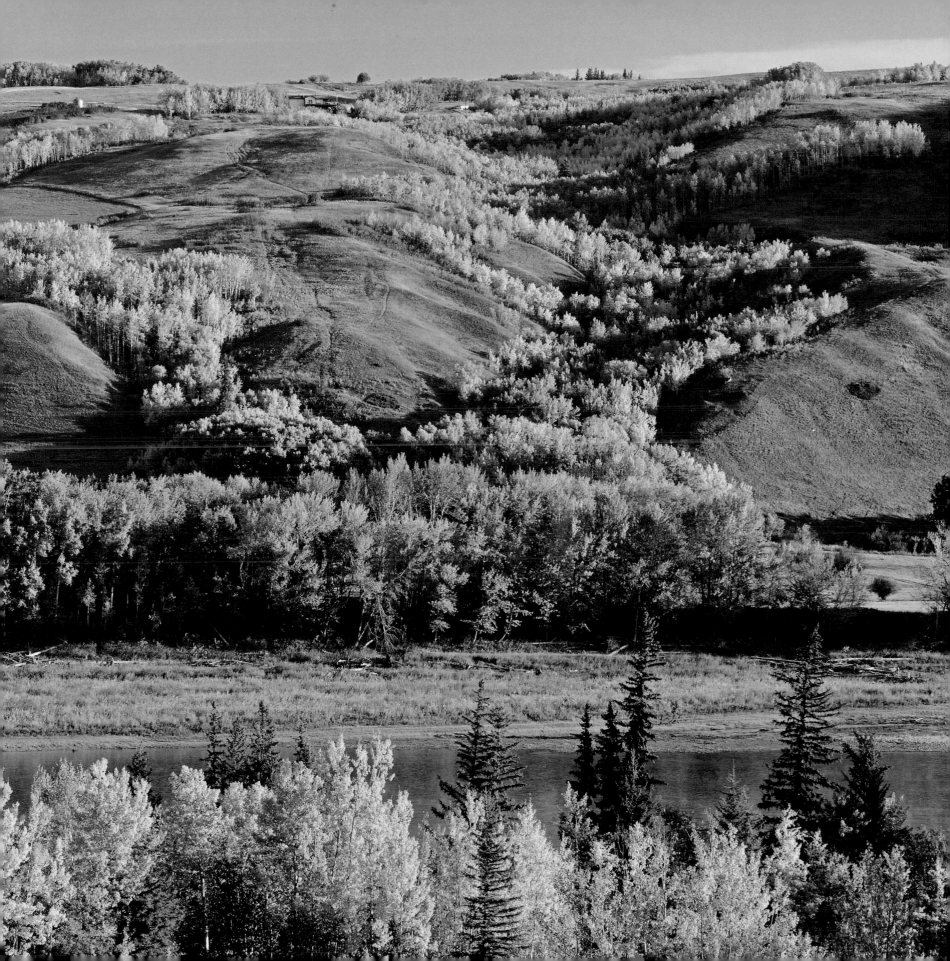

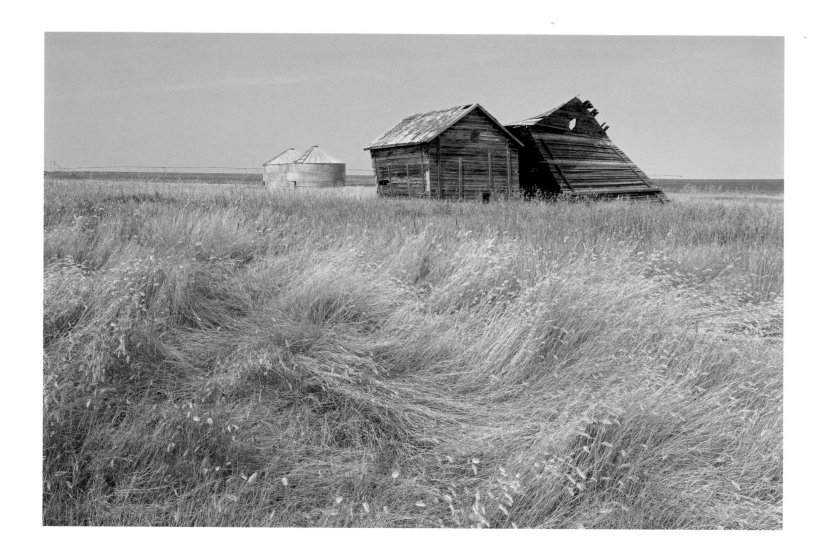

Above: Wood and metal granaries, Taber

Opposite: Sandstone concretion at sunrise, Red Rock Coulee Natural Preserve

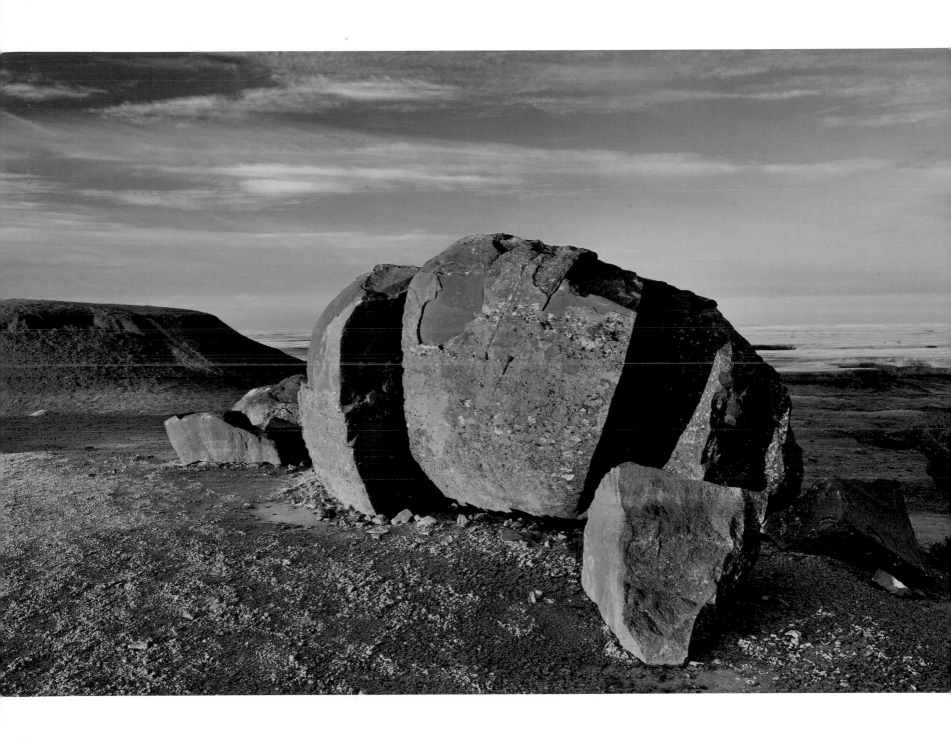

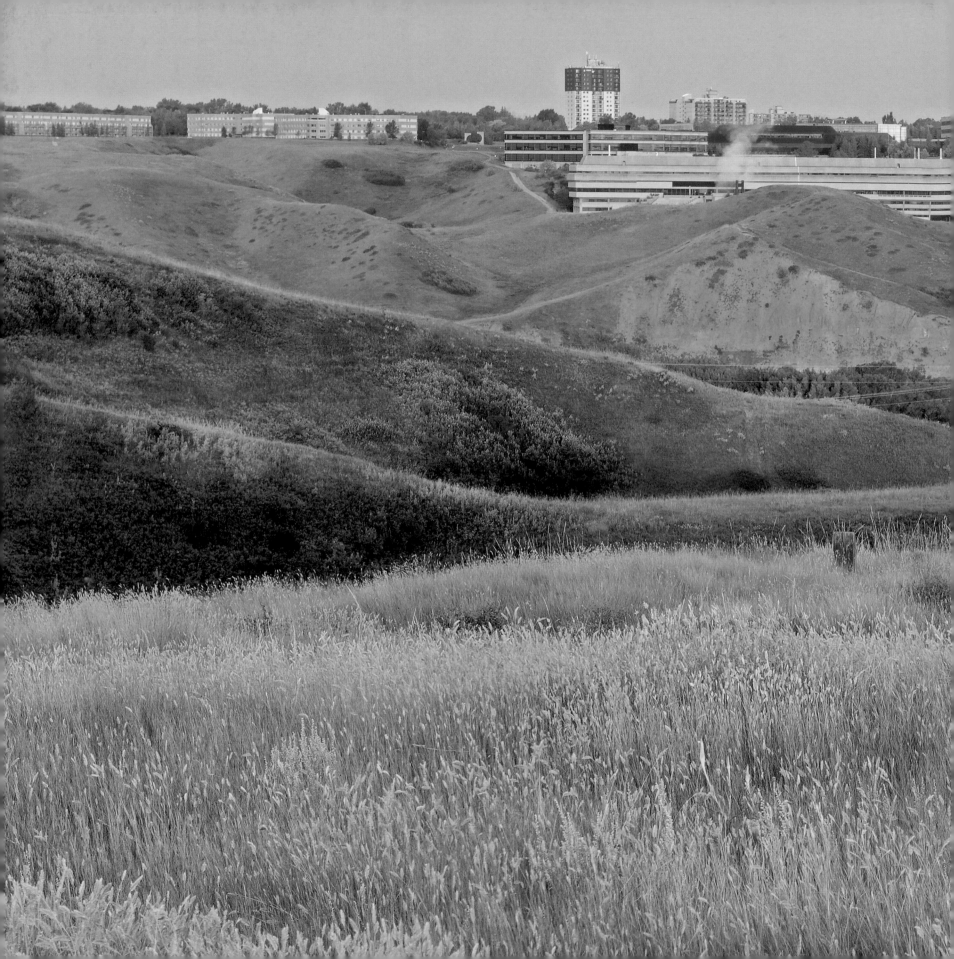

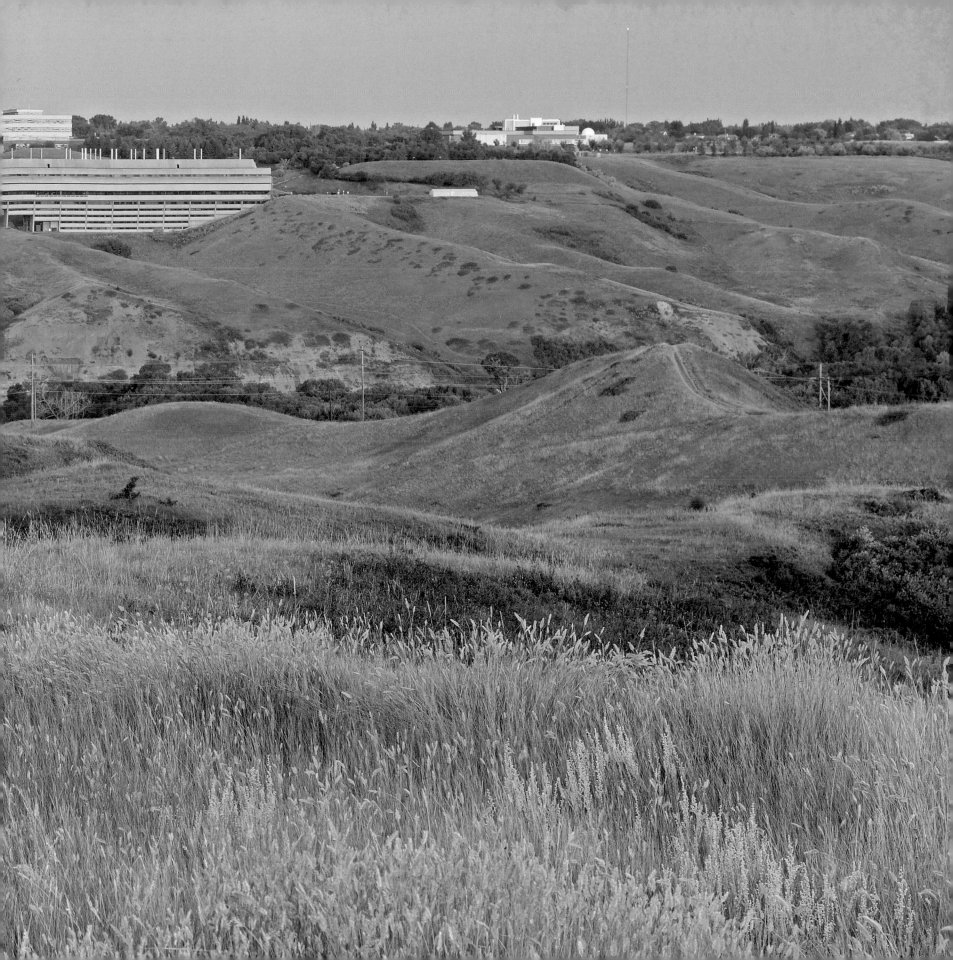

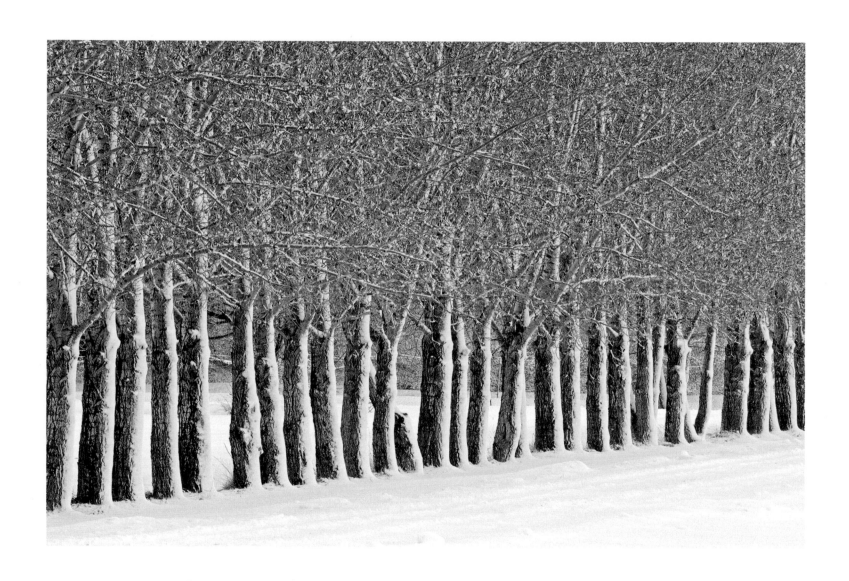

Shelterbelt trees in winter, East Coulee

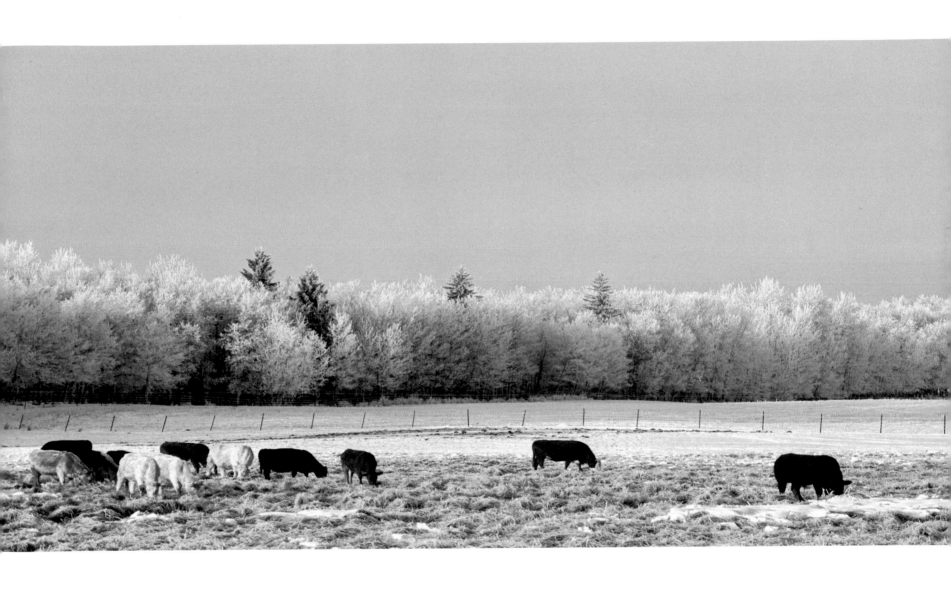

Cattle and hoarfrost, Tofield

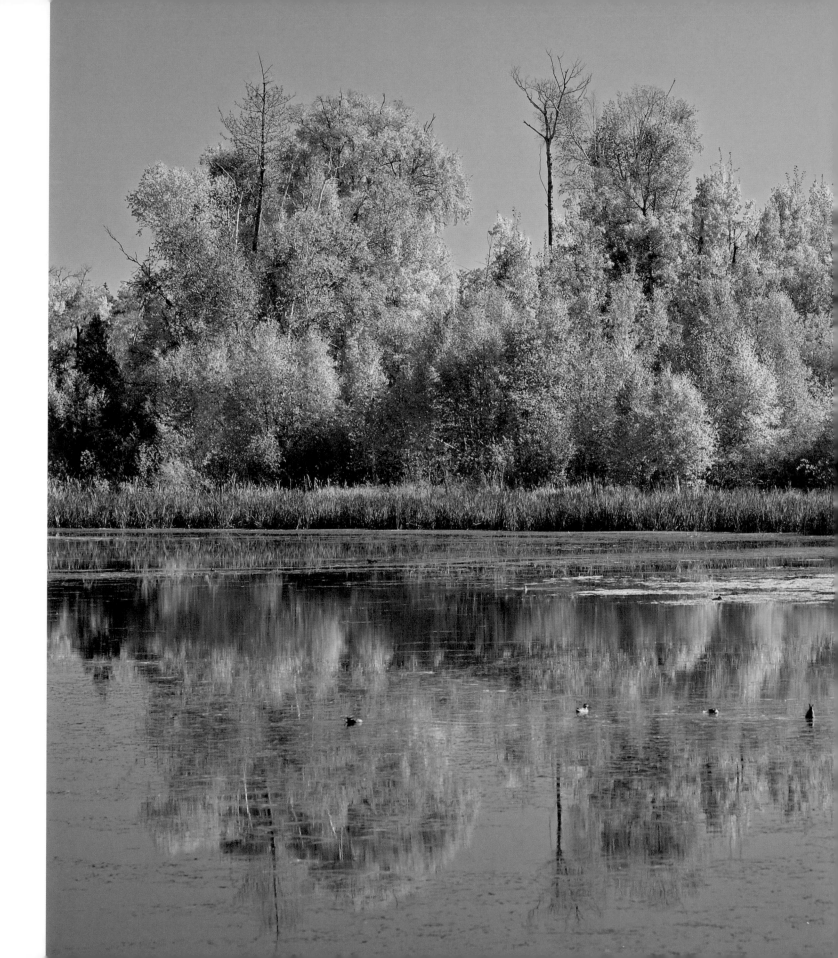

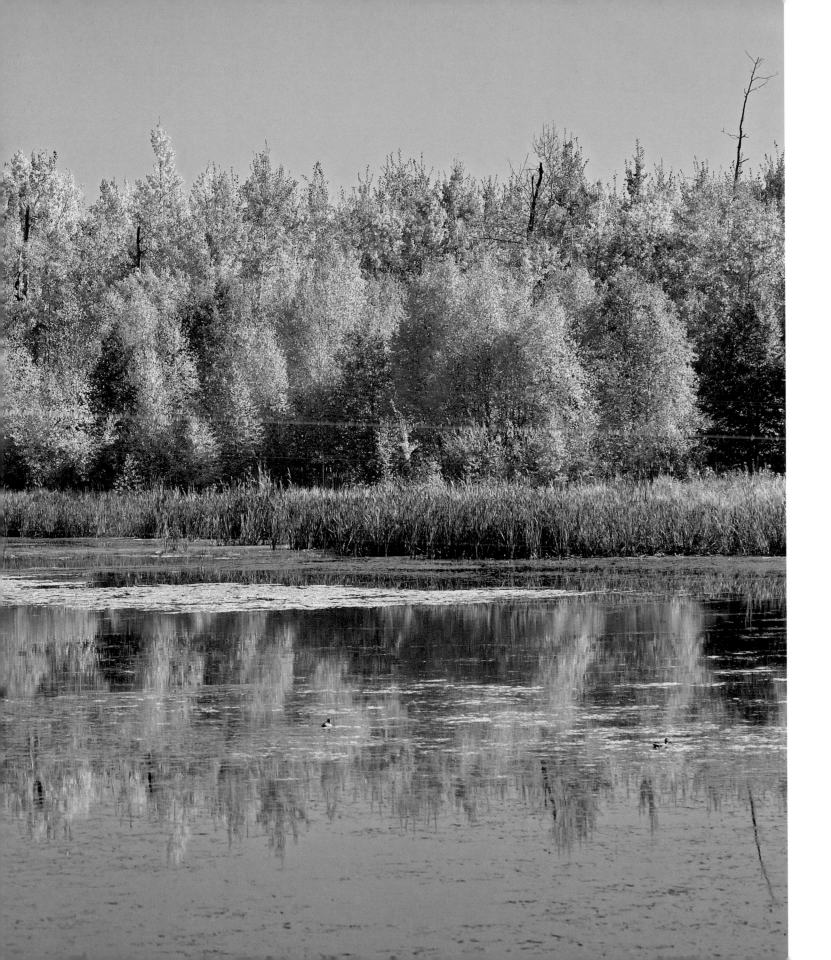

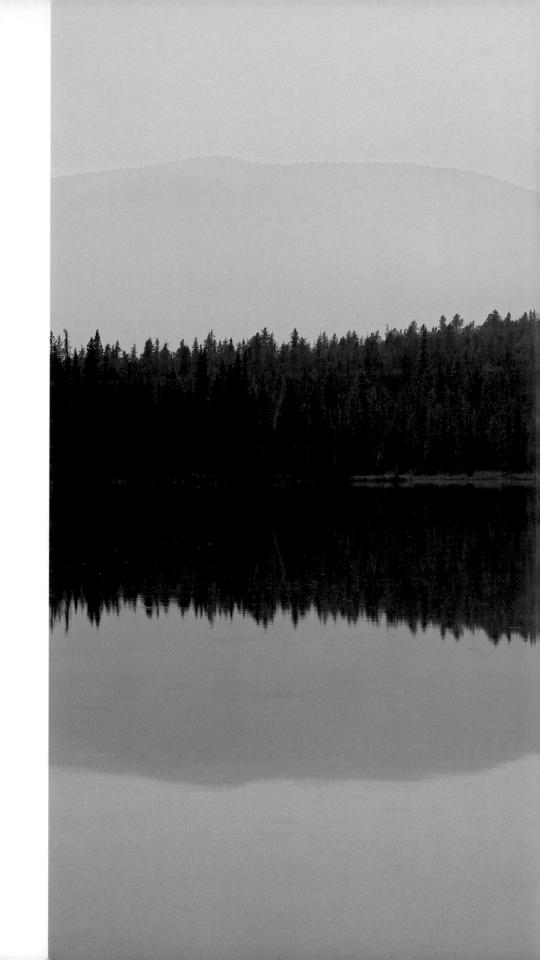

Previous spread: Autumn foliage reflected in wetland, Elk Island National Park

Opposite: Forest and Rocky Mountains reflected in pond during a smoky sunset, Nordegg

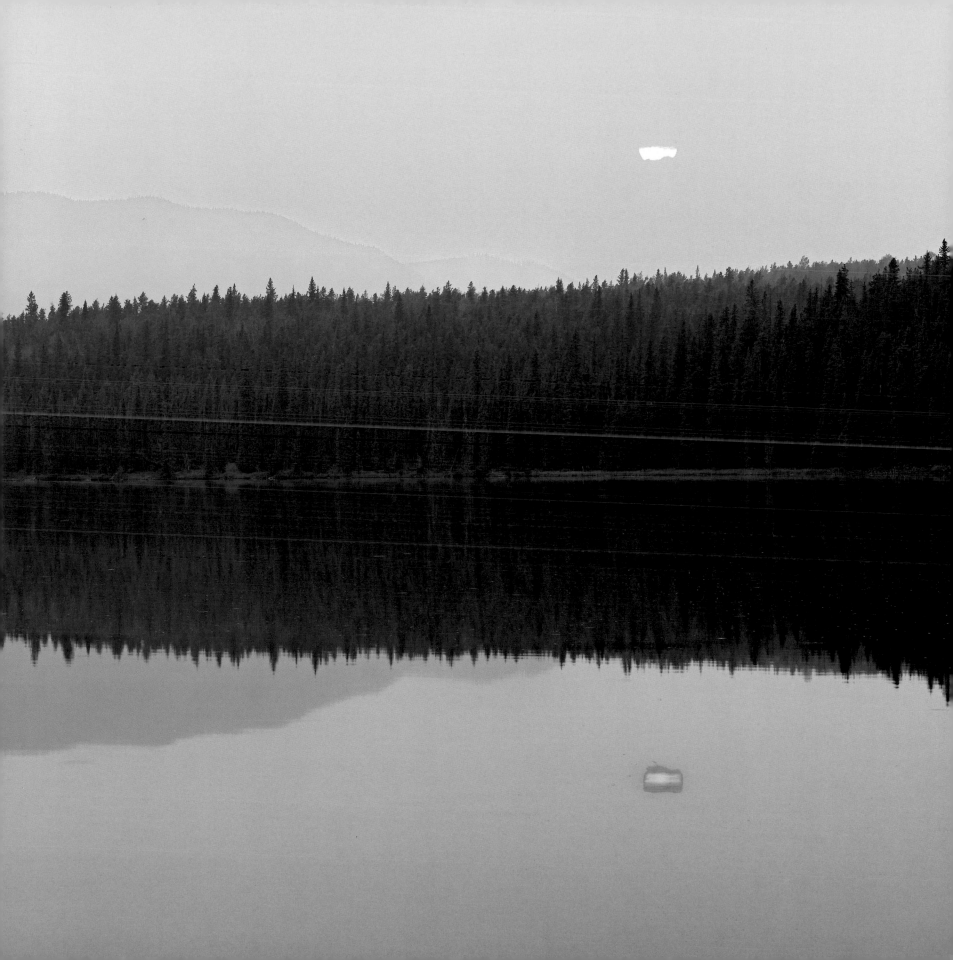

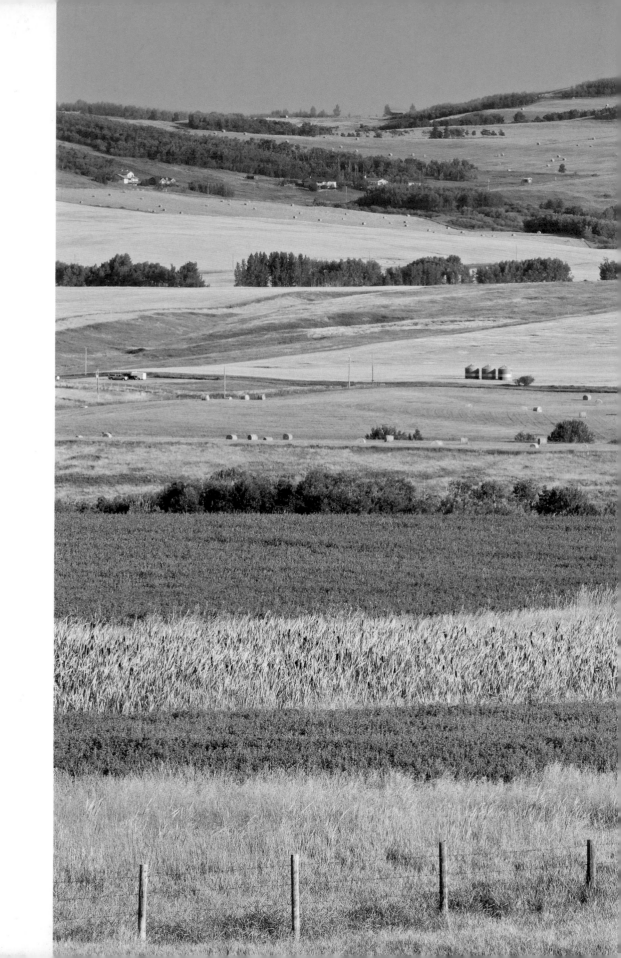

Farmland and rolling hills along the
Sheep River Valley, Okotoks

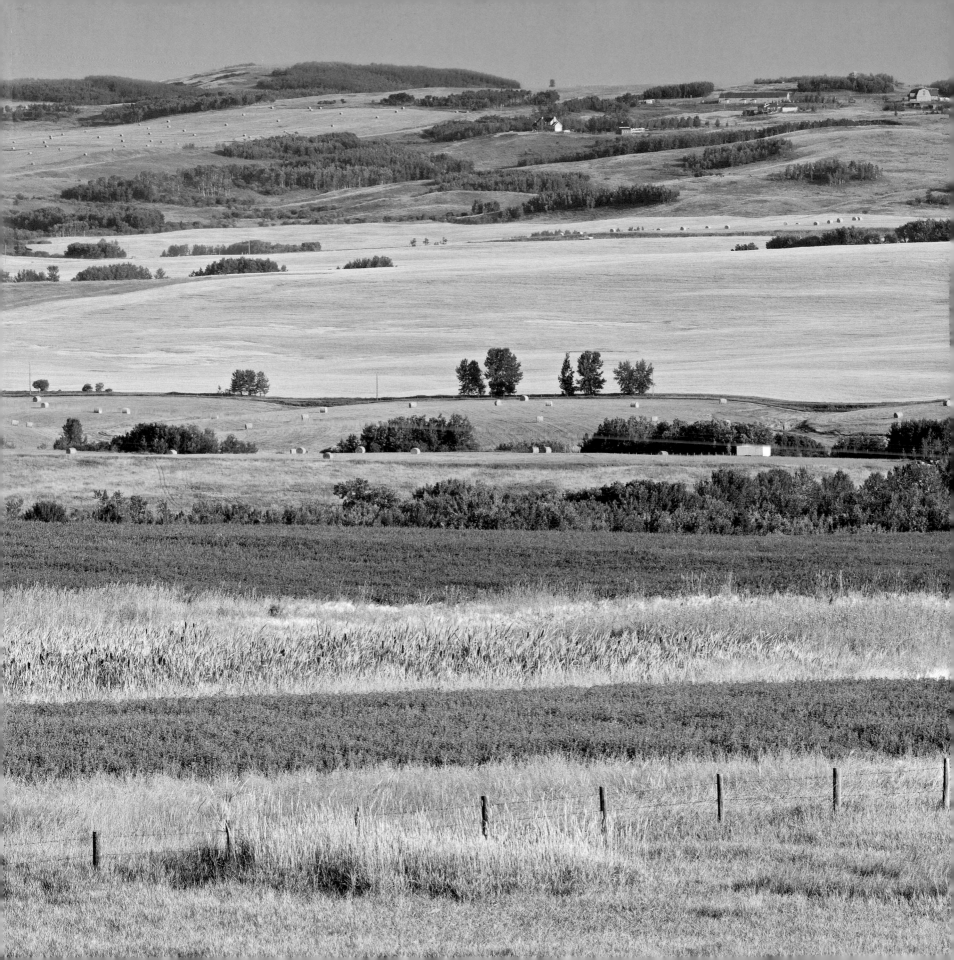

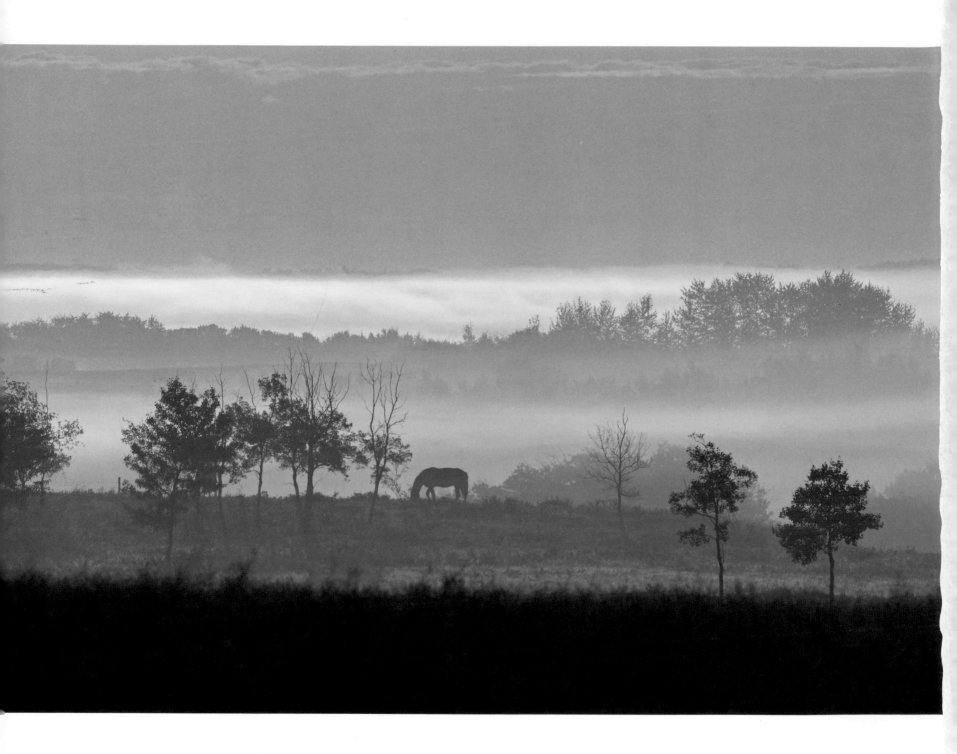

A foggy morning near Vegreville

144